What Is Art For?

What Is Art For?

Ellen Dissanayake

University of Washington Press
Seattle and London

Library of Congress Cataloging-in-Publication Data

Dissanayake, Ellen.
 What is art for? / Ellen Dissanayake.
 p. cm.
 Bibliography: p.
 Includes index
 ISBN 0-295-96612-2
 1. Art—Psychology. 2. Art appreciation. 3. Behavior evolution.
4. Human behavior. 5. Anthropology. I. Title.
N71.D57 1987
701'.1'5—dc 19 87-31648

Jacket art: *Where Do We Come From? What Are We? Where Are We Going?* (D'où venons-nous? Que sommes-nous? Où allons-nous?), by Paul Gauguin, 1897. Oil on canvas, 139.1 × 374.6 cm (54-3/4 × 147-1/2 in.), Tompkins Collection, 36.270, courtesy, Museum of Fine Arts, Boston.

To the memory of Kenneth Page Oakley

Contents

Preface

Although human ethologists have speculated about the origin and evolutionary function of many kinds of human behavior (e.g., aggression, sexual behavior, male and female roles), art, which is after all a universal characteristic or "behavior" of humankind, has not received much serious biologically based attention. Writers on the subject of the relationship of art to life, of its value to human beings, are usually literary persons, not scientists. There seems to be something about art—its indefinability, its multiformity, its intimations of transcendence—that makes the scientist feel that his methods and tools are inadequate for understanding it, just as there is something about science—its rigor, its tendency to mechanical reductionism—that makes the artist or lover of the arts suspicious of its pronouncements concerning anything in the realm of the "spirit." Art is usually contrasted with science; the twain are most often considered to be poles apart, even intrinsically incompatible.

Having experienced one of the great works of art that seem to speak in ineffable but deeply affecting ways about the attainments and aspirations and condition of human beings, one is indeed moved to silence, not explication. Anything that can be added to such a "statement" seems superfluous, and in comparison, imperfect. Who can analyze a revelation? Who wants to? Attempting to do so only defiles it, reduces it to the quotidian. And so if one speaks at all about art, it is reverently, acknowledging its incommensurability, its ultimate mystery. To claim that human beings need art is a proclamation of faith, not a scientific hypothesis.

Yet, even though particular works of art may be best left to

work their mystery without explanation, there remains something to be said about the relationship of art (understood as a general human endowment or propensity) and life (understood biologically). Since all human societies, past and present, so far as we know, make and respond to art, it must contribute something essential to human life. But what?

That the human species needs art *is* a scientific hypothesis, but one that scientists have been inclined to leave alone. The pitfalls of concrete reductionism on the one hand and vapory nonsense on the other have ensured that the professional observes a wary distance from such a question. He has too much to lose, and knows it. The few published pronouncements on the biological interdependence of art and life have more often than not been intuitions by well-meaning amateurs, unsupported by sound knowledge of evolutionary and ethological principles or of humankind's protohistory. With few exceptions art is either taken for granted as having begun with Paleolithic cave paintings and decorated stone tools—evidence of an impractical, mysterious, and essentially inexplicable urge to ornament or beautify "for its own sake"—or it is extended to a broad and ultimately vague creative, expressive, or communicative disposition observable in all life or all experience.

One who wishes afresh to consider the relationship between art and life can begin by rejecting such extreme or naive views. On the one hand, respecting the unique properties of human achievements, we will not call bird song and spiderwebs "art." Nor will we reduce art to one primordial antecedent—such as play or toolmaking or body decoration. At the same time, being biologically and anthropologically informed, we will not be inclined to assert that art is an essence inhering in objects or a phenomenon that, occurring for its own sake, is unrelated to vital concerns.

The present study claims to differ from previous inquiries by assuming an ethological point of view—that is, by considering art as a behavior—and continuing by taking account of current knowledge in a number of relevant and related fields, including evolutionary biology, cultural anthropology, physical anthropology, cognitive psychology, developmental psychology, Western cultural history, and aesthetics. It consequently aspires to a comprehensiveness that other similar efforts by specialists would not, and will doubtless provoke the skeptical eyebrows that are raised at any ambitious wide-ranging synthesis.

A hypothetical reconstruction of the evolution of a complex be-

havior, particularly one like art which is overlain with so much cultural elaboration, can only be speculative. The prudent pragmatist might well wonder: Why bother?

I dare the raised eyebrows and spend time on an admittedly unprovable speculative reconstruction because what comes from the endeavor seems to me to reveal something immensely interesting about the kind of people we—of late twentieth-century modern Western civilization—are. The numerous byways down which we are led by a consideration of the question "What is art for?" all reveal aspects of our collective *oddity*—the evolutionary unprecedentedness of our concerns and way of life. I do not mean this to be either a compliment or a pejorative. Ethologists and evolutionists do not pronounce one species or variety "better" than another; they simply describe what they see. Viewing the species *Homo sapiens* as it evolves and expresses a behavior of art is a way of understanding ourselves and the modern *condition humaine.*

Acknowledgments

During the years this book has been taking shape, I have written several "Acknowledgment" sections in my head, and, for earlier versions, two on paper. As the years go by, and one's thought evolves, persons who seemed to be of critical importance in initial stages fade away, replaced ungratefully by other more immediately and therefore more noticeably helpful ones. Certainly more people have given me help or encouragement, in various ways, and at various stages, than I can mention here.

The book was conceived and largely written over the past decade while I lived in several non-Western countries (Sri Lanka, Nigeria, and Papua New Guinea), outside the Western scholarly milieu. Such a genesis is no doubt responsible both for any virtues the study might have (if the admittedly audacious synthesis by a nonspecialist of a number of specialist fields proves to have some validity) and for some of its shortcomings. As an isolate scholar working outside the usual academic rookeries, I did not have the benefit of stimulating conversations with and criticism from colleagues, and I was only indirectly influenced by prevailing scholarly orthodoxies, fads, and taboos. As a result of my sequestration, and for better or worse, my ideas in almost all instances emerged from my own head, offspring of the mating there of the knowledge and ideas in books that I read—books that were often remnants from better days in now-impoverished university libraries.

My life for fifteen years in the "Third World" was the source for many perceptions that found their way into my scholarly interests, and it vastly enriched and enlarged my inner being. Yet there was very little in that life to encourage me in the pursuit

of the kind of academic questions dealt with in this book. The solitary thinking, reading, and doing that was required was foreign to the life I led with the persons closest to me, and few of them had any inkling of the ideas that preoccupied me and consequently of my Jekyll and Hyde existence.

One result of my not having enjoyed the advantages of direct scholarly stimulation and criticism was that I was perhaps more needful than most of evidence and affirmation that what I was doing was worthwhile, that I—working away on my own and essentially in secret—was neither a wide-eyed crank nor a clench-jawed monomaniac, but a bona fide investigator of justifiably important questions. My profoundest gratitude then is due to people, most of them busy, eminent, and productive, who nevertheless took the trouble to cheer me on my way when I in some cases shamelessly approached them by post or in person with questions or the barely disguised wish for an approving nod or pat on the head. These include John Pfeiffer and Desmond Morris, who were the first to see promise in the questions I was asking and the approach I was taking in answering them, and the late Frank Malina, founder-editor of *Leonardo,* the first journal to publish my work. Later, the directors of the Harry Frank Guggenheim Foundation, Lionel Tiger and Robin Fox, saw fit to award me a fellowship to spend six months at the libraries at Oxford, and during my time in England I was enriched by the interest taken in me by the late Kenneth Oakley, to whose memory this book is dedicated. Other persons I met while in England have stayed in touch, either with encouragement of my work or the exchange of ideas, and most often both: Jerome Bruner, Suzi Gablik, Marghanita Laski, Anthony Storr, Moyra Williams, and J. Z. Young. It has meant more than I can say to be able to feel that persons of their accomplishment have listened (and talked) to me as "a fellow toiler in the vineyard," as one of them felicitously expressed it.

Friends there have been who have believed in me, among whom I mention with particular affection Mary Bowers, Edwina Norton, Thalia Polak, and Lorna Rhodes. In formative years I was indelibly impressed by the idealism, dedication, and learning of John F. Eisenberg; more recently in New York three special associates, Francis O'Connor, Pamela Rosi, and Joel Schiff, have given, in their own individual ways, scholarly and spiritual sympathy along with everyday practical assistance. My sisters, Elizabeth Ratliff and Susan Anderson, my brother Richard Franzen, and their families, and my parents, Fritz and Margaret Franzen, provided

unstinting support, tangible and intangible, and uncomplainingly put up with me as lodger and resident bookworm when I stayed at their homes for short and long periods on my visits to America.

In 1980 a gentleman came into my life who has affected it beyond measure. Mr. David Mandel, who had been thinking about art and its place in human evolution for decades before I was born, began a correspondence which later developed for a time into a benefactory relationship. Owing to his generosity, I presented a lecture in his name to the American Society for Aesthetics annual meeting in 1981, and later became the Mandel Lecturer in the Master of Arts in Liberal Studies program at the Graduate Faculty, New School for Social Research, in New York City. It is not often that a scholar finds a fairy godfather. I should like here to acknowledge and proclaim my good fortune.

I am indeed proud to have been associated with this Liberal Studies program before its regrettable overhaul in the name of "academic respectability." For a time, under the inspiriting and facilitative directorship of Jerome Kohn, a diverse and unconventional staff was encouraged to be less concerned with transmitting bodies of knowledge and fashionable schools of thought than with open-ended examination and rethinking of the ideas and values that underlie received wisdom. In this unique atmosphere my students and I explored together many of the concerns of the present book, and I feel fortunate to have been a part of an imaginative and enriching if ultimately officially unappreciated endeavor.

I must also mention that my housekeeper in Sri Lanka, A. Margaret, performed for me many of the domestic duties that male authors usually take for granted from their wives. I owe a great deal to her and more than I like to admit to the inequities of a world in which because she and those like her have never had the opportunity to learn to read, I am permitted to have time to write.

My husband accepted with forbearance and grace the absences of his wife, physically and mentally, as she incomprehensibly pursued knowledge about art from books when his own immediate existence exemplified it effortlessly without the slightest need whatsoever for academic speculation or justification.

What Is Art For?

Introduction

"What is art for?" is not a question that bothers very many people. Art is simply there—in museums, in books, and in school curricula. What it is *for* is beside the point. It just is.

It is certainly not a question that bothers artists. They go ahead under their own particular stars, benign or daemonic, letting others worry about the justification for what they feel compelled or called upon to do.

Like many questions no one bothers to ask, "What is art for?" only shows its intriguing possibilities when one starts prodding it about. And then numerous other questions are revealed nestling under its skirts: What is art? Is art necessary? Where did art come from? What effects—on individuals and on societies—does art have?

Phrased like this, the questions seem more interesting—tangible and relevant. Almost everyone has something to say about them, from one point of view or another. Philosophers, particularly aestheticians (that ugly label which ironically refers to those who are concerned with the philosophical study of art and beauty), traditionally deal with the metaphysical or ontological status of artworks and aesthetic experience; sociologists and anthropologists address art's forms and functions—economic, political, spiritual, practical, social—in groups of people; psychologists and psychoanalysts consider what art does for individuals—amuses them, distracts them, aids sublimation, resolves conflicts, and so forth. Even poets often ponder these problems, though in general they phrase their concerns more subtly.

Common sense deriving from everyday experience also contributes to what is said or thought about these matters. The word "art" is like the words "love" or "happiness" in that everyone

3

knows what they mean or recognizes what they refer to, but, when pressed, finds them difficult to define with consistency or wide application.

In general parlance, reflected in the formal organization of municipal museums or university course catalogues, the word "art" usually refers to visual art—a group or class of things that can be looked at, things that have been drawn, painted, or sculpted. But not just anything painted, sculpted, or viewable is Art. If one pursues the matter, it is evident that most of us assume that there is some kind of qualitative difference or essence that pervades certain objects and activities—a vague, general, universal or transhistorical, almost sacred quality that makes some things capital-A "Art" and denies the appellation to others.

More specifically, one may talk not about Art but "the arts," which include not only visual objects but music, dance, poetry, drama, and the like—such as Baroque painting, Somali poetry, Javanese dance. One who speaks about "the arts" may or may not be emitting an invisible halo of unexamined reverent and metaphysical assumptions around his subject. He usually is. But at least "the arts" are understood to be cultural phenomena: we expect their manifestations to vary from culture to culture and we expect that certain individual arts and attitudes toward the arts will be found in some societies and not others. The question of ontological status recedes.

In most cases, it is not even necessary to use the word "art" at all; that we do use it is a curious fact that will subsequently be referred to from time to time. Anthropologists, sociologists, psychologists, and cultural historians who use the word "art" when they mean to discuss particular arts in particular circumstances risk begging the question of worth or value. It should not hamper our thinking (in fact, the reverse) to say "Oceanic sculpture," "chimpanzee painting," "children's drawing," and leave the word "art" to the philosophers, who at least are aware of the abysses that await them.

Having just issued this warning I will go on to disregard it. For although I am writing here neither as an aesthetician, who knows what he is doing philosophically, nor as an "ordinary person" who has the excuse of naïveté, I will be discussing art in general—though not, I must add, as a sacred metaphysical essence. I would like to pursue the possibility that although *the* arts *are* a cultural phenomenon, Art might profitably be viewed as a prior, biological one.

What is gained by substituting biology for metaphysics? Simply, it makes better sense of the facts. First, as I have indicated, the present-day Western concept of art is a mess. In later chapters it will become even clearer that our notion of art is not only peculiar to our particular time and place, but, compared with the attitude of the rest of humankind, aberrant as well. No wonder we founder so badly when we try to generalize our ideas about art to encompass the arts everywhere.

Second, modern aesthetics operates with presuppositions derived from eighteenth- and nineteenth-century European philosophy. Yet the fathers of modern aesthetics did not know, as we do, about prehistoric art—the cave paintings in France and Spain and elsewhere. They did not know anything approaching what we know about other cultures and civilizations and could not begin to appreciate the diversity and magnificence of human imaginative creations. Even what they knew of early civilizations (except for ancient Greece and Rome) was considered to be barbaric—"heathen Hindoo idols," "crude and primitive" carvings, and odd "curios" of ethnographic but not aesthetic interest. If we disagree with their judgment, we must question their premises and methods.

Third, just as Enlightenment and Romantic thinkers considered only the arts within their own culture and geographical area, they were unaware that they and all human beings have evolved, biologically as well as culturally. They did not know that distinctive human attributes (such as language, symbolization, toolmaking, and culture formation and evolution) can be seen in simpler forms in other animals and may be assumed to have evolved as well. Nor did they know that humans all over the globe are members of the same species with the same hereditary materials, the same potentialities.

Today it is recognized that the human species has had an evolutionary history of about four million years. Of that timespan, 399/400ths is disregarded when it is assumed that "human history" or the "history of art" begins, as it does in our textbooks, about 10,000 B.C. Unless we correct our lens and viewfinder, our speculations and pronouncements about human nature and endeavor "in general" can hardly escape being limited and parochial. If we presume to speak about art, we should try to take into account the representatives of this category created by all persons, everywhere, at every time. Modern aesthetic theory in its present state is singularly unable and unwilling to do this.

My approach will be ethological, or bioevolutionary.[1] That is, I will be concerned with the evolution and development of behavior in the human animal—specifically whether one can identify a general behavior of art that is as characteristic of humankind as toolmaking, symbolization, language, and the development of culture.

According to this ethological approach, "What is art for?" is a most appropriate question—meaning, "Why did a behavior of art arise at all?" What does art—like language, toolmaking, symbolization—contribute to the human species that would account for its appearance in the human repertoire?

In neo-Darwinian terms, "What is art for?" means "Does art have selective value?" and "If so, what is (or was) this selective value?" Three characteristics of art suggest that art has had selective value.

The first characteristic is that the arts are ubiquitous. Although no one art is found in every society, or to the same degree in every society, there is found universally in every human group that exists today, or is known to have existed, the tendency to display and respond to one or usually more of what are called the arts: dancing, singing, carving, dramatizing, decorating, poeticizing speech, image making. In evolutionary theory it is a generally accepted postulate that if a characteristic such as an anatomical feature or behavioral tendency is widely found in an animal population, there is an evolutionary reason for its persistence: it has contributed in some way to the evolutionary fitness of the members of that species.

Second, we observe that in most human societies the arts are integral to many activities of life and not to be omitted. If a great deal of effort is expended in particular activities by individuals or groups, this also suggests that these are activities that have survival value in a Darwinian sense.

Third, the arts are sources of pleasure. Nature does not generally leave advantageous behavior to chance; instead, it makes many kinds of advantageous behavior pleasurable.

But granted that art must have survival value, what could this survival value be? This is the bioevolutionary framework in which the question of the book's title "What is art for?" will be addressed. The use of the present tense in the question may be misleading, since the emphasis is on what art *was* for in the context of human evolution. I have retained the present tense, however, but with the connotation of something like a "continuing present." Since we are, today, the humans who evolved (and are

presumably still evolving), art still *is* "for" what it *was* for, although as cultural as well as biological creatures humans have elaborated the arts to serve multifarious political, social, and psychological purposes, and thus art may today also be "for" other things. Although many of these elaborations are interesting and could be addressed within our purview (the practice of art collecting, for instance, which is a historical phenomenon with arguable contributions to the biological fitness of collectors), they would lead us too far afield.

Although applying an ethological approach to art now can be accepted as theoretically justifiable, it may seem not only unfamiliar but unpleasant. Therefore it might be well to outline briefly what can and cannot be expected.

This is indeed a book about art and aesthetic theory, but it is not in any conventional sense an "art book." There are few pictures, for art will be treated not as objects or activities or specific aesthetic qualities, which could be pictorially illustrated. The chief aim of the analysis is not the immediate enjoyment of particular artworks, but knowledge and understanding—not of a single object alone but of art as a realm of human activity and experience in relation to other such realms.

To those who worry about murdering to dissect, I can only reply that in my experience a strong sense of wonder attends the awareness of the ubiquity and power of art as a universal human proclivity or need. Appreciation of what individual works embody is something else and is to be sought in other kinds of books and other forms of wonder. The two types of "understanding" are different and should not interfere with or efface each other.

What it means to call art a behavior is a difficult notion that demands a quite new way of thinking about the subject, particularly since discussions of art usually refer to human artifacts or products (pots, songs, masks) or qualities of these artifacts (beauty, harmony, unity in variety, fullness of expression).

In the sense in which we will be using the term, the ethological concept "behavior" does not refer to specific physical acts of behavior; thus particular artistic activities such as dancing or painting or appreciating dances or pictures will be viewed not as "behaviors" in themselves but as instances of a broad, embracing phenomenon, a general behavior of art. This is analogous to calling territorial defense, threatening, punishing, and strutting examples or instances of aggressive behavior which itself has no single manifestation but is instead an inclusive general term.

7

Viewing art as a general behavior with many varied manifestations allows for the fact that not all human societies demonstrate or emphasize equally all the "arts." Indeed, expressions of a universal behavior such as art in one human group in one spot in time and space are certain to be limited. Therefore, in the ethological purview, art in the Western sense will have to find its place as one of a number of manifestations that have existed and do exist; it is not presumed that any particular society's notion of art is the one true view.

A "behavior of art" should comprise both making and experiencing art, just as aggressive behavior presupposes both offense and defense. In practice it may be necessary, as I will do here, to separate these aspects in order to examine them closely, but the general behavior encompasses both. Similarly, the individual is a representative of the species, and we can as legitimately ask ourselves what art does for individuals as they develop and mature (ontogenetically) as what art does for our species in an evolutionary sense (phylogenetically). An ethological view presumes that art contributes something essential to the human being who makes or responds to it—not in the usual sense of being good for his soul or pleasurable for his mind and spirit (though these benefits are not denied), but beneficial for his biological fitness.

Art is then something people do, and feel. Thus we will be concerned with the subject of human needs and human minds—that is, with cognitive and developmental psychology, the study of emotion, psychoanalysis, as well as human ethology and evolution.

Since the evolutionary perspective requires us as far as possible to look at art cross-culturally, and try to lay aside the preconceptions of modern Western aesthetics, we must also be prepared to recognize that the history of art as a behavior predates by far what is usually considered to be the history of art. Chipped stone tools, cave paintings, and fertility statues may be the earliest artistic artifacts that are extant, but they are not the beginning of art as a behavior, whose origin must be at least in the pre-Paleolithic phase of hominid evolution. Art as we know it is a manifestation of culture, but one can claim that like other specific cultural behaviors, such as language or the skillful making and use of tools, it will have its roots in earlier, less differentiated, genetically determined behavior and tendencies.

The behavior of art, considered to be universal, should be characteristic of all human beings, and not just the rare or special

province of a minority called "artists," although to be sure, as is true of all behaviors, some persons may be more attracted to or skilled at displaying it.

Perhaps the most unfamiliar and controversial corollary of an ethological view is that the word "art" does not imply or mean "good art." In the first lecture of his study of the varieties of religious experience, presented in 1901–2 at Edinburgh University, William James disarmed criticism of a psychological approach to a subject that many in his audience considered to be unamenable to the pryings and peerings of science. James carefully distinguished between two different orders of question about his subject.

In a similar manner, I can say that I am concerned with an order of question that asks "What is the nature of artistic behavior?" "How did it come about?" and "What is its constitution, origin, and history?" Answers to these questions are not meant to be answers to another order of question: "What is its importance, meaning, or significance now that it is here?" According to James, answers to the first questions are existential propositions; those to the second are propositions of value, and neither can be immediately deduced from the other.[2]

By calling art a behavior I mean to suggest that it is a kind of phenomenon whose nature, origin, and history can be made a subject of inquiry without assuming that its products are good or bad. Yet, in an ethological approach to art (or religion), there is an implicit value judgment, though of a different type from those James had in mind. For if it is postulated that universally shown behaviors, like bodily organs and systems, have *selective value*— that is, do something to enhance the survival of species whose members possess that behavior—artistic behavior in that sense obviously has value to the lives of human beings, or at least we can assume that it had value in the environment in which it was evolved.

One may object that a discussion of art that does not take into account its value factors is of no use at all. It is not denied that questions concerning artistic value—such as "What is beauty?" "Why do human beings find art (or anything else) beautiful?" "In what manner is work X better than work Y?" "Why do some, or all, men respond to beauty or grandeur?"—are of the utmost fascination. There are intriguing and valuable contributions a psychobiological approach can make—and has made—to answering them (e.g., Berlyne, 1971).

But here I am deliberately restricting my own lens to a descrip-

tive rather than an evaluative view, believing that it will be a useful exercise in a field that is already confusing enough and could perhaps benefit from a different and clearly defined approach. Perhaps eventually it will be possible to propose a more comprehensive ethological analysis of art that can suggest what factors in human evolution would favor certain configurations, proportions, representations, and the like to be considered "good" or "beautiful."[3]

The question of our title is complex and not to be swiftly or succinctly answered. Indeed, my answer requires approaching from several diverse and distinct directions, each of which must be described and assembled before synthesis is possible. The reader may be forgiven for feeling unsure along the way where he or she is being led. The argument is presented somewhat in the fashion of the process of painting by numbers. That is, Chapter 1 is the "green"—all put down at once, with the successive chapters being the red, blue, gray, white, and so on. Only after all the component colors have been painted in will the whole picture become comprehensible. This manner of presentation may be uncomfortable for some. If it had been possible, I would myself have preferred gradually to build up an edifice or to pare away false notions to reveal a kernel of truth hiding inside. But the subject seems to require, at least insofar as my power to deal with it, the treatment that follows.

I

The Biobehavioral View

To recognize that human beings are animals need not be repugnant. To say we are animals is not to say we are "nothing but" animals. In fact, our "humanity" is made more impressive and precious by the realization that it resides in the complex development and interrelatedness of the same elements that are present in other animals. Like them, and like the rest of life, we are subject to the conditions and the vagaries of an inanimate, ultimately uncaring universe; unlike them, we "humanize" that universe, and in our image give it meaning. Humans are "something more" than animals because they do not take their world for granted on its own blind terms, but interpret it, fashion their experience of it in multitudinous and multifarious ways. Without human awareness, the world is a chip off a star, mechanically wheeling in a silent blankness.

These "ways" of fashioning our world can be called "culture," whose variformity is invoked by cultural anthropologists to challenge recent claims by human ethologists that underlying the forms of culture are genetically endowed fundamental principles of behavior. The resistance to such a claim is, I suspect, at bottom an irrational one—a dislike, based on misunderstanding of what is meant, of assuming oneself to be an animal; and an unwillingness to accept that, being a part of nature, human beings are in certain essential ways constrained or "limited." Rational argument is not likely to change such convictions, especially since many of those who object to the biologically based approach often are arguing against what they think are dangerous or demeaning implications of the point of view more than against the theoretical claims themselves. An evolutionary view does not (or should not)

deny that culture is of the utmost importance; the opposite view tends to insist that genetic evolution, though having some indeterminate broad influence on humankind, has been superseded—for all practical purposes—by its cultural adaptability.

It should be possible to encompass both the nature and nurture vantage points. One is not right and the other wrong. Saying that behavior is genetically programmed does not mean that it is restricted to narrow, determined manifestations. Saying that human nature is dependent on culture does not mean that human nature is not also a product of natural selection. One can be fascinated by the incredible diversity of humankind and equally impressed by its fundamental sameness—and choose to specialize in the investigation of either.

My own inclinations are to look for the similarities rather than chart the differences, and my approach is based on principles of biological evolution in general and human evolution in particular. Because "evolution" (especially in studies of the arts) often implies cultural evolution, or the development of a particular art over decades or centuries, a more neutral term is desirable to encompass development over millennia. Such a term is *biobehavioral*.

A biobehavioral approach to human behavior and institutions seems called for once it is recognized how long we have been becoming human, and what the process implies.* Until ten thousand years ago we were all living in the same way, as gatherer-hunters, and it was in the previous four million years that our species nature was being laid down.

If it is accepted that for four million years a species has been adapting to a particular environment and a particular way of life, then it seems to me inarguable that changes in individual populations of that species over a ten, twenty, or even fifty thousand year span can be only superficial. The fact that individual members of the human species can interbreed, or that individual infants of any society can be brought up to be successful adult members of any other society, indicates our essential underlying sameness.

*Persons already familiar with or convinced of this approach may find Chapter 1 overlong or overly obvious. Since I hope that my study will be read by a wide range of people, some of them unfamiliar or not comfortable with biobehavioral ideas, I have found it desirable to clarify my use of the position in some detail, and to defend it against the sorts of criticisms, based on misunderstanding, that it occasionally provokes. Biologically informed and convinced readers may skim this chapter or turn immediately to Chapter 2.

Background

In 1975, Harvard entomologist Edward O. Wilson published *Sociobiology: The New Synthesis,* a massive tome that demonstrates with a wealth of examples that genes (the protoplasmic mechanism of evolution by natural selection) are a major factor influencing the social behavior of animals. Before Wilson's book, it had already been established that genes influence behavior that is not specifically social—such things as vomiting, sleeping, scratching, and numerous other "behaviors" that make individuals fit (i.e., help them survive). Animals that are not naturally (without being taught) able to vomit, sleep, or scratch when necessary will not survive as well as those who are. (Those who perform these activities excessively will similarly be at a disadvantage. There is a range of optimum variability in the genetically affected tendency to display these and all behaviors.)

Wilson's book extended this unexceptionable postulate of evolutionary theory to social behavior as well, showing that behaviors related to animals' dealings with others (e.g., maternal-infant, sexual, aggressive, and communicative interchanges; spacing, territory and group size, and so forth) are similarly influenced by genes that delineate a range of adaptive behaviors characteristic for each species.

Wilson reiterated the ecological postulate that the habitat and the way of life (or behavior) of animals are interdependent and—since each animal species occupies a slightly different habitat—that each species' range of characteristic behaviors will vary as well. Forest-dwelling creatures will usually be more solitary than savannah-dwelling ones, who tend to be gregarious: in open spaces there is safety in numbers (for prey); in the forest it is easier to hide if you are solitary and also easier to sneak up on a victim. Solitary animals tend to be more unfriendly (aggressive) to other members of their species, and develop behaviors, such as special displays, whose ultimate effect is to give each individual his own space or "territory."

The type of habitat also influences the body of the animal who exploits it. Good vision and speed are desirable for plains dwellers, good olfaction for nocturnal, cryptic creatures of the forest floor, strong tusks for root eaters, and so on. Behavior and body both evolve, and the selective pressure of the environment will produce bodies and behaviors that fit it and each other.

Opponents of "sociobiology" do not quarrel with the 96 percent of Wilson's book that refers to animals. What raises cries of out-

rage is the final chapter ("Man: From Sociobiology to Sociology")
and subsequent books published by Wilson, and others, that ap-
ply the theory to humans.

Critics concede that humans are affected by biology to the ex-
tent that they need to breathe and eat, to vomit, sleep, and scratch.
But, they say, human social behavior cannot be said to have been
genetically affected by the requisites of habitat because humans
have the ability to modify their habitats, and much more. Because
of their unique attributes, such as language and culture, humans
have stepped out of the animal mold and are no longer affected
in any interesting way by genetic imperatives. Cultural evolution
has replaced genetic evolution.

We shall return to the controversy at the end of the chapter. It
is enough for now to point out that the evolution of social be-
havior is accepted insofar as it applies to the behavior of animals.
Whether or not it applies to the behavior of people would seem
to depend on whether or not humans are animals; since they are,
it boils down to whether or not one animal can make a case for
proclaiming itself to be exempt from biological imperatives that
affect the rest of evolved life.

Before returning to the fray, and to help us understand the im-
plications of a bioevolutionary approach to humanistic studies,
we must acquaint ourselves with other terms: human nature, eth-
ology, and, of course, evolution.

HUMAN NATURE

Although all doctrines about how humans should live—polit-
ical, ethical, philosophical—are based on some belief of what hu-
man nature is fundamentally like (even those that assert that hu-
mans have no nature), conscious awareness of a concept or problem
of human nature seems to occur only when one meets someone
who is different from oneself. Until then, people assume that what
they and their associates are is what others are, and all pro-
nouncements about how the world is (or should be) follow from
that.

When two Australian gold prospectors first entered an unex-
plored region of the New Guinea highlands fifty years ago, they
carried a movie camera and filmed their encounters with tribes-
men, who had never seen Europeans. Indeed these people did
not know that their valley was only a minute part of a great land-
mass, which contained hundreds of other tribes, nor could they
begin to suspect that the great island was itself part of a vast
region of islands, and so forth. After the initial fear and incre-

dulity of the tribesmen had turned to curiosity and attempts to explain the shocking intrusion, the white men were construed as ancestors, ghosts. Only after one was secretly observed defecating, and the product later examined and found to be "just like ours," was it realized that there was a larger world outside the valley and that these too were men. (The tribeswomen who had become "brides" of the "ancestors" said they had already suspected as much.)

This old movie, part of a recent anthropological film called *First Contact*, reverberates in the viewer long after watching it. One tries to imagine the profound change of view demanded by suddenly learning that the familiar secure, confined world that has been "all there is" is suddenly violated. One's previous innocence can never be regained, as the completeness of one's known world shatters and it becomes merely one of millions of tiny parts of a vast and unknowable universe.

Many tribes call themselves by the word in their language that means *people* (or *human*). Neighboring tribes are called *other* (or *not-human*). What a revolution in worldview takes place in order to learn that one's very notion of oneself and one's people which heretofore has been self-evident and uncontested is severely limited. "Inuit" or "Mundurucu," instead of being the model as well as the name for humans, is only one of thousands of variants on a concept one didn't even have.

Such blinkered solipsism is hardly confined to illiterate, isolated tribesmen. Judging by its ubiquity, one might even suspect it is a component of human nature. Humans everywhere, even when they know there are other specimens, tend to consider themselves and their immediate kind to be the measure of all things. From the fate of the "wild men" brought back as curiosities or worse by slavers and explorers (less than a century ago Proust recounted going to view "a Cingalese" in the Jardin des Plantes) to the atrocities that befell and are still visited upon the original inhabitants of so many parts of the world, it is all too easy to consider people who are different from ourselves to be animals or savages (not-human) and with impunity to devastate them and their way of life. Even now such a view of one's own centrality lies behind many justifications for missionary activity, war, and economic development as well as exploitation.

Gradually, since the Renaissance when more and more parts of the world had more and more contact with each other, people have learned that there are more—and more different—ways of life than any tribesman or metropolis resident could dream of.

and one can also listen to the sounds as they exist in various forms. In the science of biology or zoology, ethologists are the ones who before anything else listen to the music: they look at animals and what they *do* in their normal everyday existence, the ways in which they behave.

Not everything an animal does is scrutinized by ethologists. Breathing, for example, and flying are activities that are understood better from the perspective of physiology or aerodynamics. But other general and specific activities, particularly those that contribute to the unique way each animal fits into its larger world of natural environment and other creatures, are ethological concerns, and they may overlap with other biological fields. "Behaviors" studied by ethologists include courtship and mating strategies, territorial maintenance or spacing mechanisms, communicatory behavior, and care of the young. Most of the behaviors of interest to ethologists promote social interaction between members of a species and are not simply subservient to ordinary maintenance or physiological requirements.

Ethologists may simply describe normal behavior in one animal species—say, the wolf—or they may compare a particular behavior, such as courtship, in closely related species and in several different contexts—say, between solitary and group-dwelling animals, or among forest, meadow, and desert dwellers. The sequence of mating behavior of tigers, who are normally solitary hunters, is noticeably different from that of lions, who—though also carnivorous felids—live in groups.

An animal's behavior is carefully integrated with everything else about him, his habitat, and the habits of his fellows. A hypothetical group of very friendly tigers who prefer community to solitary life will not survive very long, simply because there will not be enough prey within reasonable hunting distance to go around. In the tiger's case, reclusiveness as a behavior is adaptive; the reverse—conviviality—is not.

The "adaptive value" or "survival value" of behavior is a primary concern of ethologists, who are not usually content simply to watch and then describe what an animal does. They continue by asking "Why?": "Why this rather than that?" "Why is this species of mouse friendly and that species of mouse aggressive?"

These "Why" questions presuppose an evolutionary answer—that is, that friendly behavior and aggressive behavior were advantageous in the environments and ways of life of those particular mouse species, and therefore were "selected for" during their evolution. Ethologists not only assume that patterns of behavior

(cooperation or competition, mating strategies, polygamy or monogamy, the type of care for offspring), like bodily organs and physiological processes, have evolved, but presume that any behavioral pattern that is characteristic of a species has a function and is the way it is for a reason. That reason is that one particular behavior pattern rather than another better enables animals who perform it to perpetuate their genes (i.e., to survive).

As far as natural selection is concerned, a pattern of behavior is not different from an anatomical structure. Both are ultimately controlled by genes, hence amenable to differential survival in any population of a species (see p. 26, below).

It may seem unfamiliar to think of behavior—which occurs in time, is not totally predictable, and may show individual, idiosyncratic features—as evolving, being acted upon by natural selection like the eye or the lung or the heart. Yet if we accept that domestic animals can be deliberately bred for specific temperamental and behavioral characteristics, we can understand that aggressivity and maternal solicitude, for example, are as surely under genetic influence as eye color and ear shape.

Ethologists would be the last to deny the important influences of the environment on behavior. But whenever learning occurs, it seems to be guided by innately derived templates or programs that reinforce some responses and not others. Not everything is possible, and some things are much more possible than others.

Although the founders of ethology made their observations primarily on ducks, geese, and gulls, in recent years interest has spread to the study of the behavior of insects, mammals, and even humans. And, as is the case for sociobiology, no one is much concerned about the validity of the ethological approach unless the animal in question is us. The subject of human ethology is similarly controversial, raising hackles and other protective devices.

Yet there is no reason why the behavior of human beings cannot be a respectable subject of ethological study; and the findings of the "social" sciences—anthropology, psychology, and sociology—are augmented when human behavior is shown to have a biological as well as cultural and social relevance.

Human ethologists propose that certain ubiquitous behavioral features or tendencies in human life are an intrinsic, relatively unchangeable part of our nature and have arisen and been retained because they contributed positively to our evolutionary success, our survival as a species. It is further assumed that if a behavior is found, to one degree or another, in all groups of hu-

man beings, then it must be selectively advantageous. The practice of cannibalism may well have been adaptive to some tribes in New Guinea or South America, but it is not a human characteristic that can be called innate or selectively advantageous in general, as one can say about pair-bonding or social-hierarchy formation, tendencies that in appropriate circumstances are universally expressed. (Manifestations of evolutionarily neutral behavior can theoretically exist, as can behavior that is detrimental to survival, but these will occur in isolated individuals or groups.)

Ethological studies of the expression of emotion in blind and deaf children illustrate the genetic basis of fundamental social communicative abilities. Although blind children have never seen faces that show pleasure, displeasure, anger, or shame and embarrassment, they themselves smile, cry, frown, and blush. Deaf children cry and laugh, though they have not heard others do so, nor do they hear themselves. Studies such as those of newborn and infant abilities are valuable for suggesting innate underlying tendencies or gestures that become ingredients of later culturally patterned behaviors such as greeting ceremonies and other social encounters (Pitcairn and Eibl-Eibesfeldt, 1976). Similarly, cross-cultural comparisons of gestures have allowed insights into specieswide similarities that suggest innate endowment (Morris, 1977), in spite of culturally embroidered variations on the basic theme.

If one travels and watches in particular the young of different nationalities, the universality of human nature can hardly be doubted. Just as Dalmatian and Pekinese puppies unerringly reveal their dogginess, Yugoslavian and Chinese babies are all undeniably and delightfully alike. If you cannot see the baby, you cannot tell from its cry whether it is Arab or Israeli, American or Russian. Children's play all over the world sounds and even looks surprisingly the same.

Human ethologists would agree that there is, then, a basic human nature, a collection of behavioral traits universally possessed by each member of the human species. Among the components of this posited "universal human nature"[1] would be such things as (among infants) fear (and thus avoidance) of the dark, fear of strangers, fear of abandonment, and active seeking of attachment through certain behavioral devices (e.g., smiling and other communicative gestures; language). One can easily understand the survival value for infants of behaving like this. One cannot dismiss these as trivial or self-evident, for not all young animals share these traits: some fear the light; some approach and are cared for by unknown members of their group; some are on their own from

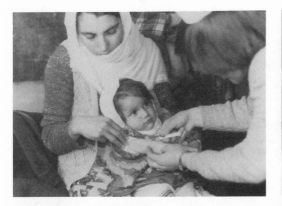

Turkey Ethiopia

Japan Papua New Guinea

In our young, who despite wide differences in upbringing look and be-
have so similarly, a common human nature can be readily seen.

a very early age and shun others of their own kind until time to
mate.

The peculiarly human needs and tropisms displayed in infancy
go on to inform such adult universal behavior as the active seek-
ing of companionship, suspicion of stangers, avoidance or ridi-
cule of the unfamiliar, and a penchant for communal self-tran-
scendence. Other components of "human nature" are shared with
other animals: identification and preferential treatment of kin,
particularly close relatives; investing power in those of greater age;
ritualizing social associations, such as those expressing domi-

Papua New Guinea

Japan

Bolivia

Children's play all over the world looks and sounds the same.

nance and submission, in similar ways. Some, though universal, appear to be uniquely human (or unique in their degree of development): the incest taboo; ritualized exchange and giftgiving; the marking of rites of passage; individual and ceremonial dress and body ornamentation; and explanatory schemes based on categories, oppositions, and rules such as the universal penchant for recognizing and demarcating the domains of "nature" and "culture."

In regard to this latter "universal" of human nature, one might point out that opponents of the biobehavioral approach are themselves epitomizing this ubiquitous human tendency to oppose nature (genes and determinism; animals) and culture (human intervention and free will; us). Human ethologists would offer that a more enlightened view is to consider culture as a part of nature. The inarguable differences between individuals from different societies and between individual groups of human beings are indeed largely products of cultural not biological evolution. Culture, however, need not be viewed as an alternative to or replacement for natural (genetic) tendencies, but their outgrowth and supplement. Culture is a biological adaption; it is essential, and humans are innately predisposed to be cultural animals. One of the most outspoken critics of biosocial (sociobiological) anthropology, Clifford Geertz, insists as one of his main theoretical points, "There is no human nature apart from culture" (Geertz, 1973). Quite so. This may make us different from other animals, but it does not mean that we are *nothing but* the product of our culture.

Genetic transmission occurs when information-encoding molecules are passed from one individual to another (from parent to offspring) by means of fertilization. It happens only once in a lifetime, and its cumulative effects are therefore very slow. Cultural transmission is the passing of information from one individual to another by behavioral means: by teaching, learning, imitation, practice, reading. Any individual can teach or learn from many individuals, and the rate of transmission (evolution) may be rapid or slow (Bonner, 1980).

Although cultural evolution has been occurring in a manner of speaking ever since humans banded together to hunt cooperatively, flake stone tools, and use fire—that is, from the time human language and speech emerged (say half a million years ago)—it has become the predominant instrument of human change and variation only since, roughly, the origin of agriculture and towns (approximately ten thousand years ago). The genetic evolution of human behavior would have occurred over the five million years

Investing power in those of greater age. Village chief. Koaltinquin, Upper Volta

Face and body decoration, Australia

Some universal human behaviors

prior to this, when humans and protohumans lived in small and relatively isolated groups of gatherers and hunters.

While the elementary features of universal human nature may become overlain and even disguised by the more recent accretions and forms of cultures, it is shortsighted to presume that those previous hundreds of thousands of years did not influence our species in significant and recognizable ways. Although adaptability and flexibility are certainly an important human evolutionary adaptation, and humans can learn many wondrous and diverse things, genes affect what one chooses to learn, one's aptness or readiness to learn it, how fast or slowly it is learned, and the time during which one is receptive to learning it. These things are affected by sets of neuronal connections in the brain, and the basic brain structure is directly established by the genes.

EVOLUTION

This book is not the place for a synopsis of the present range of theory and experiment in the complex and difficult science of evolutionary biology. However, because in common parlance the word "evolution" is used carelessly and inconsistently, it would be well to make certain elementary things clear.

In the first place, our subject here, the evolution of art, refers to biological not cultural evolution. It is almost invariably the latter that is meant when the phrase is used, as it was by anthropologists and cultural historians at the turn of the century. These gentlemen, often Germans, sought to discover and label stages in the progression of art from its origin (when? and from what form of art?) to the undisputed heights of classical antiquity, reappropriated in the Renaissance and in the neoclassical eighteenth century. Did naturalism and figurative art always precede geometric or abstract rendering, or the reverse? Could one detect a "will to form" in art of all times and places?

Although our inquiry will deal with some of the same questions (What was the probable origin of art? Is art universal, and if so, in what respects?), it is safe to say that the present approach is quite different from earlier ones, even those based on a notion of biological evolution. The conceptual background or framework I will use, derived from contemporary neo-Darwinian and ethological theory, was not articulated until the past decade or two.

It should be repeated that my bioevolutionary approach will consider art as a general behavior (not specific acts of making or response, nor the products of that behavior), and will consider that its origin was "pre"-cultural. The roots of artistic activity and

response—both phylogenetic and ontogenetic—will be sought in human prehistory, and inferred from what is known about other fundamental behaviors (see Chapter 5).

Darwin, it has been pointed out, did not "discover" evolution.[2] His contribution was not to recognize the fact of evolution but to propose a mechanism by which it could operate. That mechanism is *natural selection*. In its simplest form, adequate for our purposes here, Darwin's theory arises from applying logic to the following assumptions and observations from natural history:

1. Living organisms possess an inherent capacity to overreproduce. A population will remain constant if every pair produce on the average two offspring who become reproductive adults, thereby replacing themselves. If fewer than two per pair per lifetime are produced, the population decreases; more, and the population increases.

2. Animal populations in nature tend to remain numerically stable.

3. This balance is a result of the competition of individuals for limited resources such as food, territory, mates, safe shelter, and so forth: some individuals are more successful than others.

4. Individuals vary. They differ from each other in numerous characteristics that affect different aspects of their competitive prowess.

5. To some extent these differences are inherited by (passed on to) their offspring.

6. The ultimate consequence of all this is that the genetic makeup of any species tends to change with time, reflecting the greater reproductive contribution of certain individuals (the "better adapted" ones) than of others. This change is *evolution by natural selection*.

A feature such as a structure or behavior is adaptive if it gives a relative reproductive advantage (or "selective advantage")—that is, if the animal in question is thereby able to leave more offspring than another individual of the same species who does not have that feature.

The word "fitness" refers to reproductive success. There is no such thing as "fitness" in the abstract, but only fitness for certain environmental conditions, and these may change. Moreover, a feature may be adaptive (confer fitness) in one respect and lower it in another—for example, a willingness to mate frequently or have large litters might seem to confer fitness, but this must be balanced against the lowered fitness resulting from the difficulties of caring for more offspring than do other animals of one's spe-

cies. Thus the determination of adaptedness is complex and not always evident to common sense.

Darwin himself did not know the actual mechanism by which natural selection operates—the gene (and the DNA structure within the gene). Thus, in the sense originally meant by Darwin, natural selection acts so that the fittest individuals are selected—that is, those individuals who leave behind more offspring (who themselves live to be reproducing adults) than the average.

It is recognized today that what is selected is the genotype (the genetic materials of an individual), although the bearer of the genotype is an individual (or phenotype). More precisely, the unchanging carriers of hereditary traits are genes (and particular combinations of genes) rather than the entire genotype, so that some geneticists now refer to genes as being the units of selection. Any action or behavior that increases the number of fit genes will thereby increase the fitness of individuals (e.g., genes for assiduous parental care of infants in a species where infants are born helpless).

In order for an evolutionary approach to be relevant to the understanding of human behavior, it is necessary only that we possess some genetically mediated tendencies to behave in particular fashions, such as to feel positive about certain things in preference to others. It has been shown, for example, that humans tend to respond positively to infantile characteristics of "cuteness," such as the round heads, large in proportion to the body, and flat faces of baby animals. The inclination exists presumably because personal fitness is enhanced by our having a positive response to our own infants, who happen to have these characteristics. Therefore these stimuli, generalized to other baby animals, appeal to us.

As far as the influence of DNA is concerned, it is just as applicable in a purely mechanistic sense to behavior as to anatomy or physiology. Genes ultimately code for structural proteins which influence the properties and interconnections of cells. DNA is just as capable of influencing nerve cells as bone cells, and if we grant that behavior arises from the activity of nerve cells, it is as susceptible to genetic influence as skeletal structure or physiological systems.

Corollaries and Implications

With this brief introduction, it is now possible to deny flatly some of the misunderstandings and criticisms of the biobehavioral view.

1. This view does not mean that genetic causes alone determine behavior. No human behavior is the result of the action of one gene, and the importance of the environment in influencing and shaping the expression of genetic predispositions is axiomatic.

2. Similarly, not every act of every human is to be interpreted as maximizing its reproduction. Evolutionary change in the human species, in the history of environments in which it has lived, has tended to be in the direction of maximizing reproduction.

3. This view does not automatically imply mechanism. In the first place, no animal is a machine. Although a "free-ranging" animal (such as an antelope) does not have complete freedom of movement so that it can leave its herd and travel alone, it moves as it pleases and at random.

4. This approach does not imply that development of a behavior is predictable, direct, and inevitable. In humans, especially, cultural and individual psychological imperatives can and do override biological tendencies all the time. Biologically left-handed persons may, in societies where left-handedness is disapproved of, learn to perform certain actions, like eating, with the right hand. Some individuals refuse to eat, some eschew sex, some become recluses and hermits.

5. This view does not and should not threaten the concept of human freedom. In fact, the notion that we have a nature is absolutely essential to the concept of freedom, for if we were a blank slate (or a slate that was programmed only for the essentials like sleeping, digesting, and blood clotting), then it would not matter what people did to us, for we could learn to accept it.

6. More important, because the biobehavioral view stresses that we are more alike than previously imagined, the oft-heard criticism that it can be used to support racism is absolutely mistaken. On the contrary, it insists on the reverse. An evolutionary perspective does not and should not attempt to account for differences among members of a species, but rather should elucidate in what ways one species (e.g., humans) is different from others.

7. This view does not imply "crude biological determinism."[3] By using the words "powers" and "tendencies," choice is emphasized. Change and lability of innate behavioral tendencies are allowed for, though likely limits are acknowledged, and an awareness of what directions of change are improbable is encouraged.

The bioevolutionary approach, as used in this book, takes for granted that every organism, including human beings, tends to

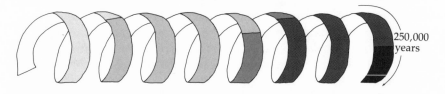

1.5 Ma B.P. *Homo erectus*

250,000 B.P. Early *Homo sapiens*

35,000 B.P. Modern humans

4 Ma B.P. Upright walking hominids

3.5 Ma B.P. *Australopithecus* spp.

1.9 Ma B.P. *Homo habilis*

Ma = Million years

B.P. = Before Present Diagram by Jessica Stockholder and Dudley Brooks

behave in ways that historically (that is, throughout time) have maximized the representation of its genes in subsequent generations. Genes prescribe the capacity to develop a certain array of behavioral traits—in sum, "human nature"—which were selectively advantageous in the environment in which the human species was evolved.

This is not the environment in which most humans live today. Humans, unlike any other animal (except those who are domesticated or kept in captivity by humans), are unique in not inhabiting the environment in which they were originally adapted to live. The proportion of time we have spent in our original and our domesticated state is not often appreciated, and is instructive (see diagram, above). We would be surprised if someone asserted that dogs or sheep, which have been domesticated at least as long as humans have been "cultured," had lost their entire original dog nature or sheep nature. Or we would be surprised if someone observed modern circus horses and claimed that they behave as they do only because of their training and owe nothing of the kinds of tricks they have learned to the capabilities and needs evolved in ancestral wild horses.

Unlike most theories about human capabilities and needs, the bioevolutionary view takes a long perspective and attempts to understand our species by setting it into a vast but coherent evolutionary range. It recognizes that something important was going on during all those millennia, and attempts to account for it in what we observe in humans today.

Having set down some of the claims that this view does *not* make (though often mistakenly charged with making them), let us list some of the positions and postulates implied by allegiance to a bioevolutionary perspective—postulates that elucidate compellingly and comprehensively certain aspects of the human condition with which all political, social, and philosophical systems must deal.

Positing that humans, like every other animal, possess an ancestral set of adaptations that evolved during the several million years that their hominid ancestors were gatherer-hunters makes it possible to explain otherwise unexplainable persistent features of human behavior. Much of this behavior is simply not intelligible on the basis of the life history of the individual, or of human history since the invention of writing, but only against the background of the long evolutionary history of the species, *Homo sapiens*. One might ask, for example, what need is served by the infant clinging and grasp reflex. Why should infants develop fear of strangers at about eight months of age, when first mobile, but not before when carried by mother? In an age when world government and harmony have become imperative, why should people continue to display intense intragroup loyalty and a readiness to die for patriotic aims and beliefs, to be initially hostile and suspicious of outsiders, and conspicuously unwilling to love or try to understand their neighbors?

The bioevolutionary perspective, in its concern for the interaction of genetic programming and social behavior, makes it possible to integrate nature and culture. Genetic and social explanations are interdependent, not seen as alternatives or mutually exclusive. Many human behaviors are like language: the individual is born with the tendency to manifest the behavior (learn to talk) but requires a culture in which the tendency can be expressed, completed (acquire a specific tongue, a specific accent, an idiosyncratic style), and individualized. We can liken human behaviors to human anatomical structures: all humans have legs, although these may vary anatomically (in length, shape, flabbiness, strength, proportion of upper to lower leg, color, hairiness) and be culturally modified (exercised, shaved, covered, bared, tattooed, ritually mutilated). Yet they are still all recognizably and functionally legs, not wings or tails (which provide serviceable locomotion in other creatures).

The biobehavioral perspective stresses the impelling force of sociality, interpreting as biologically predisposed the universally observed satisfactions of such things as belonging to a group, the

universally observed penchant for actively seeking out and enjoying the company of others of one's kind. Behaviors that promote sociality are presumed to have been adaptive and thus selected for—such as play (which encourages socializing, learning, imitating), a predisposition for acquiring notions and behavioral forms of reciprocity, and the innate tendency to identify oneself with one's group.

What Jung called the "collective unconscious" acquires biobehavioral credence and relevance, as Anthony Stevens (1982) has demonstrated, if one sees archetypes as inherited species' dispositions to react to certain salient things and behave in certain adaptively beneficial ways. Archetypes are, then, inherent neuropsychic systems that guide patterns of behavior, which initiate, shape, and mediate the common behavioral characteristics and typical experiences of humankind (e.g., relations with caregivers, with associates, with the physical world, with the self, with the unknown).

The biobehavioral approach attempts to account biologically for the emotional-psychological needs of people just as much as the physical-physiological. It recognizes and emphasizes the importance of emotion in behavior that is adaptive. Genes influence the forms and intensity of emotional response to persons and situations, which affects the readiness to learn a particular thing or respond to certain stimuli rather than others. One can recognize "ultimate" (unconscious, genetic) and "proximate" (conscious, ad hoc) reasons why we do things. We eat sugary things, we say, because they "taste good" (sweet). But the ultimate, evolutionary reason rests on the consequences in terms of gene survival. Because sugary foods have high caloric content and were "good" for us as we evolved, we developed a liking for their taste to ensure that we would eat them. (An overabundance of sugar, hence the possibility that too much sugar might be "bad" for us, did not exist when this predisposition was being selected for—an illustration of how certain behaviors can become maladaptive when the environment changes.)

According to the biobehavioral view, the time scale of human evolution is so much vaster than the time that has passed since human civilizations developed that it cannot be said that civilization is, in the long run, an adaptive development. Nor can we assign a "quotient of adaptability" to any present-day society, including our own. What we can say is that the behaviors developed during the millennia of hominid evolution as gatherer-hunters were adaptive to *Homo* as a species relative to other species

(including other hominids) who might have competed for the same resources. It is true that for several thousand years Western "civilization" has been adaptive to those who live within it, insofar as developed technology has expanded their influence and possessions at the expense of persons with lesser social-technological leverage or clout. It is a distinct possibility, however, that the highly technologized people will destroy humankind altogether, in which case their supremacy has been a short-lived (evolutionarily speaking) chimera, and ultimately maladaptive for the species as a whole. The physical-social environment of any civilization, particularly that of the modern industrial and postindustrial West, is drastically unlike that of gatherer-hunter existence, and our biological predispositions are thus ill-suited to what is presently required of us.[4]

If the chaff and misunderstandings are cleared away, a biobehavioral view of the human endeavor permits a broader, more comprehensive perspective than any other. As R. D. Alexander (1980) has written, genes were not a part of the understanding of Darwin or Freud or of any other major philosopher or student of human nature before the last decade, and they "are not yet a part of the everyday consciousness of a significant fraction of even the most thoughtful and best educated people of the world" (p. xiv). "The challenge of Darwinism is to find out what our genes have been up to and to make that knowledge widely available as a part of the environment in which each of us develops and lives so that we can decide for ourselves, quite deliberately, to what extent we wish to go along" (pp. 136–37). When we see patterns of behavior that were adaptive in the original environment in which they evolved, and realize that they are maladaptive in present-day circumstances, we can set about trying consciously to change them (by cultural means).

Indeed, acceptance of the implications of the biobehavioral view allows a special perspective that has been denied to humans during all the centuries in which they considered themselves to be unique and special creations. It is time to overcome the geocentrism regarding our person and way of life as we have overcome it in regard to the cosmic centrality and importance of our planet.

A century after Darwin there still remains a vociferous, antievolutionary bias, not simply among uneducated fundamentalists and narrow-minded creationists, but in sensitive, well-educated social scientists and humanists. I believe this bias is due to profound misunderstandings, which I have tried to dispel.

Proponents of the biobehavioral view are often to blame for these

misunderstandings. It is unfortunate that, like psychoanalytical interpretations, ethological explanations often attract the amateur. We are enamoured of ourselves and are inclined to jump to accept easy generalizations, especially about the complexities of our relationships with others and our own inner conflicts. It is as easy to concoct evolutionary explanations—finding plausible "adaptive" reasons for everything and anything—as it has been to unearth "psychoanalytical" (namely, sexual) ones.

It is also unfortunate that some writers on the subject of human evolution and ethology appear to be insensitive philistines. This may be evinced indirectly by a general insensititivy to words as well as more deliberately by appearing to relish their rude and dismissive appraisal of the most deeply regarded achievements of the human imagination, treated as if they were mere crumbs to be swept up in the sociobiological dustpan.

S. J. Gould makes an excellent point by discussing his own experience of singing in the chorus of Berlioz's *Requiem*. While he granted that the overpowering emotional response he felt could conceivably be "explained" by neurobiology on the one hand (electrical discharge of brain neurons) and sociobiology on the other (adaptive precedents), he "also realized that these explanations, however 'true,' could never capture anything of importance about the meaning of that experience." He concludes: "And I say this, not to espouse mysticism or incomprehensibility, but merely to assert that the world of human behavior is too complex and multifarious to be unlocked by any simple key" (Gould, 1980).

Gould's experience deserves attention. Biologically predisposed theorists must recognize that by reducing personal and individual experiences like his to neurological or evolutionary elements, they are not exhausting them, or even explaining anything very salient about them. Because some do not seem to be aware of this, one could assume they do not know such experiences, and one is inclined to accept their pronouncements as little as someone in pain will accept being told it is all in his head. Analytic reductionism is as limited when tunnel-vision evolutionists scrutinize aesthetic experience as when narrowly functionalist anthropologists analyze primitive ritual ceremonies or physiologists monitor sexual intercourse. Our understanding of these things in theoretical or descriptive terms is quite different (with a different part of one's understanding) than the personal experience of them. Losing appreciation of the richness of the experience only destroys one's credibility—one's credibility as a fellow human.

2

What Is Art?

If asked "Is art necessary?" most of us would probably say "Yes," meaning that man does not live by bread alone. After all, it is widely observed that most people in other societies as well as our own find pleasure and refreshment in visual beauty and in participating in dancing, singing, and instrumental music. If these are art, then it would seem to be necessary.

Are the *fine* arts necessary? Here again many would reply "Yes," although with some hesitation. Certainly we catch our breath in viewing Egyptian statuary, Hindu temple facades, Chinese landscape paintings—the masterpieces of civilizations not our own. Presumably people of these cultures responded similarly and somehow needed these aesthetic manifestations of their worldview, not simply the worldview itself.

Still, even though it may not always be consciously articulated, it is usual today to consider capital-A art as "useless" in the sense that it does not contribute directly to physical vital needs and processes. If one then claims that Art satisfies a psychological need, it is discomfiting to admit that many people seem quite able to live without the benefits of at least the more refined arts.

Thinking of art ethologically—as a behavior that has evolved because it was necessary—certainly demands that we decide where art starts and stops. Since it is evident that much high art does not appear to be adaptively necessary, will we be talking about *everything* (including whistling, aerobic dancing, children's scribbling, interior decorating, TV programs) as art? On the continuum of Beethoven quartets to Dixieland or "Lara's Theme", must we draw a line? Are limericks equivalent to haiku? To Elizabethan sonnets? Is there a continuity between capital-A art and the ac-

knowledged manifestations of a need and liking for decoration, rhythmic form, sensuous pleasure?

Perhaps it is our modern notion of art that is the problem. Easel paintings and ballet may not be necessary, but some broader, more inclusive activity may be. Or perhaps it is a pseudo problem. Many societies have no word for "art" at all. How can they display what they do not recognize? (Similarly, how can we *not* "need" what we name and elevate?) These are clearly problems for an evolutionary view of art, committed to showing that "art" is universally "necessary."

Before attempting to answer "What is art for?" then, it would be well to try to decide what we are talking about. What is art? In order to appreciate the range and complexity of the concept, we will take a closer look at the ways the arts are manifested and talked about in other societies as well as our own. As ethologists do, it might also be a good idea to look at the expression of art ontogenetically (as it develops in individuals, i.e., in children) and phylogenetically (as it appears in the Paleolithic record and as it is claimed to appear at least rudimentarily in our primate relatives, particularly chimpanzees). Then we might be in a better position to decide what the word or concept "art" refers to, if it refers to anything at all.

Does the Word "Art" Refer to Anything at All?

Unlike advanced Western society, the majority of preindustrial societies do not generally have an independent concept of (or word for) art—even though people in these societies do engage in making and enjoying one or more of the arts and have words that refer to carving, decorating, being playful, singing, imitating. (Of course, not having a word for something is not proof that the something does not exist: many societies have no words for "love" or "kinship," yet these abstractions are evident to the outsider who names and then looks for them.)

Even in our own society as we look back to classical antiquity, to medieval times or the Renaissance, we find that their notions of what we have often carelessly or naively translated with the word "art" (*ars* or *techné*) are very different from what modern twentieth-century usage means by the term. Plato discussed beauty (*kalon*), poetry (*poeisis*), and image making (*mimesis*), not "art"; Aristotle, tragedy and poetry. By *techné* they meant "the capacity to make or do something with a correct understanding of the principle involved," and had in mind not only the ancestors of

what we call "the arts" but prototypes of what we call philosophy, pure science, applied science, engineering, and even industrial technology. As in non-Western societies today, the arts were judged and appraised for their level of craftsmanship, their "correctness" of execution, and their appropriateness.

Medieval European aesthetics was not separable from cosmology and theology—much the same interconnectedness as found in the complex worldviews of the Australian aborigines, the Navajo, or the Dogon. Renaissance aesthetic principles of imitating nature, demonstrating a moral purpose, and considering beauty to be an objective property of things are clearly different from our ideas about art today.[1]

In any case, the disparate ideas about "art" in Western cultural history are hardly unifiable or consistent. An inventory of what is implied when people discuss art reveals a bewildering variety of different meanings, used severally or individually. "Art" may refer to *skill* (e.g., fineness and complexity of execution; cunning or craft—as in "artful Dodger"; accuracy of imitation), *artifice* (something done to or added; "artificial" rather than natural), *beauty and pleasure*, the *sensual quality of things* (color, shape, sound), the *immediate fullness of sense experience* (as opposed to habituated unregarded experience), *ordering or harmonizing* (organizing, shaping, pattern-making; interpreting, giving unity; wholeness), *innovatory tendencies* (exploration, originality, creation, invention, imagination, seeing things a new way, revising the old order, surprise), the *urge to beautify* (embellish, decorate, adorn), *self-expression* (presenting one's personal view of the world), *communication* (information; a special kind of language; symbolizing), *serious and important concerns* (significance, meaning), *make-believe* (fantasy, play, wish fulfillment, illusion, imagination), and *heightened existence* (emotion, entertainment, ecstasy, extraordinary experience).

Similarly, in aesthetic experience, we respond to various not always homogeneous things (e.g., skill; accuracy; costliness and extravagance; beauty of color, form, or sound; satisfying order or simplicity; the harmonious unification of opposites; intricacy or complexity; originality and innovativeness; imaginativeness and fancifulness; immediacy and vividness of presentation; concentratedness; significance or embodiment of powerful symbols).

Like Chekhov's *Darling* whose personality changed and varied to suit a succession of males in her life, art would seem to have no single immutable essence. It has been called, depending on its circumstances, orderly and disorderly, immediate and eternal,

One could claim that the attire of this Hindu religious devotee exemplifies many of the characteristics we consider to be art (see p. 36).

particular and general, Apollonian and Dionysian, immanent and ideal, emotional and intellectual.

Evidently art at times is and is concerned with all these things, but not all things that we call art always are. And a careful ethological examination of the different notions presupposed by the concept "art" causes it to crumble and disappear, for each can be subsumed under another psychological or biological need or propensity without invoking a special unifying concept at all. For example, the well-studied behavior of play is able to cover all nonutilitarian making, as well as fantasy, illusion, and make-believe. Ornamenting and decorating may also be seen as varieties of play, or as aspects of display. Exploratory and curiosity behavior can account for instances of innovation and creativity, if they are not simply called problem solving. Sensory experiences can be studied as examples of perception. All animals communicate. All require formal order and predictability: cognition cannot occur without them, and some would say that cognition *is* perceiving or imposing order. Similarly, all animals require disorder and novelty: behaviors that include or provide these need not be called art. Heightened existence is frequently sought and

obtained in experiences few would call artistic or aesthetic—such as sexual climax, successful acknowledgment or exercise of power or skill, achieved ambition, sporting events, catastrophes, carnival rides, even childbirth. Revelation and a sense of significance are components of religious experience, or of loving and being loved—not only of art.

It would seem that by assuming that any of these is art or is provided by art, a specific identifying feature still eludes us. To claim that art is any of these one must go further and say what it is that is *different* about "artistic" play, "artistic" order, "artistic" perception, "artistic" significance. In other words, one must still determine what is artistic about art.

Apart from the semantic ambiguities in commonsense or casual uses of the word "art," there is another fundamental confusion that an ethological view of art must hope to avoid. This confusion arises from the fact that it is very difficult to discuss art only descriptively—that is, without imputing at the same time an attribution of value.

It should be possible, although it is difficult, to ask "What activities or forms or material objects should be included as art?" without implying "good art." Such descriptively answerable questions include: "Is cooking or sexuality art?" "Is singing in an opera art, but singing while one works nonart?" "Are masks to be called art, or simply ritual accoutrements?" We can ask, "What makes some pots art and others not art?" if we mean not that one is "better" or "more beautiful" than the other (value words) but instead assume the reason to inhere in empirical criteria such as the uses to which they are put, the skill required or displayed, the presence or absence of decoration, the way in which they participate in situations, and so forth. Or we can say, "What determines that X is a work of art?" and state that the defining feature resides in the object, or in the eye and mind of the beholder, or in a relation between the perceiver and the object, or in a label given by a representative of the community's "art world"—to name some commonly offered loci for the attribute "art."

Other legitimate questions of this descriptive approach are "Why do people do it?" "What do they use it for?" "What are people's attitudes toward making art or toward those who make art—as distinct from making and doing other things?" "What are the sociocultural attitudes that permit art, or constrain it?" "Who is an artist—as different from a nonartist?" (Is it a state of mind, an intention, an ability, an achievement, a social label?)

All these questions *may* be asked and answered without assuming that art, either the product or the activity, has transubstantial aesthetic value. But it requires care to avoid the tacit assumption that this value is present and is the essential or operational factor of the description.

Traditional definitions of art have asked a descriptive question, ("What is art?") and then proceeded to look for an X-factor that resides in art objects as opposed to other objects—often finding this to be a quality such as "beauty," "proportion," "the ideal," "representational accuracy," or "significant form." Apart from the difficulty of deciding what these defining attributes themselves mean or how we recognize them, they are tacitly assumed to confer aesthetic betterness on the objects that posses them. Hence the descriptive goal is entangled with an evaluative one.

Another, related, method of definition has been to compile a number of attributes of art; and if mask A or poem B possesses many or most of them, and possesses them to a high degree, then these are "art."[2] In this "open-textured" view of art, there can always be new attributes of art; conversely, not all art possesses all attributes, and no attribute is indispensable. Again, it is tacitly assumed that having more of these attributes, or having them to an exceptionally high degree, means that the artwork is "better."

There are, to be sure, specifically evaluative questions, such as "What differentiates the 'fine arts' from the other objects that are decorated, or have rhythmic form, or give sensuous pleasure?" One can ask "What makes one version of an object—say a pot— better than another?" intending to use criteria, such as excellence of form, good proportion, or unity in variety, that presuppose the exercise of a nonempirical aptitude for taste and judgment. Such questions lead ultimately to consideration of "What qualities are considered to be 'pleasing' or 'good' or 'beautiful'?" At present these are questions for philosophers of art, not biologists.[3]

It is not suggested that evaluative questions are invalid or misguided or frivolous. On the contrary, they are certainly as legitimate as the questions of description and incontrovertibly more engaging. Works of art may induce exceptional emotional effects, and our involvement ensures that we find detachment both difficult and undesirable. Without denigrating evaluative aims, let us simply state here the intention of achieving, if possible, a description of a behavior of art that does not presuppose the intrinsic value (apart from "selective value") of the products of that behavior. Once that is accomplished, it might be possible to suggest new approaches and directions for evaluative questions.

The "Advanced, Western" Notion of Art

One could suggest that the complexity and ambiguity of the word "art" derives from the complex and ambiguous status of the concept of art itself in modern Western civilization. It would seem that our general, unexamined, imprecise idea of art (roughly, that it is a universal, suprasensible, intangible, transhistorical essence or power that informs some objects or activities and may have magical, quasi-spiritual elevating effects) is a peculiarly culture-bound view, as vague yet ultimately pervasive and influential as the not dissimilar Polynesian concept of *mana*. For no other society or group of human beings has ever held the view (one could call it an ideology) of art that now prevails, rarely completely articulated but everywhere presumed, in most of educated, cultured, modern European and European-influenced society.

It is not to be denied that the larger portion of people in modern Western society may have imprecise and undiscriminating attitudes toward the meaning or range of a concept of art. Yet for the past century or so, among those directly concerned with making, perceiving, and understanding the arts (the "art world"), it has been generally accepted that artists are more interested in their works as entities in themselves than they are in their success in representing some aspect of reality or ideality *outside* themselves.

A case in point is Graham Sutherland's portrait of Winston Churchill, destroyed by Churchill's widow because it was so unflattering. What Mrs. Churchill did not realize, or did not care to know, was that the artist had not painted a likeness of Winston Churchill as much as he had produced "a Graham Sutherland." In modern painting, the subject matter (e.g., a landscape) is primarily an occasion to *make a picture*, not—as formerly—to reproduce accurately a pretty or unusual or characteristic scene, to render imaginatively a mythological or historical place, to engage the viewer's sentiment or activity, and so forth. Even where these are important to the painter, his primary interest remains in the picture. It need not even *have* "subject matter."

Today as well, it is assumed by the art world that a work of art has its own autonomous value, apart from being useful (a goblet), or skillfully made (an engraved snuffbox), or impressively carved (a monument). An art object need serve no purpose other than its own existence as something for aesthetic contemplation. In this view, art is "for" nothing except itself. It need

have no other justification—such as accurately depicting reality, or putting the spectator in touch with eternal verities, or revealing phenomenological or emotional truth. The primary value of a work of art need no longer be that it edifies or instructs, that it is rare or uses costly materials, that it is well made.

Yet neither in classical or medieval times, nor indeed in any other civilization or traditional society that we know of, have works been made to serve as "art objects," to be judged by aesthetic criteria alone, or appraised primarily for their power to evoke aesthetic enjoyment.[4] Even though aesthetic excellence in a work may have been obligatory, this was so because the object or performance was already intrinsically important for other reasons and thus required to be done beautifully, appropriately, or correctly. Until the nineteenth century, beauty (at least in the man-made world) was *not* its own excuse for being.

This is certainly also the case in primitive societies. Even though persons in the societies can often tell a visiting Western anthropologist that something is "good to look at" or that one work is more successfully rendered than another, relying on what we would call aesthetic criteria for justification of their choice, it remains that in few societies is there occasion to contemplate artifacts, which we call "art," outside their context of ritual or daily use, and rarely to make them solely for such contemplation.[5]

Although Western philosophers of the past certainly discussed beauty and art (in different senses than today), it was first in eighteenth-century Britain that a subject called aesthetics began to be regarded as a distinct matter for study (Osborne, 1970). As part of a general climate of rationalism and enlightenment, subjective psychological effects of the arts were noticed and analyzed systematically, and many of the questions that now engage modern philosophers of art were formulated. Accompanying this intellectual or philosophical interest, and influenced by momentous social changes, a "fine art tradition" developed, with commercial galleries and dealers, public exhibitions, academies, schools, magazines, critics, organizations, historians, and museums of art (Fuller, 1979; Zolberg, 1983).

Increasingly throughout the nineteenth and twentieth centuries certain notions that were unknown to other centuries and places have gained the status of gospel, at least among those who produce and consume the fine arts: there is a "disinterested attitude" for contemplating works of art; there are standards of taste and discrimination that are universally knowable or agreed upon; originality is a necessary quality of great art and of the artist-

genius; the artist achieves self-expression and communication of his unique subjective vision; through aesthetic experience a perceiver may acquire a special and valuable kind of experience that he could receive in no other way. For many educated Western people, the appreciation of art has become a special mode of cognition; and aesthetic experiences, valued for themselves, are described by some persons as the most significant moments of their lives.

In fact, with our detached, aesthetic attitude we can view objects from other cultures and civilizations—Greek architecture and sculpture, African masks and utensils, Egyptian painting and statuary—and presume that they are "art" in our sense, even though in their own context they served instrumental purposes and were never regarded, as we regard them, "purely aesthetically." We are mistaken to assume that such regard is universal.

Yet perhaps, as Harold Osborne suggests, there has been a latent, unconscious aesthetic impulse that existed and was made manifest in earlier art but has remained unarticulated until the present century and civilization (Osborne, 1970:158). Certainly many works of the past and of other cultures seem to possess a sheerly "artistic" excellence capable of sustaining our disinterested aesthetic contemplation, even when we do not appreciate or understand the uses for which they were created or the values they embodied.

Such a possibility is certainly worth pondering, and trying later to encompass in an ethological theory of art. For the present, it will simply be repeated once again that art as the reader is probably accustomed to think of the term is a culturally loaded concept, and is at the same time too rarefied and parochial to be of much help in determining what art, as a behavior, could be. For that task, a brief survey of primitive societies might suggest what needs to be taken into account in order to call art a *universal* human endowment.

Manifestations of What Might Be Art

IN PRIMITIVE SOCIETIES

In the analysis of societies it is customary to distinguish between "traditional" and "modern" forms. These terms are abstractions that refer to the position of a particular society on theoretical scales that denote certain material, institutional, and ideational characteristics. "Primitive" societies are a form of traditional society characterized by small-scale settlements, a low level

of technological development, an unspecialized economy and a nonliterate tradition, and generally slow-changing, unquestioned homogenous social institutions and practices relative to nonprimitive societies.

Writers using the appellation "primitive" in regard to societies are advised to explain and justify their use of the word, since it carries unfortunate mistaken connotations of being undeveloped and lacking complexity, hence inferior. In my view there are no satisfactory synonyms. Such substitutes or euphemisms as "peasant," "preindustrial," "nonliterate" or "preliterate," "non-Western," "non-EuroAsian," "simple," "undeveloped," and "unmodernized" are either too restrictive or also likely to be interpreted as derogatory.

My use of the term "primitive" admittedly carries a heavy burden as I contrast it with "modern," "advanced," "postindustrial," "Western," "highly literate" society. It must be emphasized that I do not imply that primitive societies are inferior to our own in the sense that they are "less evolved" (in some idealistic sense). On the contrary, all present-day cultures are highly evolved, though only modern Western culture has put all its eggs in the basket of technology and literacy, and this then appears to permit certain immediate kinds of "control" and domination over cultures that have filled other baskets.

Essential to the development of my thesis about the nature of art and its place in modern life (see Chapter 7 and Epilogue) is the claim that the basic characteristics of the thought of primitive peoples differ in important ways from those of their modern counterparts, reflecting the cognitive demands of a "man-centered" and opposed to a "thing-centered" (and recently, "text-centered") environment. Such a theoretical position is admirably and thoroughly developed by C. R. Hallpike (1979), and I can only refer wary or hostile readers to his book for a full statement of a position with which I basically agree.

Again it must be emphasized, however, that I am not insinuating that primitive and modern people can be easily compared or contrasted regarding the complexity, maturity, wisdom, truth, profundity, validity, or intrinsic superiority of their mental constructions of their world. It is unfortunate that there seems to be a knee-jerk liberalism in many social scientists that insists that all human beings are equally rational "in their own ways." (Ironically, these same social scientists are usually the first to bristle at an ethological claim like mine that all human beings share underlying common behavioral tendencies that are expressed "in

their own ways.") This attitude automatically sees any statement of acknowledged differences as revealing a naive, colonial type, patronizing sense of superiority and an unsympathetic regard for non-Western people.

Let me state here that though I try to remain objective, my natural sympathies err on the side of extolling traditional rather than modern peoples, worldviews, and ways of life. Miguel Covarrubias puts the difference nicely when he says: "The Balinese are by no means a primitive people, although we use the term to differentiate our own material civilization from the native cultures in which the daily life, society, arts, and religion form a united whole that cannot be separated into its component parts without disrupting it; the cultures where spiritual values dictate the mode of living" (Covarrubias, 1937:400).

It is hoped that when readers come upon adjectives like "modern," "advanced," "civilized," and so forth in the pages that follow, they will remember that I do not mean to imply by their use any judgment of superiority, just as "simple" and "primitive" are not meant to imply inferiority. These words are used solely in a descriptive sense as shorthand forms to refer to placement on theoretical spectrums as described above. (See also Chapter 7, pp. 170–72.)

What we are accustomed casually to call art (painting, carving, dancing, singing, and the like—or pictures, sculptures, songs, and dances) is certainly widespread in primitive societies. Indeed the range of artistic manifestations is absolutely protean and appears to lead only to the conclusion that art, diverse and inexhaustible, will remain ultimately beyond explanation.

Perhaps the most outstanding feature of art in primitive societies is that it is inseparable from daily life, also appearing prominently and inevitably in ceremonial observances. Its variety is as great as the kinds of lives (hunting, herding, fishing, farming) and the types of ritual practices (ceremonies to ensure success in a group venture or to encourage reunification after group dissension; rites of passage; accompaniments to seasonal changes; memorial occasions; individual and group displays). All these may be accompanied by singing, dancing, drumming, improvisatory versification, reciting, impersonation, performance on diverse musical instruments, or invocations with a special vocabulary. Decorated objects may include masks, rattles, dance staves, ceremonial spears and poles, totem poles, costumes, ceremonial vessels, symbols of chiefly power, human skulls; and objects of use

Painted and "sculpted" dwelling, Kassena, Upper Volta

such as head rests or stools, paddles, dilly bags, pipes and spear-throwers, calabashes, baskets, fabric and garments, mats, pottery, toys, canoes, weapons, shields; transport lorry interiors and exteriors; cattle; manioc cakes and yams; or house walls, doors, and window frames. Songs may be used to settle legal disputes or to extol warriors as well as for lullabies and the expression of high spirits. A large part of the environment may be rearranged and shaped for initiation or funeral rites; theatrical displays may go on for hours or days. There may be painting on a variety of surfaces (ground, rock, wood, cloth); piling up of stones or pieces of roasted and decorated pork; considered display of garden produce; body ornamentation (tattooing, oiling, painting). Many of these occasions for art have counterparts in the modern developed world.

For some primitive societies the observance of ritual permeates the whole of life in aesthetic ways so that their existence is referred to by the anthropologists who describe it as itself a work of art. In such groups it is difficult to separate art from the life that contains it. For example, the entire existence of the North American Hopi Indians has been described as the acting out of a "rhythmic, psychophysiological performance of a cycle of ceremonies" (Thompson, 1945:546) that embodies and reinforces the

45

Decorated grain storage bin, Njoue, Chad

pueblo theocracy. According to Laura Thompson, this ceremonial cycle from the aesthetic point of view is "a multimediary, polyphonic work of art" (Thompson, 1945:548) and only by viewing it in this way can its full significance and power be appreciated. Arts and artifacts, institutions and customs, myth and ritual are integrated into a complex and unified whole, every essential part of which contributes to and is conditioned by the overall structured totality. Thompson calls this "logico-aesthetic integration."[6]

Yet there are human societies in which the observance of both ritual and aesthetic forms is slovenly and perfunctory. The people of Alor and of Tikopia in the South Seas are reported to have a rather barren material culture and not much interest in visual or pictorial art (Dubois, 1944; Firth, 1973). We may disregard as anomalous the unfortunate Ik, whose forced deportation to government reservations has disrupted their traditional means of procuring food and has ensured that they have no choice except to relinquish all behavior that is not instrumental to sheer individual satisfaction of hunger (Turnbull, 1972). Still, many or most primitive groups consider visual embellishment and decoration to be extremely important—for example, the Maroon (Price and Price, 1980); Sepik River groups (Forge, 1971); Pacific Northwest Coast Indians (Gunther, 1971).

No society demonstrates or emphasizes equally all the kinds of

behavior we would consider to be art. Just as each individual displays behavioral and emotional features potential in all human beings, but in a peculiar and unique combination that we call his "personality," every culture selects certain human potentialities and subordinates or rejects others in order to create its own particular configuration or "modal personality" (Dubois, 1944:1). Some cultures emphasize pictorial art or self-decoration, others music and dance, still others develop verbal or poetic abilities. In many groups these arts may blend and be in practice inseparable (e.g., Strehlow, 1971; Drewal and Drewal, 1983).

For example, the Dinka, a pastoral, herding people of the Southern Sudan, have few extant art objects. Yet songs are extremely important, and they display features we consider artistic: unusual language, striking metaphor (Deng, 1973). An engaging Dinka pastime is the imaginative metaphorical use of "cattle names" which young men give to each other. According to Lienhardt, every Dinka can achieve a measure of poetic ingenuity and originality in creating imagery in these names (Lienhardt, 1961:13). In societies as far apart as the Toda (South India) and Dobu (an island off the coast of eastern Papua New Guinea) each person is a song maker. Whereas the Toda singer selects from a traditional corpus of thousands of formulaic three-syllable song units (Emeneau, 1971), in Dobu there is much emphasis on novelty, originality of content and of the words used for expression (Fortune, 1932). While much primitive song is either traditionally handed down or spontaneous and improvisatory, there are groups where song makers compose their songs carefully in advance of performance (Andrjewski and Lewis, 1964; Keil, 1979).

There are other examples of diverse attitudes and abilities in what we might call "the arts." In some societies—such as Bushman (Katz, 1982) and Tukano (Goldman, 1964; Reichel-Dolmatoff, 1972)—ecstasy or dissociation seems to accompany or follow aesthetic-ritual behavior; in others, weeping is the appropriate response to successful ceremonies and songs (Feld, 1982; Radcliffe-Brown, 1922); while in yet others there is little observable emotional response. Among groups in the Sepik River area of Papua New Guinea, art is primarily the work of established artists of recognized skill and reputation (Linton and Wingert, 1971), and some societies even have an elaborate notion of an "artist" type, considering him to be charismatic, divinely inspired, and eccentric—for example, the Gola (d'Azevedo, 1973). But in other groups, art is considered to be an ability of everyone, and all members of the group can paint or carve, dance or play instruments, and they

do so. In certain groups some arts are confined to males (e.g., Sepik painting; Toda dance-songs; Lithoko praise poems) or females (e.g., Navajo weaving, Greek ritual laments) or even prepubertal girls (e.g., the Balinese *legong* dance). In some groups, several persons may contribute to the same aesthetic product (e.g., Glaze, 1981:84).

Art is usually made or performed in the service of specific ends (e.g., a hunting dance, a display of status), but there are accounts where drumming or dancing appear to be nothing other than a personal expression of feeling. Art objects may be considered sacred and valuable in themselves, but often they are valuable for the power they embody, not because of their material appearance. The Ituri forest pygmies of the Congo, for example, unapologetically used a metal drainpipe for their sacred *molimo* music (Turnbull, 1961). The Fang of Gabon are content with any statue on a reliquary (Fernandez, 1971:360), whether or not it is aesthetically satisfying. And the Chokwe of the Congo area do not mind if their religious art is crude, although secular prestige objects are carefully executed (Crowley, 1971:326). Similarly, people in the Eastern Solomon Islands do not give special artistic attention to an offering bowl used in religious worship when the relationship is solely between the deity and the individual, but when the same deity is invoked in public, the ritual object will be very elaborately carved and inlaid with shell (Davenport, 1971:406–7).

Some groups consider artists to be of high status, while others consider them, especially drummers and musicians, to be very low. Malinowski reports that the inhabitants of the village of Bwoytalu in the Trobriand Islands are the most despised pariahs and most dreaded sorcerers—yet their woodcarving and plaited fiberwork and combs are the most esteemed for skill (Malinowski, 1922:67). Art may be an unexceptional part of life and "just happen"; frequently, however, it is considered to come from a special or divine realm, perhaps being revealed in dreams or in a magical sort of inspiration.

In a number of societies one can identify a kind of apartness in the role of the artist (while he is an artist, for in primitive societies artists are seldom if ever specialists who do nothing else). He may observe taboos before and while working; he may feel the urge to carve suddenly come upon him; he may acknowledge a special relationship with a tutelary power. Also musicians may display the abstracted seriousness of any professional performer and remain aloof before and during a performance. Where artists are often considered to be in close contact with the supernatural,

a vessel for the divine spirit, they may feel a strong sense of self-importance or humility.

Not all aesthetic qualities are admired equally in every culture. Some groups value improvisation and originality, while most require accurate conventional reproduction of tradition. Although most primitive art is symbolic, not all must be—as in the individually produced, wholly abstract designs painted on the faces of Nuba men (Faris, 1972) as well as in some descriptive representational designs of Arnhem Land aborigines (Berndt, 1971:105).

In some societies art is less important for itself than for the associated symbolic meanings it conveys. Navajo sand paintings will be destroyed after use, since their value is considered to be in their creation, not preservation (Witherspoon, 1977:152). Despite months of work on them, fantastic and elaborate carvings or constructions may be burnt or discarded after their ceremonial use and allowed to rot away—though other groups will preserve sacred objects carefully. Poems may be ephemeral or memorized and preserved. Some groups are predominantly concerned with what can be called purely aesthetic or formal features—for example, the Maori (Chipp, 1971), the Maroon (Price and Price, 1980), and the Nuba, whose face and body painting serves only the function of enhancing the body's natural beauty (Riefenstahl, 1976).

As was mentioned, most primitive societies do not have a separate word for art, though they may have one for what is nonuseful but pleasant or embellished (Schneider, 1971) or for activities that are ends in themselves (d'Azevedo, 1973). Other words applied to "art objects" connote festiveness, health, balance, harmony, and goodness. Still members of these societies may well display what can be called "taste" or "connoisseurship," making judgments about aesthetic factors in objects, about songs and dances, or about the overall effectiveness and appearance of a dancer. While the Marghi of northern Nigeria do not discriminate aesthetic factors in objects, they will make such distinctions in the performing arts (Vaughan, 1973), and differentiate between a "good" and a "well-told" tale. It is generally recognized that some persons are better singers, poets, or carvers than others; in the Eastern Solomons a type of man or woman called "talented" is recognized, who is gifted in all skills appropriate to his or her sex (Davenport, 1971). Not all Nuba are equally adept at body painting, and sloppy designs usually incur comment and criticism (Faris, 1972:67).

In many African societies, aesthetic excellence is found in the brightest, most embellished objects, and those with the greatest

49

contrast in their colors or designs. Other desirable qualities include neatness, glossiness, shininess, and smoothness of finish of objects (which may imply newness or renewedness, themselves de rigueur in some groups), and neatness, elegance, and grace of dancing.

The temporal aspect or context of artistic objects within a performance is often integral to their appreciation. Masks, costumes, and other ceremonial paraphernalia are displayed in motion in an exciting, crowded, multimedia atmosphere, and are not intended to be contemplated in isolation.

"Completeness" (implying thoroughness, accuracy, and diligence), and "appropriateness" are important Yoruba criteria of aesthetic excellence (Drewal and Drewal, 1983). Certainly many if not most societies value skill in execution of objects or performances, and skill embraces such characteristics as suitability for function (so that a mask that does not fit the face well is not a good mask), intricacy of elaboration, endurance, and virtuosity. And recognition of what is appropriate or fit for a particular object or occasion is equally widespread and critical in aesthetic evaluation (e.g., Strathern and Strathern, 1971; Drewal and Drewal, 1983).

IN ANIMALS

What looks very much like artistic activity in animals[7] has been most interestingly and provocatively demonstrated in experiments with chimpanzees (Morris, 1962; Gardner and Gardner, 1978). Like children, these apes like to paint, and do so without rewards; moreover, their paintings show certain features that are agreed by human observers to be "aesthetic"—that is, balance, control, varying of a theme—and, as was mentioned, the behavior itself seems to be performed "for its own sake." Experiments conducted by Desmond Morris in the 1960s suggested that a male chimpanzee, Congo, "knew" when his paintings were completed, and went on to begin another work; more recent observations of a female chimp, Moja, seem to confirm this. Moja communicates with her trainers in American Sign Language for the deaf, and tells them "Finish," and refuses to paint further .even when they urge her, "Try more." She has labeled her drawings (e.g., "bird," "flower," "berry") and when asked later "What's this?" the labels are correctly repeated as if she really has drawn and recognized a bird, flower, or berry.

It has also been claimed that animals show preferences that some have called "aesthetic" in that there seems to be no practical rea-

son for their choice. For example, birds prefer geometrical or regular patterns to irregular ones; fish prefer the opposite (Whiten, 1976:32). Rats prefer Mozart to Schoenberg (Cross et al., 1967). Monkeys prefer blue-green colors to other colors and bright to less brightly lighted plain slides (Whiten, 1976). It is quite possible, of course, that these preferences reflect tendencies that have selective value and we are not aware of these—for example, a preference for blue-green in monkeys might encourage their remaining in trees and feeling uncomfortable in surroundings of other colors where they might be more exposed to danger (Whiten, 1976:39).

It has also been demonstrated that chimpanzees can look at photographs or drawings and apparently associate them with objects and persons; subsequently they are willing to perform a task in order to see a picture more clearly in focus, suggesting that perhaps they receive pleasure from the purely aesthetic aspects of the display (Gardner, 1973:84–85).

Male chimpanzees in the wild have been observed by Jane Goodall to perform a sort of "religious display" (van Lawick-Goodall, 1975:162) that is apparently elicited by dramatic natural occurrences such as fast-flowing water, the onset of very heavy rain, a strong wind, or a sudden loud thunderclap. The animals charge in slow motion from one tree to another, stamping and slapping on the ground, pausing to sway branches to and fro, to the accompaniment of the rustling of the vegetation and the pounding of the rain. Once a whole group of adult males was observed to perform together in a torrential downpour (p. 164). Goodall has seen similar displays at times of general excitement or emotional arousal, as when a male arrives at a good food source, or when two groups meet, or during status conflicts. But, she says, the "elemental" display is of longer duration and seems to have a more rhythmic quality. She hypothesizes: "From such primeval, uncomprehending surges of emotion, man's awe and wonder would have increased as his awakening intellect became more aware of the significance, to himself, of the natural phenomena around him" (p. 164). It is, of course, questionable whether there is anything "artistic" in the chimpanzee rain dance, but the suggestion of a prototype for ceremonial dancing is inescapable.

IN THE DEVELOPMENT OF ARTISTRY IN CHILDREN

From his studies of their artistic development, Howard Gardner finds (Gardner, 1980;1973) that all normal human children by

the age of seven or eight possess the necessary physical and mental abilities to make and respond to art—pictures, stories, and music—and that the differences between youthful and mature art are ones of degree and complexity, not of kind. He notes that the developmental point at which children begin to become responsive to art and the arts is when they are able to understand the referential nature of symbols, and to use them, though even very young children display a sense of rhythm and balance, and take pleasure in color, textures, and patterns.

Rhoda Kellogg (1976), after examining more than a million children's drawings, claimed that children spontaneously draw similar forms in the same developmental sequence. According to Kellogg, this uniformity indicates that the human eye and brain are predisposed to recognize and respond to certain shapes, and the maturing child artist is guided by an innate proclivity which reinforces the production of some shapes (especially circles, diagonals, and crosses, and diagrammatic and pictorial combinations of these such as the mandala) and the discarding of others. The chimpanzee Congo also showed the developmental sequence outlined in Kellogg's studies, though he did not progress to the pictorial stage before experiments had to be terminated because of his pubertal belligerence.

More recent studies tend to cast doubt on the cross-cultural validity of Kellogg's theory (Alland, 1983; Goodnow, 1977). Under controlled conditions with preschool and early school-age children in six cultures (Bali, Ponape, Taiwan, Japan, France, and the U.S.), Alexander Alland found that apart from representation of the human figure one could not generalize about universally demonstrated stages in the development of children's drawing, since cultural influences appear early and have a strong effect on overall style. Nevertheless, Alland posits (rather like Kellogg) that certain aesthetic principles (what might be called "good form") are universal and coded in the human brain, thus "guiding" the playing with form that characterizes children's developing drawing ability.

Certainly children's drawings, like those of chimpanzees, show tendencies toward repetition, random variation, and gradual sharpening of form (C. Alexander, 1962). Symmetrical and balanced forms inevitably emerge and are found to be appealing (p. 141). General rules concerning strategies in the making of pictures may also be operating. As they draw, children tend to use a basic vocabulary of forms. Parts are related to one another in a sequence using regular patterns and according to specific princi-

ples, such as the joining of separate, even bounded units or segments (such as head, trunk, legs) rather than an embracing outline (Goodnow, 1977).

Although representation need not be an automatic result of children's drawing, those who do make pictures with intended content seem to use all-purpose forms ("tadpoles," circles, and ovals)—a characteristic that reflects not only their lack of skill but their relatively imperfect or immature understanding of general concepts.

Also like chimpanzees, the child artist finds the process to be more important than the result, and children rarely admire or contemplate their finished work, though they may request others to acknowledge it. Chimpanzees and very young children may draw on top of previous drawings, indicating that they lack a sense of the communicative or display value of a picture. It is interesting that Nadia, the autistic child prodigy whose artwork was anything but puerile in its mastery of perspective and foreshortening and in its dramatic power, also sometimes drew on top of previous pictures she had made (Winner, 1982:142).

IN THE PALEOLITHIC RECORD

The earliest evidence of art in the paleontological[8] record depends on what one is willing to call art. As this is the question the present chapter is concerned with, the only thing to do is begin with what appears chronologically and hope that something indisputably artistic will show itself.

The first identifiable hominid-produced artifacts, crude choppers that were made by *Australopithecus* about three million years ago, can hardly be called art in anyone's definition. By the time of *Homo habilis* (2.5 to 2 million years B.P.), at least some toolmakers liked green lava and smooth pink pebbles (Pfeiffer, 1982) and even worked pieces of ocher for unknown, perhaps ritual purposes (Campbell, 1982).

The widespread use in middle Acheulean times (500,000 to 200,000 B.P.) by *Homo erectus* of red and other colors of ocher, often shaped, in places as diverse as Olduvai, France, India, and China, suggests that it had some important use that was apart from direct physical survival—perhaps for body decoration and other ceremonial use.

Homo erectus was the first hominid to make precise and specialized tools—two-faced, almond-shaped, and symmetrical, requiring twenty-five to sixty-five blows (Pfeiffer, 1982). The higher mental abilities expressed by this achievement—foresight, visu-

(Left) Acheulean flint hand-ax displaying embedded fossil shell of mollusc, *Spondylus spinosus* (J. Sowerby), West Tofts, Norfolk. Length 135 mm (Right) Acheulean flint hand-ax displaying fossil echinoid, *Conulus*, Swanscombe Middle Gravels, Kent. 9.5 cm × 5.6 cm.

alization of a form in the mind or conceptual abstraction, and even an appreciation of the notion of binary opposites—suggest that an aesthetic sensibility could also be said to have existed. Indeed, there is suggestive evidence that *Homo erectus* had an interest in appearance as well as practicality when they (and early *sapiens*) occasionally used for their implements a kind of rock called (today) puddingstone, although flint was more abundant and easier to work. To us, puddingstone seems "very beautiful" and perhaps this was why its makers chose it (Oakley, pers. comm.). By 250,000 B.P., in sites containing remains of primitive subspecies of *H. sapiens* (of the steinheim and swanscombe varieties), stone tools have been found that have been fashioned so that an embedded fossil, already naturally occurring in the flint, acquired central importance (Oakley, 1981). This indicates that the tool was fashioned with an eye to its appearance as well as its function. In the later stages of the Lower Paleolithic, too, tools were sometimes worked longer than was necessary for sheerly functional consid-

erations, suggesting that the maker found their symmetry and balance pleasing.

There is also evidence that unusual and attractive pieces of fossil coral were noticed and carried about as *objets trouvés* by Lower Paleolithic "presapiens" and Middle Paleolithic Neanderthal man (Oakley, 1971; also p. 96). This may have been "for their own sake" because they were unusual and attractive; but it can just as well be interpreted that they were considered to be charms and possess supernatural properties. Indeed, both explanations may be accurate. In the Upper Paleolithic we know that *H. sapiens sapiens* very commonly used fossil shells for decorative purposes (Oakley, pers. comm.).

After 100,000 B.P. one finds bone artifacts engraved with a variety of intentional marks, suggesting well-established symbolic expression of some sort. By 70,000 B.P. one can discover stylistic differences that identify artifacts as being made by one hominid group rather than another (Conkey, 1980). At about the same time, some groups were burying their dead—in all probability with some ceremony. The most famous prehistoric burial site is that of a cave in what is now Shanidar in Iraq. The time of year of the burial (early summer) is known, because under the corpse was laid a bed of branches and scattered flowers that can be identified as to species today by fossil pollen analysis (Leroi-Gourhan, 1975). The introduction of flowers into a grave is an instance of embellishment, an act arising from religious or ritual if not aesthetic motives. It is surely more than purely functional behavior.

Much of primitive art today is ephemeral, made of perishable materials or even deliberately discarded or destroyed. It is likely that most Paleolithic art was of this type and that the earliest "artistic" artifacts were fashioned by both sexes on and from organic materials such as skins, bark, reeds and wood long before anyone thought of painting the animals that have been miraculously preserved for us on the walls of caves. It is common in today's primitive societies to make objects from easily available local materials and to decorate them, and Paleolithic peoples at some point undoubtedly began to do the same.

Amulets and pendants found in human occupation sites attest to a penchant for self-decoration, and it is reasonable to assume that Upper Paleolithic people, like many primitive and modern peoples today, adorned their bodies and faces with pigments or ochers, which of course would leave no permanent trace. Again one must decide whether this is to be called art. Denise Paulme (1973) finds body ornamentation to be a universal human practice,

and the ornaments in general almost never lack social significance. Surveying types of adornment in modern tropical Africa, she lists a number of commonly used items such as feathers, cowrie shells, chains, beads, and body paint, and practices such as fashioning or mutilating parts of the body itself, as in hair styling, tooth filing, piercing ears and nose, and tattooing or other scarification. Any part of the body can be selected for special attention. Among the many purposes of body ornamentation she lists the following: to give the wearer personal attractiveness, to distinguish the noble and rich from others, or married from single and so forth; to identify the origin, social status, and sex of the wearer; to symbolize potency; to differentiate men from animals; and to protect parts of the body. Bells help to avert evil, to aid parents to find children, and to punctuate dance rhythms. The donning of a costume temporarily allows one to change prestige, to acquire exceptional powers, and to escape everyday humdrum life. Body ornamentation can be a very social occupation, the participants spending hours (as in the Walbiri or the Nuba) decorating each other, in a practice not unlike that of mutual grooming in primates.

The use of art for family- or self-glorification is found widely in many primitive and modern societies. Although we think of an emphasis on individual distinctions as characteristic of occupationally differentiated and hierarchical societies, it can also be observed in relatively homogeneous and unspecialized groups (cf. Dark, 1973). There is evidence in the Paleolithic record of some persons being given more elaborate burials, but the degree of social stratification that existed remains unclear.

It seems unwise to look for instances of functionless or "pure" art in Paleolithic or even Neolithic society. As we have seen, apes possess the ability and interest to paint functionless pictures, but do not do so unless they are captives for whom there are willing providers of painting supplies at hand.

The earliest known percussion instruments, made from the bones of mammoths, have been found at Mezin (Ukraine) in a Cro-Magnon settlement of 20,000 B.P. (Bibikov, 1975). Decorated with a cutout geometrical design, and colored red, they were found with other artifacts that indicate that all were part of a ceremony that involved music (probably singing) and dancing. Bone flutes, one as old as 29,000 B.P., have been found in Central and Western Europe and the Soviet Union. A "castanet bracelet" from Mezin and footprints beaten into the floor of a number of European prehistoric caves (Pfeiffer, 1982) are evidence that dancing was practiced by

Phallocrypts, Baktamin, Star Mountains, Papua New Guinea

Bridal dress, India Tattoed man, Japan

Some examples of body ornamentation

Cro-Magnon times, though the rain dances of chimpanzees, described above, should suggest that dancing might well have been a human activity from remoter pre-Paleolithic times.

Our inquiry into possible early manifestations of art will now stop, well in advance of the cave paintings and accomplished sculptures of Cro-Magnon people, who were as highly evolved as any human beings who have existed after them and as potentially capable of their achievements.

The Elusiveness of the Common Denominator

We have surveyed, albeit cursorily, an enormous range of material, looking at manifestations that at least resemble what we are accustomed to think of as art or aesthetic proclivity in primitive societies, in prehistoric remains, in chimpanzees, and as they develop in children.

In all this we have been guided by an idea that has been well established in Western rational thought at least since Aristotle— even though often criticized and now considered to be outmoded. That is, we have been trying to find out what something (art) is by examining all the instances of it and hoping thereby to find a common denominator. It is no secret that it is notoriously difficult if not impossible to define most things that way. Not all chairs have four legs, not all crows are black; and quite obviously, as our survey has indubitably shown, not all art displays one common feature.

The sheer number of varied and even contradictory features that would have to be encompassed in a superordinate concept, "art," will now have to be accepted by the reader, as it has been for a long time by aestheticians. In looking for necessary and sufficient common properties that would define a class (art), one runs the risk of either leaving important things out or accepting an extraordinarily cumbersome assemblage.

Recent analyses by cognitive scientists and philosophers of the process of concept formation and categorization have expressed disenchantment with the search for defining properties or features of a class or of a "typical" member of a class (Smith and Medin, 1981; Rosch and Lloyd, 1978). Contrary to the ideal of Western reason, it has been experimentally shown that most if not all categories do *not* have clearcut boundaries, even though the prototypical members of the class may be clearcut enough and commonly agreed upon. It has been found that, in many cases,

categories are better approached by considering how they function rather than what they objectively are.

An interesting example for our purposes is the concept "weeds." The basis of this category is not physical (or metaphysical) similarities between members of a class, but rests on the way in which members of a society treat certain plants when they are considered to belong to this class. Use of such a definition organizes the world rather than describing it (Ellis, 1974). The category of art could be usefully approached in this way, which is in effect the method of Nelson Goodman (1968), who asks "When" (rather than "What") "is art?" and claims that what art is depends on the ways in which the work in question functions as a symbol.

Before we examine art according to its function, I would like to suggest that there may be another reason for our difficulties. It could be that, for our own misguided reasons, we are uniting in one ill-defined concept ("art") a number of disparate instances that *do not really deserve or require this unification*. In the late nineteenth century, ladies were sometimes afflicted with an indisposition called "the vapours."[9] Yet what is this "vapours"? Today no one seems to have it (them). Instead, one refers to a number of separate, unrelated complaints: depression, premenstrual tension, dysmenorrhea, anxiety neurosis, hypochondria, headache, a touch of the flu, and various similar ailments. Is it possible that art could be a conceptual vapours or phlogiston, eventually to be replaced, when our powers of discernment or diagnosis have improved, by a number of more specific terms? We can now see that the blanket term "vapours" is indicative of a now outmoded attitude held unconsciously by an entire society about women and health. It is quite possible that our concept "art" would also reveal unrecognized attitudes and presuppositions in the society that uses it so broadly and reverently.

Or perhaps "art" is a value-laden term that we use carelessly and misleadingly—like "madness," which specialists find can be more accurately treated and usefully discussed when called something else, such as "mental illness." One anthropologist of African "art" has already done this when he refers to an artifact or ceremony as an "affecting presence" (Armstrong, 1971) and eschews discussing "art" and "beauty" altogether.

The discussion in this chapter has done little to help us on our way, or indeed to increase our confidence that the general notion of "art" has any precision or any universal usefulness. While our

survey has been of use in pointing out the ubiquity and importance of the arts in primitive societies, we have also seen the complexity and confusion that attends our Western use of the word and concept "art." What is worse, there seem to be unresolvable differences between Western ideas about art (no matter how confused) and expressions of the arts in children, non-Western peoples, and prehistoric times.

At the same time, it seems clear that the arts have integral importance in individual human lives and in human societies generally. Perhaps if we examine what the arts *do for* people (rather than what they appear to *be* in their various manifestations), we might find a satisfactory starting point from which to understand and describe art as a general human endowment.

Although philosophers and cognitive scientists have warned that looking for conceptual common denominators is unwarranted and misguided, *it is necessary as ethologists to describe a specific human ability or tendency that genes could transmit and environments could act upon.* If we hope to identify a behavior of art, we must know what we are talking about.

Rather than asking "What is art?" then, we will try another question, "What does art do for people?" and approach our subject from another direction.

3

What Does Art Do for People?

When one thinks about it, the fact that there is art is curious indeed. What is the reason for this apparently universal human tendency to form and shape, to make things special, to decorate or beautify, to single out and take pains to present something in a considered way, one "right" way?

Why not just leave things as they are? An extraterrestrial observer, unfamiliar with the form of life known as *Homo sapiens*, could soon comprehend most of the widely performed activities of human beings: acquiring and preparing food; making shelter; dressing and bathing; resting; making useful tools and furnishings and utensils. He might understand fighting, flirting, ordering, and obeying—because these result in obvious advantages for one or both parties.

But why paint or flute the rim of a pot? Why decorate one's home? One's body? More than that, it seems remarkable enough that a species would add marks or symbolic features to functional artifacts, that it would, for example, carve or paint depictions of animals on the walls or doorposts of a house, but why should these be "beautiful" or "decorative" in addition to being merely fearsome or brightly colored?

Even when one can point to useful, functional social motivations and effects of art—such as showing one's social position, impressing others, illustrating an important myth or precept, propaganda—it is not always clear why attracting attention, conveying information, and the like should take the form of concern with *aesthetic* elements such as shape, proportion, design, and color arrangement.

Still, as we have said, the fact that people everywhere value

the arts and take the trouble to express themselves aesthetically suggests to an evolutionary biologist that there is a reason: doing this (rather than not doing this) contributes to human evolutionary fitness. Faced with the overwhelming evidence that people everywhere make and respond to the arts, the ethologist would have to presuppose that the arts must have survival value.

Functional Explanations for Individual Arts

Certainly anthropologists who study the arts in primitive societies usually conclude that they serve one or another useful functional purpose. For example, Firth (1951) claims that making and using art objects affects the system of social relations, and that the symbols embodied in art objects correspond to some system of social relations. An instance would be the Dinkas' giving of metaphorical cattle names—one of many ways they express and reinforce communal integration. Even among the Alor where the only art is gong beating and versification, these activities are in the service of the primary means of social control and integration—finance. Sotho praise poems deepen the audience's awareness of itself as a historically continuous community as they encourage conformity to socially approved modes of valorous behavior in battle (Damane and Sanders, 1974). In the Hopi, logico-aesthetic integration aids social coherence; according to Thompson (1945:546), it "sets up ideal conditions (in terms of external and internal pressures toward a single goal) for the development of an integrated system of social control. The ritual performance of the Bwiti cult aids in the "resolution of cognitive dissonance in a transitional culture" by integrating past and present (Fernandez, 1966:66).

That the arts are selectively valuable because they serve social ends is a suggestion with which the ethologist could scarcely disagree. Certainly there are striking analogies between some arts and socially salient anatomical or behavioral features evolved by animals and birds. Body ornamentation, for example, might be said to be selectively valuable for the same reasons that special colors and markings and exaggerations of anatomical features are important in other animals: to attract mates, to differentiate individuals, to impress, to indicate status or condition (e.g., Drewal and Drewal, 1983). Decorating and elaborating utensils and other useful items would make commonplace tasks more enjoyable, as well as serve for status and other identification.

The contribution of rhythmic chanting or singing to lighten and

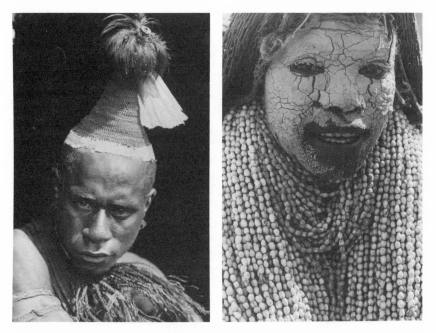

(*Left*) After initiation, Gogodala men wore a conical woven cap plastered onto the head, into which the hair grew, making the cap unmovable. Uladu, Western Province. (*Right*) Caked mud and Job's tears seed necklaces are the insignia of widowhood for Huli women. Mendi, Southern Highlands.

Body ornamentation indicating status in Papua New Guinea

pace cooperative work has been noticed frequently. Singing and dancing would serve social ends when used to aid in the coordination and celebration of important social activities—to prepare and encourage moods for hunting, working, or fighting (e.g., Glaze, 1981). Malinowski records an observation of his Trobriand Islanders that one can easily imagine occurring throughout millennia. During a devastating gale, a huddled frightened group chanted in loud voices a penetrating singsong, charms to abate the force of the wind (Malinowski, 1922:225).

Holes dug or stones assembled can acquire social significance. Walter Burkert (1979:41) has pointed out that piling up stones is an elementary form of "leaving marks," a common practice to demonstrate territorial proprietorship in many animals. Today, Eskimos construct cairns "for company" (Briggs, 1970:35), and

Australian aborigines build simple temporary or permanent monuments that "personalize" and "sacralize" the landscape (Rapoport, 1975) or express in socially shared ceremonies the desire for increase (Maddock, 1973).

Such speculations about functions of the various arts are not only interesting and probably correct, they are ethologically plausible. But they are also limited, being local and particular. And they still do not address the real question: why should piling up stones take an *aesthetic* form (shapely, arresting, decorated) rather than a casual one? Why should people ornament and paint their bodies to be *beautiful* rather than just red (e.g., chiefly), blue (e.g., unmarried), or ashy gray or black (mourning).

The answer to that question is what we are after: whether or not a general behavioral propensity "art" can be identified that suffuses or characterizes the arts. Is the art in the arts necessary? By phrasing the question this way, and examining the proposals that have been made to support affirmative answers, we might be able to understand what art is and is for by what art does.

Functional Explanations for Art in General

While evolutionary biologists have as a rule refrained from attributing selective value to art, or mentioning it in any evolutionary context, others have shown a more commendable awareness of the universality of what could be termed an artistic proclivity in human nature. In the century after Darwin, many humanistic thinkers—psychologists, philosophers, historians, critics of the arts—have ventured to express their views of what art does[1] and why, and how it is integral and indispensable. Their speculations reflect sensitivity and an awareness of the ubiquitous and powerful effects of the arts, and although they are not expressed in bioevolutionary terms, as a first step it would seem well worth viewing and examining them as if they had been offered as ethologically plausible hypotheses. The following arguments have been artificially constructed from the views of a number of thinkers; some tend to overlap or presuppose one another.

One frequent explanation for the fundamental importance of art to our lives is the observation that in so many instances *it echoes or reflects the natural world of which we are a part*. Such statements acknowledge the physical and psychological substrates on which our responses to aesthetic elements depend and the per-

vasiveness of spatial metaphor in our conceptualization of experience (Lakoff and Johnson, 1980). "Empathy" and kinesthetic theories, for example, propose that properties of certain nonhuman objects (such as the long drooping limbs of the weeping willow that automatically suggest sadness and grief) are inherently, by association, expressive of certain emotional states. One cannot deny that fundamental perceptual and organizational properties of the human mind (as elucidated by Gestalt psychology and substantiated by recent neurophysiological research), and the predisposition to recognize rhythm, balance, symmetry or proportion, and deviations from these, account for much of our sensitivity to the lines and movement in dance and sculpture; to the composition, repetitions, and variation in painting and the arts of design; to rhyme, meter, and formal arrangement in poetry, drama, and literature, and so forth. The ubiquity and pervasiveness of rhythm in bodily and cosmic processes have been pointed out by many; Freud (1924), as is well known, theorized that the pleasurable effects of rhythm are derived from its association with the rhythms of sexuality. Descriptive words for ecstatic aesthetic experiences such as "up" and "inside," the quasi-physical accompaniments to experiences of art such as changes in breathing, feeling "enlargement," "calm," "excitement," "arousal and release of tension" (Laski, 1961) are exaggerations or manipulations of normal life processes that extend throughout the sentient world. It is only "natural" that art should be concerned with them and that they should be integral to its effect—that individuals should find their manifestations desirable and satisfying.

Yet, in order to be satisfactory as an evolutionary explanation of art, this view must be able to explain why there seem to be such wide variations in response to these natural or more broadly based biological elements when they occur in art, and indeed why they should be incorporated into artworks at all. If being so presented is the reason for their effectiveness, their power would reside less in their fundamental naturalness than in some extra-natural feature that art provides. And the selective advantage accruing to individuals with a particularly developed sensitivity to such properties would remain to be explained.

Art is said to be both pleasurable and advantageous because *it is therapeutic*: it integrates for us powerful contradictory and disturbing feelings (Stokes, 1972; Fuller, 1980); it allows for escape from tedium or permits temporary participation in a more desir-

able alternative world (Nietzsche, 1872); it provides consoling illusions (Rank, 1932); it promotes catharsis of disturbing emotions (Aristotle *Poetics* 6.2), and so forth.

Certainly pleasure and satisfaction may accompany our forgetting or escaping the cares and trivialities of practical daily life and vicariously experiencing the shapely, economical, beautiful, integrated properties that characterize aesthetic as compared with ordinary experience. In this respect, art can help the individual adapt to an often uncomfortable and indifferent world. Yet it is difficult to see in what ways art provides these therapeutic benefits that are different from the same benefits that have been attributed to ritual and play (Lewis, 1971:199–203; Freud, 1920). One could suggest that it is making-believe, "acting-out," formalizing, or distancing that is therapeutic, not "art."

Moreover, much therapeutic art is not what would be thought of as great or significant in other respects. As catharsis or sublimation, Harlequin romances will probably be as effective as Shakespeare. In fact, the most complex and renowned works of art in modern society are sought out and experienced by relatively few, suggesting that escape, consolation, and catharsis are obtained by the majority in arts or activities whose aesthetic standing is dubious if not altogether lacking.

The psychological benefits of art that are proposed usually also rely heavily on adherence to one or another theoretical school of psychoanalytical thought (Freudian, Kleinian, Jungian), support of which is necessary before the explanatory possibilities appear incontrovertible.

It would seem, then, that the therapeutic benefits purportedly attributed to art (the sense of connection between internal and external reality, the mastery of giving form to and integrating conflicting feelings, and the satisfying of a creative or expressive urge) presumably could just as well be gained by constructing a radio set, perfecting a swan dive, writing a letter, keeping a journal—that is, by achievements that are not usually called art.

It is sometimes proposed that art is adaptive and desirable because *it allows direct, "thoughtless" (or unself-conscious) experience,* a kind of apprehension that has atrophied in modern times (Barzun, 1974). As humans have advanced from prehistory to the present, they have acquired certain abilities such as reflective self-consciousness, language, symbolization, and abstraction which tend to distance them from nature even as they confer impressive evolutionary success. Art then can temporarily restore the sig-

nificance, value, and integrity of sensuality and the emotional power of things, in contrast to the usual indifference of our habitual and abstracted routine of practical living (Burnshaw, 1970). By short-circuiting the analytic faculties, art connects us directly to the substantial immediacy of things—we feel the direct impact of color, texture, size, or the particularity and power of the subject matter.

One cannot deny the contemporary need felt for direct sense experience: it is currently being sought in various personal therapies and meditative practices, as well as in art. In traditional societies, however, art is more often the means of access to a supramundane world, a level of reality different from everyday immediacy. Even if today we are alienated from nature, an evolutionist seeks to explain selective value in terms of a behavior's origins—in this case, at a time when human beings were, presumably, part of the "Nature" they are estranged from today. Moreover, while some art does indeed demand and encourage immediate apprehension, other art (e.g., atonal music, written poetry, conceptual art) requires reflection, applied study, and even cerebration.

It has also been suggested that *because art exercises and trains our perception of reality, it prepares us for the unfamiliar or provides a reservoir from which to draw appropriate responses to experience that has not yet been met with.* John Dewey (1934:200) believes that without the arts the experience of volumes, masses, figures, distances, and direction of qualitative change would have remained rudimentary. Yet animals perform perceptual feats as astonishing as those of humans without the aid of art. Herbert Read (1955; 1960), affirming Susanne Langer's major premise that art was and is crucial to the cerebral evolution of the human organism, maintains that art has been and is the essential means by which humans develop and extend their consciousness (and self-consciousness), enabling them to develop special skills, sharpening their essential faculties, and giving them an increasingly firmer grasp of reality. David Mandel (1967) suggests that art museums or concert halls might be called spiritual gymnasia where people stretch and develop their consciousness on works of art. He proposes that art and the internal richness it can bestow would be of primary importance in future human evolution which could be self-conscious and deliberately directed. Even more than an account of art's evolutionary past, Mandel's position offers an inspiring visionary design for the future, but its achievement will depend on

political implementation as much as inherent biological momentum.

If indeed art encourages the exercise of vital abilities, this may well be less because of its uniquely aesthetic properties than because of qualities that it shares with play and with exploratory or curiosity behavior, activities that also are commonly credited with numerous practical side benefits (see Chapter 4, p. 78). And even though the abilities to recognize shapes, perceive dimensionality and relative sizes, and respond to balance, symmetry, and rhythm are obviously biologically useful skills, this does not really explain why human art everywhere presumes to deal with so much more than its elementary components. Why would these require (or develop into) complex aesthetic organization and expressly embody significances over and above their usefulness as training devices?

Apart from aiding in the accurate perception and identification of shapes, distance, and other distinct or discrete entities, art has been mentioned as assisting our capacity to tolerate ambiguity, a useful and adaptive ability. In aesthetic behavior, it is said, we respond to and interpret overlapping or multiple meanings which are inherent in the metaphorical nature of art. Metaphor serves as a stimulus to "functional regression" (in psychoanalytical terms), and in that respect art acquaints us with aspects of mentality and experience that our everyday practical mind ignores or dismisses as illogical or contradictory. Yet dreams and fantasy provide as well as art the experience of metaphor and ambiguity. Even if there may be, as has been observed, a common underlying process for all three human activities (Kris, 1953:258), no reason is offered why its biological function should be better fulfilled in evolutionary terms by art than by dreams or fantasy.

Contemporary psychological theory has suggested other adaptive functions for fantasy and dreams that are also sometimes attributed to art. The content of fantasy, it is proposed, is frequently concerned with important and desirable goals that have not been attained, as well as with different roles or aspects of the self that are possible or actual. It is advantageous to have these readily in mind in case real life presents inklings of opportunities to express them (Klinger, 1971:356). A similar function has been proposed for dreams—that they keep us in touch with the irrational and prelogical portions of our mind from which we can draw valuable information that our rational and logical mind will not heed. Art, then, like these "has the unique faculty of preparing us for the onslaughts of life" (Jenkins, 1958:302–3). It "can

turn our attention to particular directions, intimating what should be of concern to us, what regions of reality contain information that we should do well to absorb. It can . . . recommend subject matter for our perception, feeling, and thinking, and it can hold up goals for our action" (Berlyne, 1971:295). Also, art satisfies a person's "craving for widening, deepening and developing [his] cognitive orientation, regardless of imminent demands for action or required behavioral decisions" (Kreitler and Kreitler, 1972:358). Still, it remains to be explained how and why specifically aesthetic recommendations are more useful than those we gain from social conversation or newspapers, or in what ways they more effectively deepen or develop our cognitive orientation.

The tendency in art to make use of repetition, rule, and ritual can be seen as adaptively useful in that these features *assist in giving order to the world* (Storr, 1972; Humphrey, 1980; Gombrich, 1970). The human mind undeniably is predisposed to create and respond to order; the ability to classify, to generalize, to separate subject and object, self and nonself, has been a paramount contribution to humankind's evolutionary success. Art, it is sometimes said, makes use of and enhances evolutionarily advantageous cognitive abilities.

The very process of drawing a picture of something (say, an animal) is already an act of separating it as an object from its immersion in the totality of experience. Considering the objectivized animal as a symbol of successful hunting or a natural power is yet a further step in abstraction, conceptualization, and the use of one's environment and experience. Complex symbols enable humans to understand and interpret, to articulate and organize, to synthesize and universalize their experience.

Insofar as art contributes to objectivization, to abstraction, and to symbolization, it is said, it is therefore adaptively beneficial to humans. Yet order and abstraction are elements of nonaesthetic as well as aesthetic situations. Similarly, a symbol, to be effective, need not be aesthetically presented; the form or structure of a work do not become aesthetic simply because its content is symbolic.

Although art is praised for contributing to order, there are those who have drawn attention to the *"dishabituation" function of art*: in artistic experience we often respond in an unusual, nonhabitual way. The artist isolates and complicates what is presented to us so that we must *see* it, not merely recognize it in the routine

habitual way of ordinary experience. This "deviant" feature of art—breaking up the familiar, disordering the expected, and acquainting us with the unusual—has been claimed by Morse Peckham (1965) to have selective value in that it provides the sense of new possibilities that encourages potential adaptive behavior when old solutions are found no longer to be effective. Yet art is not the only activity to aid dishabituation—play, dreams, fantasy, ritual[2] all do the same—and the proponent of this adaptive advantage must explain what it is about art's contribution to dishabituation that would justify its being specifically selected for along with those other behaviors. Again, the important factors producing dishabituation may be those that art shares with these other proclivities—not "aesthetic" ones at all.

Art is said *to provide a sense of meaning or significance or intensity to human life that cannot be gained in any other way* (Hirn, 1900; Cassirer, 1944:143). Persons who feel assured of this meaning, it is said, are more likely to accept the periods when there are difficulties and problems in life; they will have a zest, a feeling of being personally involved in their position in life, of belonging and mattering. J. Z. Young (1971:360) points out that art has the most central of biological functions, "of insisting that life be worthwhile, which, after all, is the final guarantee of its continuance."

That people seem to need a "substitute for life," an escape from suffering, and a sense of intensity or significance is not to be gainsaid. But art is not the only or even the most common means of providing these: other nonaesthetic experiences such as being in love, religious emotion, some crowd phenomena, sports, and emotions engendered during unusual events such as childbirth, death, wars, or natural disasters are sources of escape and excitement as well as avenues to a sense of meaning, significance, or intensity. Play, too, traditionally has provided the fiction of an alternate life, the excitement lacking in normal experience, and the opportunity to pretend.

It is true that in art there is often revealed a "reality" that seems to be behind everyday experience, or a world that is beyond this world—whether this is considered to be the Unconscious, the mystical realm of God, the metaphysical realm of Truth, the supernatural, a world of dreams and fantasy, the subjective world of the Self, or some other Other World. Still, there is no reason why the revelation of this other realm need be specifically aesthetic. The emotional appeal of such a revelation or intensification may not be aesthetic at all, but rather the satisfaction of another

"drive" or "need" or appetitive behavior. The fact that it is accompanied by artistic elements may be incidental. Dreams and fantasy provide—as well as art—acquaintance with affecting alternate or intensified realities.

One of the commonest early explanations of art's value was its ability to arouse sympathy or fellow feeling among people (Spencer, 1857) or otherwise to strengthen social bonds (Grosse, 1897; Dewey, 1934). "Functionalist" sociological and anthropological interpretations stress as well the *social ends of the arts.* Such is an agreeable position for an evolutionist to adopt, insofar as behaviors that enhance an already advantageous human sociality are by definition selectively desirable. Such a position would account for what we know of examples of prehistoric and primitive art, as well as acknowledge that art produced in historic times has predominantly served social ends such as documentation, illustration of precepts and stories that are significant to society, pictorial reinforcement of traditional beliefs, distraction and entertainment, impressive display of wealth and power, facilitation in a group of a dominant mood, and so forth. Even in contemporary art that is most resolutely "for its own sake," one can easily discern social as well as purely aesthetic consequences.

Yet by "art" today is usually meant a broad, inclusive general concept—and it is in this sense that it is difficult to find or substantiate a social function. Art in the modern Western sense contributes to species' sociality only in the most tangential ways, having become increasingly private and elitist. One can perhaps understand the biological usefulness of sympathetic alertness to an emotional outcry from a fellow (later refined to a musical phrase) or of appreciating verities of experience particularized in a tribal tale or nineteenth-century novel, but it is more difficult to explain the value of gooseflesh in response to a few lines of poetry that are not even spoken aloud but remain as black marks on the page. Knowing that persons of this kind of emotional sensitivity are often life's victims, not its victors, it seems difficult to assign selective value to tears or raptness or silence—frequent responses of fellow feeling caused by art.

Moreover, there are few today who when talking about the "social" function of art are referring primarily to the most socially influential modern examples—such as ephemeral crude pictorial illustrations and dramatic performances in village and urban societies of the past or present,[3] or much of the recorded popular music, television programs, or advertising in modern America.

Art as storytelling. Governor Davey's Proclamation to the Aborigines, 1816

Although these arts are socially widely influential, what about other examples of art that are appreciated or known only by an elite? One can also ask whether the posited contribution of the arts to social cohesiveness depends on aesthetic satisfactions or intentions as much as on accompanying ritual or economic considerations.

Similarly, although art is a means of reaching out to others for mutuality, a means of communication (Alland, 1977; Hirn, 1900) as well as communion, these can be achieved in other, nonaesthetic ways, both direct and symbolic. We cannot say that the need for attachment is the reason for artistic behavior, although the phenomena of attachment and mutuality (see Chapter 6, pp. 141–44) help to explain why we find art to be affecting.

It should be evident that there are serious problems attending each proposal for art's selective value that we have examined. The problems seem to arise because art has been confused or amalgamated with other proclivities or behaviors that have selective value, such as ritual observance, play, fantasy, dreams, self-expression, creativity, communication, order, symbol making, and intensification of emotional experience.

This is further corroboration of what was discovered in the previous chapter: when people are talking about what art does, just as when they talk about what art is, they could just as easily (and more accurately) use another word. Again we are led to the distinct possibility that art—like "vapours"—could easily evaporate, or—like "madness"—might better be called something else.

If our question "What is art for?" is starting to sound shrill and exasperated, perhaps it is because some palpable truth keeps slipping through our fingers (and eluding as well our mind's eye, ear, nose, and tongue) so that we have to doubt whether it will ever be firmly grasped or satisfactorily apprehended.

4

"Making Special": Toward a Behavior of Art

We have been discouragingly unable to answer satisfactorily either of the questions asked in the previous two chapters. In both cases, having asked what art is or what art does, we have found that seemingly accurate and plausible answers ulitmately confuse "art" with other behavioral proclivities and provide nothing that would warrant positing a separate entity.

Before giving up completely, let us look more closely at two of these behaviors which seemed in both chapters to be especially intertwined (albeit often unconsciously) with art—in the modern concept, in actual practice of the arts, and in the theories proposed for art's functional importance. These are ritual and play.

No one would deny that in primitive societies the arts are in most instances intimately connected to ceremonies or ritual practices, indeed are hardly separable from them. And in some primitive societies, as in our own, the arts are frequently considered, like play, to be something extra, enjoyable, pleasurable.

For an evolutionary interpretation, play and ritual promise to be particularly illuminating, because, unlike art, both have antecedents in lower animals and have acquired an impressive ethological and (in the case of ritual) anthropological literature.

Play

Like "art," the term "play" is equivocal. Used by ethologists as well as laymen, it is a sort of catchall for a number of ways of behaving that appear to have no manifest survival value. It exhibits itself as variously as romping around wildly, or painstakingly constructing a sandcastle; in highly organized games of ac-

tion and contest, or sedentary and solitary daydreaming. Play in humans can be frivolous or serious, structured or haphazard, solitary or shared.

In its ambiguity and undefinability, as well as in other ways, play resembles art, and indeed several thinkers have posited a more than casual relationship, considering art to be a derivative of play, a kind of adult play behavior.[1]

According to ethological literature, play is a characteristic behavior for most mammals and even appears in over forty species of birds. It is found notably in creatures that are sociable and have a long period of immaturity, and is normal for all higher vertebrates. In higher animals, adults as well as juveniles may play. Play makes use of innate patterns of behavior, acquired patterns of behavior, and elaborate combinations of the two. For practical purposes, play in animals and humans can be considered essentially the same, except that human children may use play imaginatively to act out fears and other psychological problems or to assume roles that attract them. Also, human beings have assigned definite formalized rules to some games.

In describing play, it is useful to list a number of features that ethologists have used to characterize it (Fagan, 1981; Thorpe, 1966; Meyer-Holzapfel, 1956; Millar, 1974; Lancy, 1980).

Play in animals can be distinguished from many daily activities by its apparent unrelatedness to the "serious" business of living. Generally it occurs when primary biological needs have been met; if the animal is hungry or ill or when the environment is no longer benign—as when an enemy approaches—play stops. Although, in humans, we know that children will play even when hungry or exhausted and that chess and football may be deeply serious endeavors, the general "nonseriousness" of play is accepted, and it can also be called "nonfunctional" in the sense that it is usually spontaneous and not directed toward a specific near-at-hand functional goal (or a goal with obvious survival value). That is to say, although play may be directly and willingly engaged in, one plays not to satisfy primary needs such as those for food, water, sleep, shelter, or defense. Animals as well as people may engage in play mothering, play fighting, and play mating, which are different from the real activity. Unlike mothering, fighting, and mating, the play versions are under voluntary control: they can be interrupted; special restraints—such as retracted claws—are used.

Play behaviors are spontaneous and unpredictable, unlike strongly motivated serious behavior which tends to follow a predictable, almost programmed sequence. On the contrary, move-

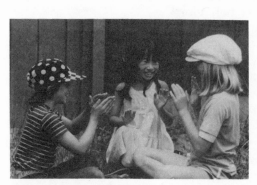

United States Uganda

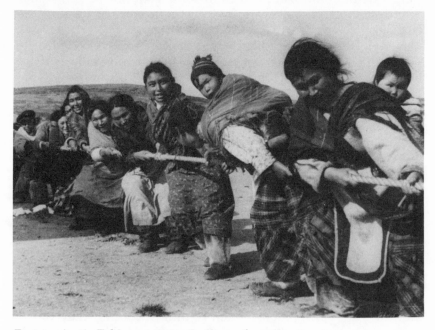

Eastern Arctic Eskimo women in "tug of war"

Play may be frivolous or serious, structured or haphazard, solitary or shared.

ments and movement patterns in play may appear outside their normal, serious context; movements from two functionally dissimilar contexts may even be combined (e.g., when puppies dig and solicit attention in one behavioral sequence).

In other words, play is self-rewarding. The creature plays "for its own sake," not for the sake of direct survival; play is intrinsically rewarding "in itself," not for the sake of an extrinsic goal such as caring for young, avoiding danger, procreation, or finding food. The player may appear quite indefatigable, expending far more time and effort than would be required by functional acts, and obviously derives pleasure, entertainment, and satisfaction from the activity. The quality and source of pleasure probably varies, but in human beings it frequently is concerned with overcoming self-imposed difficulties, which may include feelings of mastery or omnipotence.

Play is generally social: creatures play with one another. Children's play, even when solitary, often concerns an Other, and may require appreciation, if not participation, by others.

Play is characterized by a repeated exchange of tensions and releases—bouts that end, after a buildup, in a sort of closure, only to be initiated once more. Variables such as surprise, complexity, incongruity, uncertainty, whim, and conflict—which are avoided in serious behavior—are important and integral components of play.

Thus it would seem that play is related to a desire for change, for novelty and entertainment (in contrast to "doing nothing"). Yet it is not quite the same thing as curiosity or exploration, as these may precede a serious activity or themselves be serious. Thus it is to be expected that animals that play, which are the "higher animals," are those that seem to like stimulation and novelty. Many animals, especially human infants and primates, have been shown experimentally to prefer interesting and complex patterns to simple ones: they actively seek them out and will even "work" to have them.

Although play is relatively free and spontaneous, it also may be concerned with order and with form, with rule and ritual. Repetition, recurrence, and restoration of order bring relief after wanderings and alterations. Restraints of time and space may be invoked, an arena set up according to certain rules or formal conventions whereby otherwise ordinary objects and their arrangement take on a special significance (Rosenstein, 1976; 324).

Other important qualities that are made use of in play are exaggeration (either extremely smaller or larger movements than the

normal), imitation (of other players, of adults), and elaboration (a form of exaggeration in time as well as in space).

Perhaps the most salient and suggestive feature of play is its metaphorical nature. Something stands for something else—a ball of paper thrown along the floor releases prey-catching movements even when a cat is not hungry and when the object is not a normal prey object. A sibling becomes a puppy's "enemy." A stick of wood is a doll or boat for the playing child. This acceptance of "make believe" is expressed in numerous ways. Certain rules of the game are accepted: a particular facial expression or higher-pitched voice or bodily movement announces that what follows is "play"; subordinates may take dominant roles (as when lion cubs bite or pester their parents), so that reversal and inversion of "normal" behavior is the rule; familiar motor patterns are out of context and this adds to the pleasure. Imitation becomes pretense, as the edges between one frame of reference and another are blurred.

Although play as it occurs is characterized as "useless," numerous practical benefits have been claimed for it as a general predisposition or behavior. Nineteenth-century thinkers saw it as a means for exercising and expending surplus energy (Schiller, 1795; Spencer, 1880–82) or of allowing practice and perfection of activities that would be useful in later life (Groos, 1899). Freud saw play in children (and adults) as an avenue for wish fulfillment (Freud, 1948). More recent speculation—recognizing the value of a long period exempt from adult responsibility, when the young human being can learn what his elders consider valuable—has emphasized the essential role that childhood play provides both for practical education (learning skills) and socialization (Bruner, 1972). Even animals deprived of the opportunity to play when young do not develop normal adult social behavior; also it appears that they require the experience of play in order to fine-tune, modulate, and integrate instinctive behaviors such as catching prey. Indeed, play has been deemed essential in stimulating children to think, invent, adapt, create, even use their language fluently (Piaget, 1946). Play, by providing a "no risk" arena where innovative behavior can be tried and mastered, may facilitate in all children—not only emotionally disturbed or handicapped ones—new, creative behavior.

The reader will have noticed a number of suggestive similarities between art and play. It is interesting that some African societies use one word that appears loosely to encompass both activities (Fernandez, 1973; Schneider, 1971).

In Western thinking too, the differences between the concepts of art and play can be said to be largely a matter of definition, and can usually be interpreted as a difference of degree rather than of kind. Art is generally considered to be permanent, serious, with estimable effects, while play is transient, frivolous, and relatively unproductive. After a frightening medical examination, a child may *play* the part of the doctor, but will *make a picture* of himself as helpless before a powerful figure (Kramer, 1979); in such a case "art" portrays reality, perhaps leading to eventual coping, while "play" is evasive fantasy or wish fulfillment without real assimilation. Yet artistic behavior may be engaged in lightheartedly and its products may be ephemeral, while play may be taken with utter seriousness and its effects considered worthy of remembrance.[2] The line may be hard to draw between certain activities as art (involving "work") or play—for example, in gardening, cooking, chess, or in playful doodles that are later seen to contain the germ of an important artistic creation—yet in most cases the particular example can be labeled art or play without difficulty.

In normal usage, art is considered to be a quiet or passive occupation, especially for the perceiver, while play is active. In general, less is expected of play than of art. Play usually merely distracts or amuses, while art ennobles, teaches. The materials used in play are not always enticing in themselves, whereas art generally (though not always, particularly today) relies on its "sensuous vehicle" (Rosenstein, 1976:324). Moreover, the artist must exert a strong measure of control over his activity, while play may get out of hand (Gardner, 1973:165). The arts tend toward the integration and organization of experience in a more comprehensive way, so that art could be called a "goal directed form of play" (Gardner, 1973:166).

In spite of the differences, it must be admitted that art and play share many salient characteristics, and it is understandable how some of the functional and emotional values of play have frequently been assigned to art. For insofar as art is a kind of play, it will contribute the benefits that play contributes.

What we are trying to determine is whether in the differences between art and play there is any unique value that would result in a behavior of art being selected for during human evolution.

Ritual

Although the arts are associated with ceremonial rituals in all societies that we know, the resemblances between art and ritual

as abstract "behaviors" are not so evident as the similarities be-
tween art and play. Art and ritual as we routinely think of them
today in Western society appear to be so unlike that it may seem
strange to suggest that there is anything more than a fortuitous
association between them. Whereas ritual reinforces established
communal beliefs and practices, art says something new and in-
dividual. For us, ritual—though it may in some instances evoke
comfortable or even heightened emotion—is most often consid-
ered to be repetitive, predictable, and somewhat sterile. Through
art, on the other hand, we are introduced to a wider world, often
the unique interpretation of another, in which we gain a sense
of new knowledge and possibilities.

Yet in traditional and primitive societies, ritual ceremonies are
often the chief occasions for exhibiting the objects and activities
that we call art. Greek tragedy—to us a high form of dramatic
art—was originally a ritual of cleansing and atonement: Athenian
drama festivals were preceded by ritual sacrifices (Figes, 1976).
The development of music in the West has been inseparable from
Christian liturgy, and from the fourth to the sixteenth century
pictorial art was almost exclusively in the service of Christian
worship.

As background for an understanding of the relation beteen art
and ritual, let us examine the ethological concept called *rituali-
zation* as applied to the behavior of gulls. In the evolutionary pro-
cess of ritualization, one behavior, derived from an accessory
movement of ordinary behavior (often concerned with mainte-
nance or intention, such as preening, lifting the head to look
around, or flapping the wings before flight), acquires through the
course of evolution a communicatory function, and in its new form
"means" something quite different from its original neutral pro-
totype. For example, in hostile encounters the herring gull may
violently pluck grass or peck the ground (Tinbergen, 1952:9),
movements normally used more mildly in nest building. These
now violent and ritualized movements in their new context have
nothing to do with building a nest; they signal to the other gull
that the performer is angry, and concurrently they relieve and
demonstrate aggressive feelings without injuring the gull or its
opponent.

Such modified and ritualized behavior is often exaggerated or
stereotyped and loses its original utilitarian significance, as in the
courtship display movement of the garganey duck, originally de-
rived from preening. In the new context of signaling his amorous

intentions to the female, the male's bill touches but does not clean a conspicuous light blue patch on the wing (Tinbergen, 1952:24).

In all vertebrates, ritualized behaviors are often found in displays concerning territorial occupancy, threat, and in courtship, where they indicate availability, interest, and such features as endurance, strength, and "beauty." In these important social contexts they act as a kind of shorthand for communicating messages about one animal's mood or probable behavior to another or others. Emotionally motivated behavior such as hostility or sexual arousal is channeled into an unambiguous, formalized signal or display that serves automatically to stimulate or release appropriate and efficient responses or actions in other individuals, reducing possible misunderstanding and consequent risk and also strengthening by its repetition sexual or social bonds (Huxley, 1966:250).

It might be asked what a description of ritualized behavior in animals has to do with human ritual, such as the performance of Christian liturgy or Greek tragedy. One must be careful not to leap hastily or uncritically from ritualization of behavior in animals to the performance of rituals by human beings. In the human species, the inherited ritualized behaviors that are so common in other animals have been largely replaced by learned, culturally specific behaviors. These, however, still achieve essentially the same results as the inherited ritualized behaviors of animals. Like their prototypes in animals, these are relatively short sequences performed between two or three individuals—such as gestures of greeting and parting or ways of showing status—that serve to simplify social interactions, avert aggression, and assist bonding (Lorenz, 1966:282). In detail they vary from culture to culture, though many are certainly based on inherited, unlearned elements (e.g., averting the glance, making one's body appear smaller, and hanging one's head in submission or shame) (Morris, 1977), and all societies have them, suggesting that they are a natural and effective means of moderating social life. They are what each culture considers to be the norms of etiquette or "good manners": who goes first, who sits where, how one treats another.

Although we share with animals unlearned genetically determined ritualized displays (such as smiling),[3] and show many more learned ritual displays that yet fulfill the same social communicatory functions as unlearned ritualized displays in animals, human beings are unique in having developed prolonged ritual ceremonies—which are learned and culturally specific—that promote

France Bedouin salutation
Ritualized gestures of greeting in two human societies

Peacemaking ceremony in Northeastern Arnhemland, Australia. Note that the points have been removed from the spears.

the social stability of the larger social group and are heavily dependent on investing symbolic meaning in words, objects, and movements.

Current anthropological accounts of ceremonial ritual in human societies describe it in a manner that recalls ethologists describing ritualized behaviors in animals (e.g., Lomax, 1968:14, 224). Although the ethological concept of ritualization and the anthropological concept of ritual do not suggest phylogenetic homology, they may be usefully considered as functionally analogous, and this correspondence in form and function may be instructive in comprehending the two phenomena before turning to a comparison of human ritual and art.

Ceremonial rituals are communicative (Rappaport, 1984): they "say" something of value to their participants and give the group a "language" in which normally inexpressible things can be expressed. As we have seen, ritualized displays in animals are also communicatory devices for sending information to others who understand the message.

Ethologists stress that in ritualized displays, emotionally motivated behavior is "formalized" or "canalized" so that social harmony is more smoothly achieved and maintained (Huxley, 1966:250). The functions of human ritual ceremony have been described in astonishingly similar terms by anthropologists, as when ritual symbols are called "a set of evocative devices for rousing, channelling, and domesticating powerful emotions, such as hate, fear, affection, and grief" (Turner, 1969:42–43), or when the "myth-ritual complex" is said to act "as a mechanism of social control by providing an external regulatory system for states of bodily feeling" (Munn, 1969:178), or when rituals are said to "regularize ambiguous or wasteful relationships" (Rappaport, 1971). The ability of the Cubeo in the Northwest Amazon to mount a complex mourning ceremony is said to testify "to their skill in arranging to generate proper moods and sentiments," and they organize the ceremony by calibrating the sequence of ritual events with changes in their feelings, which also follow a definite course (Goldman, 1964:118, 121).

Just as ritualized animal displays are concerned with promoting social concord, it is an axiom of anthropological theory that human ritual is both a means and an end in expressing and reinforcing social cohesion.[4] Individuals with different expectations, abilities, and levels of understanding achieve a unity by participating in the ritual. The ritual is larger than its individual participants.

Individuals with different expectations, abilities, and levels of understanding achieve a unity by participating in ritual ceremonies. Initiation, Fly River area, Papua New Guinea

Just as human rituals are performed in a place that is temporally and spatially marked off from routine, everyday life (Kapferer, 1983:2), so is it characteristic of human ritual ceremony in general that objects or words taken out of their everyday context may acquire a potency not ordinarily evident. Metaphorical and symbolic uses of words and objects are the essence of ritual. Similarly, ritualized displays in animals make use of movements derived from ordinary daily behavior, yet in their new context they acquire a new, charged meaning. They may be accentuated or exaggerated (e.g., the part of the body being used may be conspicuously marked; the gestures may be accelerated or attenuated), just as circumlocution and figurative and deviant modes of expression typically add to the emotional effect of ritual, as in Aranda songs (Strehlow, 1971), or the special "seance language" of Eskimos (Freuchen, 1961:277), or with the metaphors, puns, homonyms, homophones, and similes that occur in the sermon of Bwiti cult ritual (Fernandez, 1966:66–69).

In many animals, ritualized behavior exhibits what is called "typical intensity" (Morris, 1966:327): it is usually strictly regulated so that a faster or slower frequency, or a wider or narrower

angle of movement, or a change in rhythm alters the communicatory effectiveness of the signal and most likely will not release the appropriate response (Lorenz, 1966:276–77). Nonambiguity may be further ensured by exaggeration or enlargement and redundant repetition (Lorenz, 1966:281). These characteristics of stereotypy and rigidity are also to be found in human ritual ceremonies where often all details must be performed in a certain sequence and in a prescribed, often iterative, way (e.g., Strehlow, 1971).

In ritualized behavior in animals a number of variable and independent elementary instinctive movements may be merged into a single, smooth, obligatory sequence (Lorenz, 1966:277). Similarly, some human ritual behavior, once it has been set in motion, appears to continue as a predictable, smooth sequence—achieved not by instinct but through learning (or conditioning) and hence anticipation. This seems especially so, for example, in those rituals whose object is a state of trance for their participants, as in Balinese rituals (Belo, 1960) or voodoo rites in Haiti (Deren, 1970; F. J. H. Huxley, 1966:425), where the possessed ones appear to have been "programmed to go off."

Similarly, hallucinatory visions of participants in rituals may be stereotyped, as in Bwiti cult ritual in the Fang of Gabon or the Tukano of the Northwest Amazon in Colombia, where the physiological or visual experience seems in great measure to be related to the expectation of the individual.

One apparent difference between ritualized displays in animals and human ritual is that in the latter a symbol or word may be ambiguous so that several actions and things can be implied by a single formulation (Turner, 1967:28). The simple and unequivocal ritualized signal is, in human ceremonies, replaced by a ritual symbol that may be saturated with allusive significance. Such symbolic condensation or concentration can serve to unite in one graspable whole a complex store of information about cultural and natural processes that would be too vast to remember separately and individually, as for example in the Australian aborigines' totemic myths and rituals where categories of human society are classified by the same words as categories of nature (Maddock, 1973:405). In this respect human ritual ceremony, like ritualized behavior, ensures economy of expression, though in a different manner.

Anthropologists describe the functional value of ceremonial rituals to human societies in terms also strikingly similar to those used by ethologists in ascribing selective value to animal ritual-

Boy Scouts on parade at the annual patriotic march to Abraham Lincoln's tomb in Springfield, Illinois, United States

Double Tenth Day national holiday celebration, Taiwan

Stereotypy, repetition, exaggeration, patterning, and formalization of ritual ceremonies

Friday prayer, Iran

ized behaviors. Rituals, for example, promote smooth social functioning in a number of ways: by uniting or binding the participants in common beliefs and values by reiterating them, thus explaining the world and providing a sense of meaning. Rituals integrate collective bodily feelings and emotions with the requirements of collective social life. Rituals regularize relationships, as in rites of passage. They convert the arbitrary into the necessary, thus certifying practices and dogmas that are of vital interest to the group. They may dissipate painful ideas and obsessive fears, by allowing them to be "acted out" in a formalized way.

In humans, rituals also efficiently and memorably transmit important information. The repetition, the symbolic condensation, the emotional heightening, the use of all the senses—all aid memorization of the "tribal encyclopedia" (Havelock, 1963; Pfeiffer, 1977, 1982), certainly advantageous in nonliterate societies.

When we compare the behaviors of ritual and play, we find important resemblances as well as important dissimilarities. If play in particular instances is nonserious and nonfunctional, ritual is in contrast most serious and immediately functional. Its proximate reason is to cure, bring hunting success, regularize a role change or relationship, while the proximate reasons for play are generally to "have fun," "fool around." Also, while play is almost always pleasurable, ritual may or may not be characterized by the enjoyment it affords its participants.

South Indian wedding

Bris (Jewish ceremony of circumcision), Philadelphia, May 1943

Rituals regularize relationships, as in rites of passage.

But in other characteristics the two are alike. Both are highly social. Both make more than usual use of tension and release, out-of-context behavior, surprise—the manipulation of expectancy and anticipation. Both make more than usual use of the qualities of repetition, exaggeration, imitation, and elaboration. Play is much more concerned with change and novelty, spontaneity and unpredictability than ritual is. Ritual generally tends toward stereotyped, prescribed, and even inflexible activities, but it does take place in a festive or unusual atmosphere that contrasts markedly with the routine of everyday life.

Most important, ritual, like play, is concerned with metaphor in that it is saturated with symbolism, the creation of another world in which once ordinary things acquire the potency of standing for extraordinary things. In this world, ordinarily incompatible things may be combined or reconciled into unprecedented and convincing unity.

Art too, as we think of it, partakes of make-believe and metaphor, combining the unlike. A bicycle seat topped with handlebars is the head of a bull. A lady dressed in white is a dying swan. The belly of the Shulamite is a heap of wheat encircled with lilies. In both art and ritual ceremony, "another world," different from the everyday, is invoked. In primitive societies where ritual and art are inseparable, truly fine things (what would today be called art objects) are not often seen or heard other than in relation to ceremonial and ostentatious occasions, so that they acquire an aura of "specialness" by their very rarity (Glaze, 1981; Biebuyck, 1973:166).

Further comparison of ritual ceremony with art demonstrates additional striking resemblances in both form and function. Both are communicative, "saying something" to viewers or participants. In fact, both provide a language in which otherwise incommunicable things can be said (Feld, 1982:92): images, words, gestures say *more* than their denotative, ordinary meaning. In both, there is also patterning, channeling, formalizing of emotion. A form is provided for otherwise unruly or diffuse content, and this shape or structure allows the emotional meaning to be conveyed. Art makes use of out-of-context elements, redirecting ordinary elements (e.g., colors, sounds, words) into a configuration in which they become more than ordinary. This is so in today's art as well as, for example, in that of the traditional Eskimo, where the "best" improvisatory poet-singers were usually considered to be the shamans who were adepts in a special ritual "seance language" in which everything was called by other names or circumlocutions

89

(Left) Art partakes of make believe and metaphor, combining the unlike. Ben-Zion, *Poetus Laureatus,* iron sculpture (Right) Art makes use of out-of-context elements, or redirects ordinary elements into a configuration in which they become more than ordinary. Ben-Zion, *Pebble Poem*

(Freuchen, 1961:277). Both theatrical and ritual performances may produce in their audiences transformations of being or consciousness (Schechner, 1985).

Although stereotypy and rigidity are not characteristic of art for us, other cultures and periods of history have been less enamoured of originality and novelty and have formulated explicit artistic canons. Some art may even, like some stereotyped movements of ritualized behavior, depend on a sort of typical intensity. Just as the amplitude of movements (say, head bobbing or wing flapping as intention movements in gulls) must be within a certain typical range in both space and time (not too wide or narrow, large or small, fast or slow) or they will not be recognized by other gulls as a communicative signal, a similar attention to typicality, in time, can be discerned in some human music making. The Kaluli of New Guinea spontaneously pace the delivery of melodic intervals in their "melodic-sung-texted-weeping" so that seven equal-value notes always take seven to eight seconds to perform

(Feld, 1982); in Bushman *num* songs, the underlying beat is always seven to eight pulses per second (Katz, 1982).

In humans, as in all creatures, there are likely to be parameters of normalcy within which one perceives structural elements in time and space so that, for example, we judge a particular tempo to be "fast" or "slow" in relation to an innate reference rhythm (Holubar, 1969) and respond accordingly, just as we recognize irregularity in many shapes or gestures because of inherent predispositions as to what is regular.

Human ceremonies and animal ritualizations do differ in that the latter are performed directly and unambiguously while the former are often rich and resonant with many-layered meanings and associations. In the arts, where temporal and spatial organization are at the same time predictable, within limits, and unpredictable, within limits—producing the tension and release that are important to aesthetic response (Kreitler and Kreitler, 1972; Meyer, 1956)—the predisposition to be sensitive to "typical intensities" and parameters of normalcy in space and time is undoubtedly a factor in what the artist and perceiver consider these limits to be.

The tendency for symbols in human rituals and in art to be saturated may perhaps be likened to the phenomenon of exaggeration in animal ritualized behavior. Exaggeration or emphasis can be achieved not only by stress or enlargement and conspicuous temporal or spatial placement but also by repetition. Observers of ritual in human beings have commented specifically on its elements of repetition and even redundance (e.g., Leach, 1966:404, 408). Instances of exaggeration (including repetition) in art are too common to require enumeration. Other features of ritual, such as economy, unity of disparates, and multiplicity of meaning, as well as a sense of unbroken inevitability are well-known characteristics of what we today call art, in primitive societies and in our own.

The oft-noted similarities among art and ritual and play should provide some confidence that we are not mistaken to attempt to understand art (like ritual and play) as a "behavior" that has evolved and has had selective value. It seems reasonable to presume that the three originally were intimately associated. In simpler societies that are nearer than we are to the type of social group in which humankind evolved, one may easily see the close, if ambiguous relationship (e.g., Gell, 1975; Heider, 1979; Radcliffe-Brown, 1922; Goodale, 1971).

"Making Special"

Having described the difficulties attending the usual nonethological ideas about art—what it is, what it does, whether and why it is necessary—and after the preceding introduction to the ethological concepts of the behaviors of play and ritual, it is at last possible to begin to discuss art as a behavior.

My own notion of art as a behavior, whose evolution will be hypothetically reconstructed in the following chapter, rests on the recognition of a fundamental behavioral tendency that I claim lies behind the arts in all their diverse and dissimilar manifestations from their remotest beginnings to the present day. It can result in artifacts and activities in people without expressed "aesthetic" motivations as well as the most highly self-conscious creations of contemporary art. I call this tendency *making special* and claim that it is as distinguishing and universal in humankind as speech or the skillful manufacture and use of tools.

In whatever we are accustomed to call art, a *specialness* is tacitly or overtly acknowledged. Reality, or what is considered to be reality, is elaborated, reformed, given not only particularity (emphasis on uniqueness, or "specialness") but import (value, or "specialness")—what may be called such things as magic or beauty or spiritual power or significance.

Making special implies intent or deliberateness. When *shaping* or giving artistic expression to an idea, or *embellishing* an object, or recognizing that an idea or object is artistic, one gives (or acknowledges) a specialness that without one's activity or regard would not exist. Moreover, one intends by making special *to place the activity or artifact in a "realm" different from the everyday.* In most art of the past, it would seem, the special realm to be contrasted with the everyday was a magical or supernatural world, not—as today in the advanced West—a purely aesthetic realm.[5] In both, however, there is a sort of saltation or quantum leap from the everyday humdrum reality in which life's vital needs and activities—eating, sleeping, preparing or obtaining food—occur to a different order which has a different motivation and a special attitude and response. In both functional and nonfunctional art an alternative reality is recognized and entered; the making special acknowledges, reveals, and embodies this reality.

Both artist and perceiver often feel that in art they have an intimate connection with a world that is different from if not superior to ordinary experience, whether they choose to call it imagination, intuition, fantasy, irrationality, illusion, make-believe, the

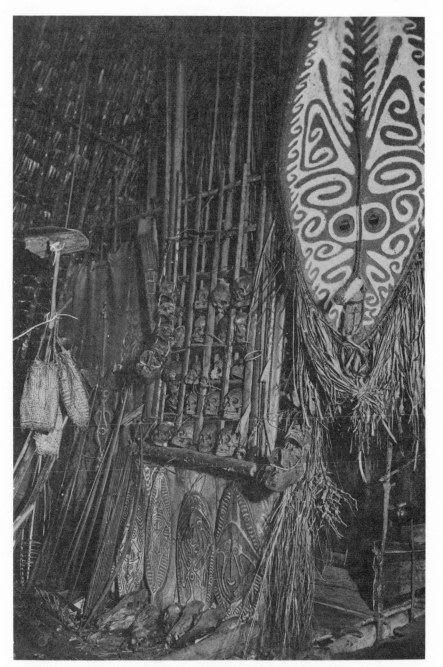

Shrine in Urama men's house, Papua New Guinea, containing human skulls and shields representing ancestral spirits

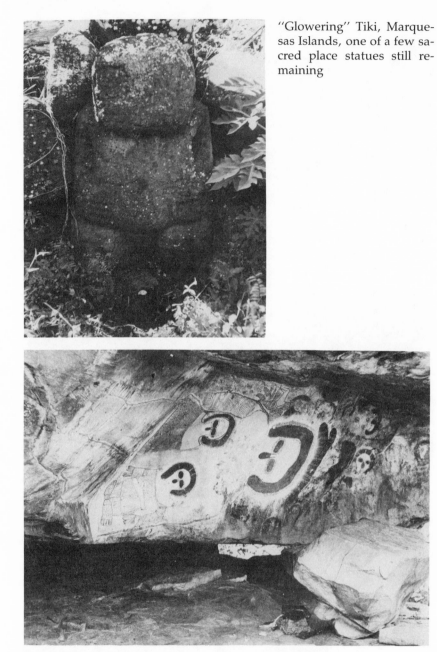

"Glowering" Tiki, Marquesas Islands, one of a few sacred place statues still remaining

Rock shelter paintings, Northern Kimberly, Australia

Examples of making places special

ideal, dream, a sacred realm, the supernatural, the unconscious, or some other name. Often the work of art is considered to be symbolic of this other realm, as in primitive rituals or in modern psychoanalytic interpretations of art (e.g., primary process; Jungian archetypes). Insofar as he or she has access to this special realm, the artist—as indeed is frequent in primitive societies—may be looked upon with suspicion, fear, or awe.

In the most simple sense, as Claude Lévi-Strauss has observed, any activity adds fresh reality to reality. Marking a tree on a trail sets off that tree from others, makes it distinctive, but lacks the intention to do more than what is needed for the purpose of finding one's way. Making special is to be distinguished from "marking," because it seeks to shape and embellish reality (or experience) so that it appears otherwise additionally or alternatively real. Our lens is refocused; a new figure or ground is established in regard to the former topology and we will probably respond emotionally with stronger feelings than we would to "nonspecial" reality. Reality is converted from its usual unremarkable state—in which we take it or its components for granted—to a significant or specially experienced reality in which the components, by their emphasis or combination or juxtaposition, acquire a meta-reality.

Surprisingly, those who have troubled themselves to describe universal human behaviors (e.g., Wilson, 1978; Young, 1978; Fox, 1971) do not mention "making special." It cannot, however, be substituted for or reduced to any of the behaviors that are normally listed. It is true that many observers of human nature have proposed that there is in humans an appetite for more than bread alone; they observe that human beings need more than would be suggested merely from an objective knowledge of the requirements of their vital processes. This is sometimes called a "religious need" or an "aesthetic need." Occasionally the two are confused, as when religion is called a form of human art (Firth, 1951) or when it is suggested that religious emotion may be a kind of aesthetic appreciation (Fernandez, 1973). (See also Chapter 7, note 29.)

One also sees reference to a "cognitive imperative" (d'Aquili et al., 1979) or intrinsic "need for explanation" (Young, 1978:31) that requires humans to fit the facts and events that they perceive into some kind of an overarching socially shared explanatory scheme which then produces "aesthetic" satisfaction. But these formulations ignore what my scheme recognizes as a need to elaborate as well as shape, in certain circumstances to do more than is nec-

Polished section of Corallian *Isastraea,* Weymouth, Dorset. 8.5 cm. "There is little doubt that the chert was transported by the Acheulean hunters from a distant source, and that they valued it on account of the pattern which it displayed when flaked" (Oakley, 1981)

essary, and to do this expressly to invoke an order different from the everyday.

From very early times it seems evident that humans were able to recognize and respond to specialness—at least this would seem to be the explanation for Acheulean people of 100,000 years ago selecting a piece of patterned fossil chert and flaking from it an implement that utilized the pattern, or carrying about with them an unusual but "useless" piece of fossil coral (Oakley, 1971; 1973). The Peking variety of *Homo erectus* made tools from gem-quality crystals of quartz (rock crystal) brought to their dwelling site from a considerable distance.

Perhaps the proclivity to make special existed even a quarter of a million years ago in the use of shaped pieces of yellow, brown, red, and purple ocher found among the human remains in a sea-cliff cave in southern France. It might be supposed that these were chosen for their "special" color, and thus suitable for "special"

purposes (Oakley, 1981). Red haematite was brought from a source twenty-five kilometers distant to an Acheulean dwelling site in India, probably for use as a coloring material (Paddayya, 1977). The presumably very ancient practice by humans of applying ornamental designs to their bodies can be interpreted (as does Frederick Lamp, 1985, regarding the cicatrizations and fine patterns of hairbraiding in modern-day Temne women of Sierra Leone) as a way of adding or imparting refinement to what is by nature plain and uncultivated, of imposing human civilizing order upon nature—that is, making it special.

A behavior of art cannot of course be "reduced" to making special, although I maintain that all art can be shown to possess this "common denominator." The notion of making special might appear to be too simple, leaving out some of the more significant features of our modern notion of art. What is accomplished, however, more than compensates, in my view, for what is lost.

In the first place, using "making special" as a starting point, rather than some hazily defined essence, allows us to consider artifacts from other societies that were made without a self-conscious aesthetic motivation in the same category with modern artifacts that we unhesitatingly call art—without invoking the ambiguous or unsubstantiatable aesthetic notions that are usually presupposed.

Positing a human need or tendency to make things special allows us to explain why many people are able to live quite contentedly without *good* art (a fact that is difficult to account for by those who claim that humans have an "aesthetic" need). What is needed is not necessarily Good (or Aesthetically Admirable) Art, but apprehension or personal fabrication of "things made special." (Of course specialness often leads to "goodness," in the qualitative sense, for beauty and complexity and utmost skill are end points of specialness. But what characterizes "good" art is a question for philosophers and critics, not, at least at the present stage, for ethologists.)

Moreover, accepting the tendency to make special accounts for the fact that some societies (e.g., Balinese, Hopi) seem to be so formal, mannered, ceremonial. They make, as it were, everything special. In such societies, life and art interpenetrate. One might object and say that once a "special" practice is repeated and becomes conventionalized or ritualized, it is no longer special, but simply "the way things are done."[6] This is not to be denied, and certainly primitive and traditional life everywhere is permeated

Making special. Offerings are blessed before being presented at the temple, Ubud, Indonesia.

with elaborations and embellishments that are considered "necessary." There are also degrees of specialness, and determining whether something is special and how special it is are certainly academic questions. Nevertheless, I believe that the general concept is useful and potent.

Recognizing the ubiquity of making special, and its apparently effortless integration into the day-to-day life of many unmodernized societies (so that the sacred and profane coexist, the spiritual suffuses the secular), points out to us the degree to which art is divorced from life in our own society. It helps us to understand why art, which according to the modern notion is autonomous and "for its own sake," is still conceptually stained with the residues of essential activities and predilections.

Identifying a core propensity of making special explains why art so frequently and strongly resembles ritual and play. I am not the first to characterize art as consisting of transformation, "bracketing," recognizing and entering an alternative reality—though I call this "making special." It must be emphasized, however, that not all bracketing or transforming or making special is art. Indeed, the attentive reader will not have overlooked that both ritual and play, like art, "make special." Both, like art, are

concerned with metarealities, and we have seen how they are in many respects hardly to be distinguished from art.

At first glance, it might seem that just as we earlier disposed of such proposed defining features of art as order, artifice, and intensity because they were as frequently found to characterize nonartistic as artistic behaviors, we would be justified in disqualifying making special, since it characterizes ritual and play as well as art.

The purist might well do so. However, the close evolutionary connection between ritual and art and between art and play, as suggested by their association in both the languages and the observable behavior of many primitive peoples, should reinforce our hope that we are on the right track ethologically speaking. Order, artifice, and intensity are ingredients in many more kinds of activity than is making special, which as far as I can ascertain is to be found only in ritual, play, and what the modern West calls art.

Although the notion of making special, then, must not be considered to be synonymous with a behavior of art, it is certainly a major ingredient of any specific instance of it, and "art" can be called an instance of "making special." Accordingly, if we wish to speak of *art* at all, as a behavior as well as an entity or an essence, it seems wisest and most realistic to consider it as an assemblage or superordinate class comprising what are called "the arts" (i.e., singing, dancing, carving, and so forth). This may seem pedestrian, since it leaves out the exciting questions of value and thus the heady power of exclusiveness.

From an ethological perspective, art, like making special, will embrace a domain extending from the greatest to the most prosaic results. Still, mere making or creating is neither making special nor art. A chipped stone tool is simply that, unless it is somehow made special in some way, worked longer than necessary, or worked so that an embedded fossil is displayed to advantage.[7] A purely functional bowl may be beautiful, to our eyes, but not having been made special it is not the product of a behavior of art. As soon as the bowl is fluted, or painted, or otherwise handled using considerations apart from its utility, its maker is displaying artistic behavior (or ritual, or play; as we have seen frequently, in some societies the distinction may be unclear and unnecessary). The housewife who puts down cups and plates any which way is not exercising artistic behavior; as soon as she consciously arranges the table with an eye to color and neatness, she is doing so. (Or she may be enacting a ritualized idea of "a table

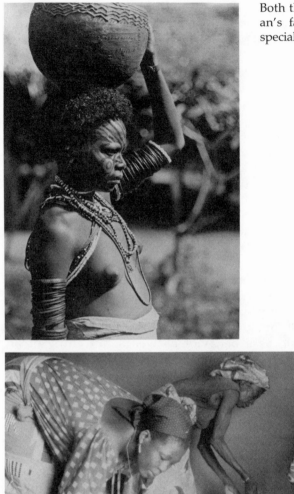

Both the clay pot and woman's face have been made special, Papua New Guinea.

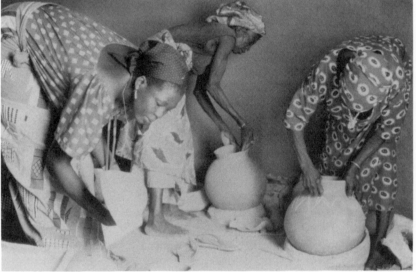

Women making clay pots special, Upper Volta

Other examples of making special

setting for a special occasion.") The functional, empty, unre-
markable wall may be enlivened by a mural, or bas relief, or even
graffito.

I have been asked whether an artist masturbating under the
floorboards of the gallery where his works are on view, or an
artist's infliction of pain on himself performed as a necessary ele-
ment to the work of art, is a "transformed reality." I would reply
yes, for both actions are artificial, self-conscious forms of activities
that in everyday life are performed in quite different circumstan-
ces. Acts of masturbating or carving oneself up in themselves are
not artistic activities; performed deliberately for aesthetic reasons,
out of context, "made special" by the occasion and making the
occasion special and extraordinary, they are.

A NEW LOOK AT "WHAT IS ART?"

With the notion of making special in our possession, we can
look at some other examples of the question, "But is it art?"

It is not uncommon that writers who wish to demonstrate the
"universality" and importance of art will give examples of aes-
thetic behavior or feeling from the animal world—such as the
bower bird who individually and carefully decorates his bridal
bower, or the chaffinch who varies his song (see, e.g., Burnshaw,
1970:199ff.; Joyce, 1975; Hartshorne, 1973). These isolated and
anomalous instances are curious and interesting, but it seems more
parsimonious to call them examples of ritualized display (the bower
bird) or play (the variation of a species song by an individual bird).
Both are, of course, instances of "making special" in the sense of
elaborating a basic functional item (a nest, a communicatory vocal
signal).

Similarly, chimpanzee "art" might better be called something
like motoric activity, exploratory behavior, or play. The proclivity
of apes to paint when allowed or encouraged to do so supports
the hypothesis that there could have been in the higher primates
from which humans evolved a similar "readiness" to scribble, fill
a given space, and balance marks within it, repeat strokes
rhythmically, and so forth (see Morris, 1962)—a readiness that
could be incorporated into the proclivity to write, as well as to
shape and embellish from a consciously "aesthetic" intention.
However, as is the case with chimpanzee language, although the
abilities are admirable and far beyond what might have been ex-
pected, intentional invention of symbols or deliberate combina-
tion of symbols (in language) and embellishment and shaping (in
art) stops at a rudimentary point. I do not think anything is gained

by labeling these achievements of apes "language" or "art," abilities which the human animal did not manifest until relatively recently in its evolutionary history. What they do show is that the prototypes of art (and language) extend back into the primate family, anchoring us even more firmly into our biological past as well as emphasizing the extent of our unique and unprecedented use of these prototypes.

Acts that resemble human art in that they express affect are widespread in the animal world, but expression alone is not art. General, not specific information is communicated, and the message is more or less predictable and foreordained. Moreover, expressive acts of animals are usually unlearned, where human arts are cultural activities that are learned.

The fascinating activities of birds and animals that resemble human art can be a source of pleasure and wonderment without one feeling the necessity to include them with human art as one vast universal creative or expressive or aesthetic urge, and suggesting that they are somehow related. In my opinion, they have no direct bearing on a discussion of aesthetic behavior and its origin in human beings.

What was said for chimpanzees can in large measure be said about the drawings of young children: these are the products of pleasure in motoric activity, of curiosity and exploratory behavior, or of play (or the combination of all).

Specific artistic behavior could be said to occur when the child shapes or embellishes some material of his everyday life with the intention of making it special so that it will be responded to by others for its aesthetic quality (i.e., as a symbolic product, a transposition of the ordinary elements which *because of this transposition* acquire a new importance). The child may also wish to be admired for his skill, accuracy, or perseverance, or the work's beauty or verisimilitude, but before he can be said to display intentional artistic behavior he must also be able to realize that he has formed or decorated something and made it into something others will appreciate in terms of that arrangement and embellishment. A copy of a book illustration is not art, nor is scribbling or babbling singsong. Yet in such activities artistic skills are being developed. All the perceptual and motor skills that develop in childhood are integral to later artistic endeavors: art is not "added on," so to speak, to an already achieved ability (Gardner, 1973).

Certainly the instances of "art" described for primitive societies in Chapter 2 as well as many "artistic" activities in modern society today are examples of things and activities made special. It

would seem, however, to be more straightforward to consider them, say, as "playful elaboration," or "ingredients in ritual ceremonies," or simply as descriptively named activities (e.g., painting, music making, carving) rather than "art." Of course, a critic with specifically aesthetic standards might well choose to call some of these objects or displays "works of art" and elucidate or defend his label by aesthetic criteria. As human ethologists, however, we will do better to use the word "art" as little as possible, because of its biological inadequacy and vacuity.

THE SELECTIVE VALUE OF MAKING SPECIAL

As an essential feature of a behavior of art, as well as characterizing ritual and play, the tendency to make special would be an inherited predisposition, selected for according to Darwinian principles. Although traits as complex as human behavior are influenced by many genes, each of which shares only a small fraction of the total control of the expression of the behavior, natural selection can still affect whether or not a certain predisposition is retained and often for the ways in which it is manifested. What is inherited is a capacity or a tendency to behave one way rather than another. The genetic predispositions and the constraints of the environment together guide the developing behavior; if it confers greater selective fitness, it will in the long run be retained. We could postulate that societies whose members tended to make things special or recognize specialness survived better than those who did not.

We can next consider how the behavior of "making special" might have arisen and what its selective advantage could have been. Evolutionists have puzzled over the selective value of the extravagant songs of birds, which would seem to be far more elaborate than necessary for simple transmission of information about species, sex, breeding condition, and so forth. Countless species convey these data in much simpler and equally effective ways. The apparently superfluous nature of bird song has led some investigators to jump to the opposite extreme view—reminiscent of modern views of art—that it is an evolutionary luxury, performed "for its own sake," for the sheer enjoyment it gives the singer (Hartshorne, 1973; Thorpe, 1966).

A recent paper that seeks to establish the "exploitative" nature of some animal communication—that is, persuading reluctant members of one's species to do what they may hesitate to do—suggests that bird song may rather act as a kind of oratory, persuasion, hypnosis (Dawkins and Krebs, 1978:308). Being overdone,

it cannot be ignored. Birds who sing longer or more elaborately than others could be super-advertising their territorial proprietorship (to make others stay away), insistently demonstrating their vitality and intense interest in what they are communicating (e.g., their sexual availability, their physical endurance).

In a similar manner, making special (as, say, embellishing, repeating, or performing a particular act with virtuosity) might well have originated as a demonstration of the wish or need to persuade others (and oneself) of the efficacy or desirability of what was being done. Taking pains is a way of being more certain to achieve one's intention. Taking something seriously (that deserves to be taken seriously) is likely to ensure its being carried through. If a certain accidental mark or feature proves effective, on the next occasion one might do it again deliberately, and even make a few more. In addition, the fact of one's taking pains convinces others and oneself that the activity is worth doing: it is reinforcing. When allied to life-serving activities—tool manufacture, weaponry, ceremony—elaboration (as reinforcement) would enhance survivorship. Humans who spent time and effort to make deleterious activities special would have survived less well than others who turned their attentions to more promising ends.

It seems likely that the earliest instances of making special would have been in *recognizing* specialness—as when *Homo erectus* carried about unusual stones and fossils. Such a propensity is perhaps little different from the tendency in many animals (e.g., corvids, bower birds, pack rats) to notice bright or novel objects and play with or otherwise appropriate them. As such, it could be called an instance of curiosity or neophilia—neither specifically human nor rare. However, in humans there seems to have been the additional tendency to differentiate between the ordinary and the more than ordinary, to exalt special or unusual things to a different realm or order from the usual or nonspecial. This tendency, which contributed to and was affected by humankind's evolving powers of symbolization, could confer adaptive benefits in many spheres of behavioral activity—as when anxiety was concentrated and transposed ritually to a symbolic sphere and thus made somehow more easy to handle and deal with (Burkert, 1979:50).

According to the ethological view, then, *making special* had selective value. However, it seems impossible to make a case for selection to have encouraged during human evolutionary history an independent behavior of art for its own sake. Until recent times, as the following chapter will seek to demonstrate, the arts have

Sacred board and pointing instrument for sorcery, Australia

Flaked quartzite ax or pick and decorated stone ax, Australia

Making life-serving instruments special

been handmaidens to other selectively valuable activities. Art's "spinoffs" or residues—that is, independent, detached or disinterested, autonomous aesthetic creation and response—would seem to be superfluous relics whose independence and importance are a recent, culturally bound emergent phenomenon. And, since art for art's sake is a phenomenon that has arisen only recently, there has quite obviously been not enough time for it to

have an evolutionarily significant effect. Moreover, being confined to only a small segment of humankind, and an elite segment within that, there is no possibility of generalizing it as a characteristic of the entire species.[8]

To be sure, individuals show different inclinations and abilities to make things special, or to make and react to the arts, but these can be explained as a consequence of general genetic variability. Everyone can run or swim or speak or use tools—universally highly adaptive endowments. But not everyone need be an Olympic champion, an orator, or a watchmaker.

Yet, now that making special has been identified and described, there remains much more to be said about the origin of art as a behavior, its evolution, and its selective value. The scene has been set, however. We know what we are talking about—a fundamental general behavioral tendency to "make special" and respond to "specialness." Upon this will be grafted other important emergent physical and mental endowments which will in turn be acted on throughout the millennia of human prehistory by various environmental demands.

From the interchange between the aptitudes and needs of a fragile living creature and the countless constraints of impersonal physical laws will emerge an intricate, multiform, self-reinforcing, open-ended behavioral propensity. This propensity is an attribute that cannot be reduced to a common denominator or circumscribed in a neat definition. For want of a better word, however, we will call it "art."

5

The Evolution of a Behavior of Art

In attempting to determine what art is for, we had to make several detours when in Chapters 2 and 3 our pathway ran into various cul-de-sacs that suggested that the word "art" had no ethologically useful meaning. Finally, in the previous chapter we reached an ethologically acceptable promontory from which to cast our view over the landscape of human evolution. Insofar as we can talk about a behavior of art at all, we must recognize first of all a pervasive component of any instance of such a behavior— making special. It is "making special" that can be said to have evolved and had selective value.

Although we have discarded the idea of tracing the evolution of a behavior of art in the modern sense (that is, for its own sake), it is certainly possible to say more about the evolution of a behavior of art in an ethological sense (that is, for the sake of the fitness of the individuals who perform it). This behavior of art might be described as *the manufacture or expression of what are commonly called "the arts," based on a universal inherited propensity in human nature to make some objects and activities special*. As such we can trace the emergence and development of various strands or tributaries in human evolution that have contributed to the arts and to artistry and attempt to show why these were selectively retained. These reasons will be answers to the question "What is art for?"—what it was for in human evolution.

While, as we have seen, in some instances it is possible to confuse art with ritual or play (or indeed with other behaviors), this is a problem only if we insist on using modern categories and concepts that, being culture bound and narrow, divide up the "world" in ways that are actually irrelevant to a broad evolution-

ary view. For we will be discussing the rudiments of the arts as they were evolving before the "creative explosion" (Pfeiffer, 1982) of some 40,000 to 25,000 years B.P. We will be examining broad, polyvalent, mutually reinforcing behavioral tendencies that were contributing to the whole of evolving "human nature" from the time of the earliest hominids, some four million years past. In its beginnings, particularly, the behavior of art will be seen to be inextricably intertwined with other intrinsic propensities that characterized developing and present human nature.

Evolutionary Questions

Evolutionary interpretations of behavior usually address at least two interrelated questions. One concerns origins. In the case of art, quasi-evolutionary views in the past have generally tried to trace its source to a single antecedent: for example, play (see Chapter 4, note 1); body ornamentation (Rank, 1932:29); a "configurative urge" (Prinzhorn, 1922); a creative or expressive impulse (Hirn, 1900; Rank, 1932); sympathetic magic;[1] relief from boredom (Valéry, 1964); or motives of self-glorification (Yetts, 1939). One could similarly propose that the beginning of art was in the practice of rituals.

Yet to search for one particular origin of such a complex and heterogeneous behavior seems misguided and needlessly restrictive. This is so because the above and other sources one might suggest (e.g., a need to communicate; the awareness of or love for beauty; an impulse to decorate) would each have been first manifested sporadically and rudimentarily in a large number of nonartistic contexts; some can even be identified in animals. Why should one of these rather than any other be chosen as *the* origin of art?

Indeed, I will suggest that it is most useful to consider the behavior of art as being composed of many filaments (manipulative, perceptual, affective, symbolic, cognitive). Although each would have been operating and developing from the very earliest times, their coalescence into the production of specific works of art would not have occurred until relatively recent stages of human evolutionary history. The story of the unfolding and combining of these many strands is the second aim of an ethological interpretation of art—the reconstruction of its evolutionary course.

Although we and all hominids who have existed for at least the past quarter of a million years belong to the species *Homo sapiens*, there were other branches—both earlier and concurrent with

ours—along the complex, intermingling, and lengthy course of the river of human evolution. During this enormously long time, at least four million years, our hominid forebears lived in a generally uniform tropical environment in a generally uniform way, as nomadic gatherer-hunters. It is not too much to say that their behavioral as well as morphological and physiological heritage was developed during that long period to sustain this way of life. Although the largest proportion of human beings alive today subsist primarily on planted and harvested cereal grains, settled agricultural communities and urban living occurred only a mere ten thousand years ago, an insufficient time for significant genetically controlled changes to occur. Our mentality and metabolism, our fears and longings, needs, satisfactions, and dreams are much more those of our earlier ancestors than of village or city dwellers.

The Early Hominid Way of Life

Speculation has often arisen about just what factor was responsible for initiating the development of the particularly human evolutionary enterprise. Once this development was set in motion, many aspects were mutually influential and reinforcing (see next section).

Until recently it was thought that hunting as a way of life was crucial to the characteristics that are considered essentially human—such as the skillful making and use of tools, language, a high degree of socialization, and so forth. While hunting undoubtedly contributed to these skills, it has been very cogently argued that woman the gatherer, even earlier than man the hunter, played a critical part in the transition from hominoid to hominid.[2]

Early hominid males and females must have each gathered and hunted, fished and scavenged, as still occurs in some present-day primitive societies. What seems as significant as any division of labor that might have eventually ensued is that they brought back what they acquired—plant as well as animal food—and shared it with the group. Since many animal mothers do this for offspring, and some (hunting) carnivores bring food back to their dens, it seems that selection could act upon genetically endowed tendencies in both males and females to be sharers of the food they acquired by their own individual efforts.

Sharing of food is one factor in the general endowment of sociability that was already well developed in primates. The hominid primate, who lacked the potential weapon of large canine teeth of its direct ancestors, seemed to have already found that

the development of cooperative interdependence was essential to its particular way of life. It is thought that the earliest hominids lived in large, stable social units (thirty to a hundred individuals) with the capacity of fragmenting into smaller groups when this was made necessary by fluctuating availability of food (King, 1980). Rigid social and gender hierarchies and stratifications that seem so characteristic of humans today could have been manifested only in larger, more settled, and diverse populations made possible by the later development of agriculture. For nomadic gatherer-hunters it was important to be interdependent—essentially unstratified and egalitarian.

Such a way of life would encourage what we call intelligence: the ability to learn, remember, and plan. Unlike a forager or grazer, who eats more or less all the time, the early hominid would have felt hungry and yet not have found food readily to hand. Procuring food though one is not hungry, like being hungry when there is no food available, encourages foresight and that fragile yet powerful human possession, self-control. It was more important to cooperate than to quarrel about matters such as food or mates; we can suppose that changes in internal nervous and glandular mechanisms occurred in order to better control feelings like rage and lust, thereby allowing for more deliberation, intentionality, and restraint in behavior rather than uncontrollable instinctive responses. The replacement of largely hormonal determinants by cortically controlled responses allowed the appearance of more personal relations between individuals and made possible an even more abundant range and richness of sociability. Ill and injured—even orphans—were cared for, individuals acquired importance, pair bonds could develop, as could "families" with inner as well as group loyalty.

Procuring food in groups and making it edible would foster improved vocal and nonvocal communication, and the development of certain technical, motor, and sensory skills, such as toolmaking, dexterity, observing powers, appreciation of symmetry, and the development of "handedness"—a dominant, more skilled hand and eye (with ensuing reciprocal effects on the right and left hemispheres of the brain).[3]

Once fire was preserved and used, about half a million years ago in some parts of the world, the necessity to maintain it would encourage not only communicative skills but awareness of time as recurrent—day and night, the seasons—when fire would be more and less of a necessity (Marshack, 1972). The development of fire might also allow for more leisure, since cooked food would

require less eating time. Although gatherer-hunters did not have what we could call an easy life, they certainly were, like all other animals, indolent when possible. Their leisure must have been occupied with practicing and developing skills, but equally so there must have been time to idle, to chat, to dream.

Young social mammals are renowned for their curiosity and readiness to play; there is no reason why the children of early humans would not have shared these propensities. Play contributes to sociability as well as to the inventiveness inherent in variation and making believe. In a way of life that is essentially conservative, play would be not only an avenue for imitative learning but a reservoir for innovative behavior, for curiosity and exploration.

We can expect that gathering-hunting as a way of life not only would encourage an independent "cognitive style" (Berry, 1976) but would affect the view of nature held by the humans who practiced it, just as later settled agricultural and technological societies have other styles of dealing with the world and have viewed their relation to nature and the cosmos in yet other perspectives. Increasing intelligence and ability to plan and control the circumstances of one's group would contribute to self-consciousness and to the wish to deal more effectively with forces outside one's control. Magic, the solace of religious explanations, ritual, and the arts were undoubtedly part of human mental and emotional life from very early times, providing rules of conduct and prescriptions and expressions of belief in an insecure and violent world. Common beliefs and customs bind individuals together; congruence of minds and deeds is essential to the continuance of a small group of mutually dependent, relatively helpless creatures.

Some Fundamentals of Human Nature That Evolved Alongside Making Special

Students of the evolutionary emergence of humans from their animal ancestors have identified a number of characteristics that are present in a rudimentary form in lower animals but are uniquely human in their high degree of development and interrelatedness. Often one particular characteristic is chosen to be called the crucial factor in humankind's evolutionary success. More accurate, I believe, is the recognition that none can be considered apart from the others: they developed together, contributing to and influencing each other.

I see these integral components of all human behavior as fila-

ments or skeins that can be interlaced in different combinations to make cables or braids that then combine into more complex behaviors, such as those that make up the arts (e.g., songs, poems, stories, decorated objects, and so forth). What I mean will be illustrated after artificially isolating and describing each general behavior or predisposition. They can be said to be innate powers and tendencies—products of natural selection during the aeons of hominid evolution. They require the setting of a particular culture in order that their potentiality can fill specific roles that will be performed in an integrated, specific way. They are intrinsic and inextricable ingredients of human nature.

Each component has contributed in its way to art, whose versatile garment shows, under the embroidery and ornaments of its many uses, the multicolored threads and filaments of its primordial substance. The elements of art are human nature's fundamental elements, though often, in modern Western art, they appear in nonfunctional manifestations.

THE MAKING AND USING OF TOOLS

Some theorists—often holding a materialist or Marxist view of art—propose that human skill and creativity were originally developed through using and shaping objects to serve as weapons and implements (Plekhanov, 1974; Wilson, 1975). Such interpretations view "art" as material objects, not as a behavior, as we do here. Nevertheless the ability to make and use tools skillfully is a distinguishing characteristic of humankind, integral to many behaviors, even though it is no longer claimed as it once was that the ability to make tools is peculiarly human. Even some birds and sea otters *use* tools, and certainly the earliest Hominidae would have been capable of using improvised tools and weapons, as do present-day baboons and chimpanzees, when circumstances demand (Oakley, 1972:26).

The earliest hominid tools may have been untreated stones lying handily about, used to scrape soil from edible roots or to peel or pound otherwise inedible vegetable material. These would not be recognizable as "tools" today, nor would we find any evidence of such plausible early tools as pointed wooden sticks used for digging or knocking down fruit from trees, or plaited fiber slings conceivably used to carry infants in order to leave the hands free. Identifiable manufactured stone implements are not found before about two and a half million years ago, and it seems reasonable to assume that they were preceded by tools made from perishable organic materials.

It is important to recognize that rapid cultural advance is not a natural consequence and necessary concomitant of the mere possession of tools, as it was once thought. Apparently, among all the hominids who had been using crude tools for millennia, it was only in *Homo erectus* that specializations in the brain accompanied, reinforced, and were reinforced by toolmaking in a way and to an extent not achieved by the others.

One can see how the two—brain specialization and competent toolmaking—could be mutually influential. Effectiveness in tool manufacture would ensure that the neural structures responsible for such achievements were further exercised. The abilities to visualize in a lump of rock a still-unformed shape and to anticipate what its use might be (or, having an aim in mind, to anticipate a means of achieving it) are cognitive abilities that involve powers of symbolization, abstraction, and conceptual thinking. Later, being able to appreciate symmetry or the mirroring of opposites in a tool blade could assist an appreciation of binary relationship (Foster, 1980) that might be generalized to other features in the environment—an additional step toward abstract thinking, which itself would be applied to more diverse and effective tools (Conkey, 1980; Kitahara-Frisch, 1980).

Making and using tools skillfully has other consequences. An animal who actively manipulates objects, whether in play or in making and using tools, would find his environment more complex and interesting than one who was not aware of the potentiality in his surroundings. Handling would have encouraged recognition of classes and classification. Close visual attention and prolonged eye and hand coordination are cerebral rather than ocular functions (Oakley, 1972:25), and the involvement of the left hemisphere of the brain in language ability, control of the right hand, and analytical sequential thought suggests that there has been a close original and continuing connection between these three vital human endowments. By facilitating the fuller development of speech, the mutually reinforcing processes of improved tool use and manufacture and continuing elaboration of the brain also affected the organization of cooperative activity, the acquisition and transmission of technical skill, and indeed all the faculties needed for survival (Weiner, 1971:97).

NEED FOR ORDER

Human beings seem to have a natural tendency to make sense of their environment, to find or impose upon it a pattern of order and hence comprehensibility. This observation can be intended

to mean something as simple and obvious as the fact that predictability and familiarity are indispensable for any animal, including human beings, or it can be extended to complex and allusive hypotheses about the inherent structuring faculty of the human mind. Whatever the limits or intentions of the assertion, human beings as well as all animals find it unquestionably important to be able to classify, to sort impressions and perceptions into some kind of order such as normal and abnormal, safe and dangerous, edible and inedible, we and they, and so forth. For humans, it seems additionally and equally important to be able to fit their diverse and chance experiences into a comprehensive explanatory scheme—to recognize what is true and false, knowable and unknowable, sacred and profane, real and illusory, good and bad.

The physiology and structure of the brain suggest that its function is to select patterns for response out of an enormous flux of information (Platt, 1961:403). Indeed, the principle of "order" is, in its simplest sense, a mere explanation of the fact that something is perceived at all, for there is psychophysiological evidence that neither a steady flux nor an unpatterned random flux can be satisfactorily comprehended (Platt, 1961:403). Yet in human beings the patterning tendencies have evolved to a very great complexity, so that compared with other animals we can order a greater number of things in a greater number of ways. To a greater degree than they, we can find general schemes to include particular things or events (Young, 1978:2), pay attention to the shades of expression of others (Young, 1978:3), and be sensitive to temporal as well as spatial patterning (Young, 1978:491). By means of culturally derived patterns such as rituals, myths, and language structures, we can assimilate otherwise intellectually diffuse or emotionally intolerable experience. Over and above the requirement to take note of experience that is perceived as having structure and shape is a tendency to seek order for its own sake, to find delight and satisfaction whenever it is recognized, and to actively seek or long to impose it ourselves (Storr, 1972; Gombrich, 1980).

Although the observed fact of human pleasure in regular formal shapes and patterns would seem to have analogies in animals, it is humans who have the manual and conceptual ability to formally mold their experience actively and consciously. Giving shape and form to the amorphous or erratic, which occurs inveterately in the arts, can be seen as an intensification or the intentional exercising of this general structuring proclivity.

Narrative, for example, is a peculiarly human formalizing or structuring device that belongs to life as well as art. Barbara Hardy in her literary criticism stresses that man is "a story-telling animal," that human life is made up of narrative, and that the special aesthetic activity known as novel writing is an intensification of what we all do all the time (Hardy, 1975). When we report an occurrence to a friend, or recollect our own experience in reverie, we select salient details and omit others. In an elementary way we perform the same activity as a novelist.

The narrator of Witold Gombrowicz's *Cosmos* (1965) declaims: "But how can one avoid telling a story *ex post facto?* Can nothing ever be described as it really was, reconstituted in its anonymous actuality? Will no one ever be able to reproduce the incoherence of the living moment at its moment of birth? Born as we are out of chaos, why can we never establish contact with it? No sooner do we look at it than order, pattern, shape is born under our eyes." Life as lived can be considered "shapeless," "one damn thing after another." Shaping it, giving it narrative structure, is a way to comprehend, interpret, or remember it.[4]

LANGUAGE AND SPEECH

Claude Lévi-Strauss finds the essential mark of culture not to be tool-making but articulate speech (Charbonnier, 1969:149; Lévi-Strauss, 1963:68–69, 358).[5] There is no denying that the human ability to communicate by means of spoken language has been fundamental to our other evolutionary accomplishments.

Language is not a unitary phenomenon; in fact, different aspects of it are handled by different portions of the brain. It can profitably be thought of as a collection of disparate achievements that developed at different rates and from differing needs in the course of evolution (Linden, 1976:254). From a neurologist's point of view, human language is founded on a series of adaptations that have distorted the size and shape of and affected the integration among different areas within the left hemisphere of the brain (Linden, 1976:256), which is, as we have mentioned, also involved in manual dexterity of the right hand. Language exists on a continuum from expressive noises and vocal signals whose aim is to make others perform certain acts to syntactical propositional articulate speech, based upon and related to complex and highly evolved classificatory and cognitive endowments possessed only by humans.

The relationship between language and thought is one of the most important, exciting, and vexed subjects in human self-un-

derstanding. Ironically, it is a subject that can be recognized only when the cognitive abilities implicit in language itself are freed to be able to reflect on it and themselves—to become aware, for example, that words have only an arbitrary connection to the things they name—a fact that is not appreciated by children and unsophisticated adults. That language molds thought by categorizing, conceptualizing, and structuring experience is a notion that has been articulated only in this century. How this is done, and what the implications are, are concerns hardly felt outside Western academic circles.

A crucial subdiscipline of the field of human cognitive studies is that of ape language. Although this is not the place to try to summarize the present theories and controversies, which are in continuous and lively ferment, it will be instructive to look at some of the findings in ape communication that suggest where important species' differences lie (Ristau and Robbins, 1982).

Ape language acquisition shows intriguing similarities to the learning of language by children. For example, in both child and chimp, language initially arises from and aids action, and words are more easily learned when the referents are functional or when they are presented functionally. Typical messages of both chimpanzee and language-learning child will probably consist of entreaties, demands, mollifications, and declarations of ownership and location (McNeill, 1974).

Chimpanzees are able to invent new words by combining two previously learned words, and can put several words together with what some claim to be a rudimentary understanding of grammar. They show the ability to generalize, as by using the word "more" in untaught situations ("more go," "more fruit") and demonstrate at least a rudimentary kind of symbolizing ability in labeling experiments (where in the absence of an object they respond appropriately in naming tests, or use labels correctly in problem-solving tasks).

Yet apes differ from human children in a number of respects. They do not ask questions spontaneously or show a child's irrepressible avidity to learn language. They do not report what has happened to them, do not play or experiment very much with their elements of language, and do not seem to be able to introduce and define new topics (Gardner, 1973:82, 85). They do not as easily understand new combinations of naming or syntax as a child would do. Although they may string a number of words together, these tend to be redundant and repetitious rather than expressing new information. Apes do not seem to exhibit as much

reciprocity or turn-taking as children do in human conversation.

It is also important to recognize that in humans, unlike in chimpanzees, language is not only essential to higher levels of cognition but is important as a means of social interaction. Indeed, language, intelligence, and sociality are so inextricably intertwined that a deficiency of one implies serious limitation in the others. People everywhere engage in language communally, compulsively, and automatically. Without it, we are not human.

It is not known at what hominid stage, whether as early as *Australopithecus* or as late as the first (archaic) *sapiens* populations, communication by speech and language was established.[6] It seems difficult to imagine how integrated cooperative activity or skilled toolmaking could be accomplished without it. Basic to the deliberate manufacture of tools, as we have said, is the power of abstraction and conceptual thought, the visualization of the tool in a formless lump of stone. We might postulate that during the time of the species expansion of *Homo erectus*, when tools were progressively standardized and began to become specialized (between ca. 800,000 and 400,000 B.P.), were also developed the necessary cerebral and anatomical capacities for abstract conceptual thought and articulate, syntactical, propositional speech—abilities that would be so advantageous to survival that they would be universally encouraged and refined by natural selection.

CLASSIFICATION AND CONCEPT FORMATION

N. K. Humphrey claims that in the course of evolution there would have been very strong pressures on animals to perform techniques of classification—that is, what is good, bad, edible, inedible, and so forth. He notes that an activity as vital as classification was bound to evolve to be a source of pleasure (Humphrey, 1980:64).

Classification or concept-forming ability occurs in a demonstrable gradation, with no abrupt division, from human to ape to monkey; the learning ability of monkeys and apes shows a capacity for appreciating abstract concepts or configurations to a degree far superior to that of any other subhuman animal (Weiner, 1971:70). Undoubtedly present even in *Australopithecus* (whose brain had an inferior parietal lobe, thus making it capable of rudimentary spontaneous conceptual thinking and abstract causal thinking—d'Aquili and Laughlin, 1976:166),[7] the ability to abstract or generalize would have been progressively developed alongside the other characteristics with which we are here concerned in the evolution of modern humans. Among these, human speech and

communication, as was described, promoted a considerable expansion in the brain, not only of the motor speech center and of "input" or "feedback" sensory centers and connections to make possible the range and expressiveness of speech, but also of the coordination and association areas that allow vocal or visual symbols to be recognized and classified (Weiner, 1971:69)—what can be called the "interpretive cortex" (Young, 1974:487).

Jerome Bruner has pointed out that as human beings increased their store of knowledge, it was necessary to develop linguistic ways to represent and preserve this knowledge in a fashion that would be helpful outside its immediate context of initial use. This was accomplished by means of conceptual "systems" whereby means and ends could be associated and the absent, the invisible, the possible, the conditional could be thought and talked about (Bruner, 1972:701–2).

Certainly the ability to contemplate the existence or possibility of existence of objects and events that are not immediately present—to be aware of time past and future,[8] to imagine and invent, to speculate and suppose—is essential to the complex kinds of mentation that we consider to be distinctively human.

SYMBOLIZATION

Inseparable from abstract or conceptual thought and language is the ability to symbolize, to recognize one thing as standing for or representing another. The capacity for learning symbolic associations is great in chimpanzees, as has been demonstrated by their spectacular success in learning sign language, as well as in other experiments where they correctly used plastic shapes and designs that had been assigned an arbitrary meaning. The capacity to attach special value to objects or images because of their relationship to others or to oneself (because they "stand for" something else) is essential in art, and this ability may be seen in rudimentary form in primates and small children, as for example when they appropriate an object that "stands for" someone or something else that is significant to them.

Symbolizing is itself an ability capable of degrees, and is not dependent on language (Premack, 1972). From the recognition of simple association between one thing and another, to the acceptance of an arbitrary symbol as standing for or referring to a thing, to the concentration of a community's vital concerns in a compelling and socially shared symbolic object or event, to the ability to operate entirely by employing symbols, as in abstruse mathematical equations, humanity has developed and become what it

is because of its dependence on and predilection for using symbols.

SELF-CONSCIOUSNESS

J. Z. Young has suggested that as language developed, the ancestors of humankind undoubtedly began to employ the symbols used to indicate the actions of others to refer to themselves. Animals of course recognize others, but the critical human stage was "the acquisition of the power to make symbolic representation by language of concepts indicating the distinction between self and other. This allows expression to oneself as well as to others of the experiencing of the self and of the world, which we call being conscious" (Young, 1978:39). Chimpanzees, it has been discovered, recognize themselves in a mirror. But it would seem that no chimpanzee *knows* that he is aware of himself.

The ability to represent oneself to oneself as a self would seem to require a complex cognitive apparatus as well as a great deal of social intersubjectivity—being able to imagine oneself in another's place. John Crook (1980) posits that increasing intellectual powers allowed more subtle modes of social interaction (e.g., reciprocal altruism, exploitation of others and the ability to detect exploitation by others, empathy, comparison of the self with others) which fostered this kind of self-realization.

The consciousness of self is itself capable of degrees, and it is suggested that the development of the capacity for highly abstract thought (as in Buddhist *mindfulness* and in what Piaget calls "formal operations") leads to what could be called a meta-self-consciousness, in which the self may be deliberately objectified and considered in a highly detached, analytic way. This type of self-consciousness is relatively rare, and should not be confused with the universal human awareness of self as a created entity, one that was born and which will die, and is aware of its awareness.

THE CREATING AND USING OF CULTURE

The behavior of animals is largely determined by genetically controlled mechanisms, so that their responses are more or less automatic. While it is true that human beings also may react automatically to threatening or submissive or sexual or infantile postures and signals, these are much more under control by the brain than their counterparts in other animals, and with "will power" or other culturally fostered restraints can be resisted or even controverted. The sexual behavior of dogs or monkeys is much more stereotyped, irresistible, and genetically regulated than ours, and

one can say that being more determined it presents fewer problems as well as fewer avenues for the rewards of choice and deliberate elaboration.

We are born with a genetically influenced readiness to do certain things—for example, to learn a language, or to care for babies, or to join in pairs or groups with others. At the same time, the "program" is labile in the sense that we still need to learn, within a cultural tradition, specific ways of doing them. A particular genetic predilection such as language or sociability will not manifest itself successfully in a human being who is deprived of immersion in a culture, which may be described as a world-picture that is shared, tacitly and overtly, by a group of people—a picture that explains the experienced world to them satisfyingly, coherently, and compellingly.

The importance of the interaction between the development of the need for culture and the evolution of the brain cannot be overstressed. The genetically controlled attributes of early humans (such as bipedalism, carnivorous habits, prolongation of immaturity, cortical control of behavior, brain structure and size) and cultural components that were acquired nongenetically (e.g., tool using and making, symbolic communication, socially sanctioned rules regulating inter- and intra-group conduct) would have evolved together, mutually reinforcing each other. Changes in each of the genetic characters would have induced changes in the components of culture, and conversely progress in the latter would have stimulated further development in each of the former. As we saw in the discussion of the making and use of tools, these were "feedback" mechanisms which themselves were products of evolution (Weiner, 1971:77).[9]

Human beings can pass on their cultural traditions of behavior through conceptual thought and verbal language much faster than these behaviors could be transmitted through the slow-paced methods of phyletic evolution. In a sense, even a culture's traditions develop through "natural selection," but on a psychosocial rather than genetic basis.[10] Cultures evolve and change not through physical or genetic mutations and recombinations but by retaining, reintegrating, or deemphasizing randomly arising habits and customs. Social customs, like biologically evolved structures, are adaptive; because certain norms and rites are more suited to a particular way of life than others, they, and not those others, have persisted. However, the loss of a particular *cultural* behavior does not mean it is necessarily gone forever. It remains as part of the potential reservoir of the species, and may variously re-

emerge whenever external circumstances and the dominant dynamic of social interaction change, warranting other options. Only when the *genetic* basis of a particular form of behavior is discarded is that expression permanently lost.

What the cultural-social mode of behavior allowed the evolving human animal was the chance to risk, test, and appropriate new ecological options, novel means of hierarchic control (of self and other, group and environment) *without* becoming irrevocably committed to these alternatives. The cultural behavior patterns that progressively persisted were, in our long prehistoric phase, ones that accorded with (indeed exemplified) developing human biological nature. The genetic changes in our precursors reflect the progressive commitment to and consolidation of these ecological and hierarchic achievements, the biobehavioral lability, the sociocultural mode.

SOCIALITY

Male chimpanzees competitively perform a type of attention-demanding behavior or display to which other chimpanzees react not with counteraggression, appeasement, or avoidance (the usual responses to aggressive display) but rather by enhanced socializing, including play. Michael Chance and Clifford Jolly (1970) propose that the term "hedonic" be used for the mode of behavior to which such social solicitation leads. Whereas agonistic displays produce stereotyped and antisocial responses, the animal displaying hedonically fosters associative rather than disruptive behavior in its fellows and promotes "ongoing but flexible social relations which can act as the medium for the dissemination of information within the society" (Chance and Jolly, 1970:177).

Chance and Jolly's "hedonic mode" illustrates how our primate heritage encouraged behavioral mechanisms that enhanced socialization. Individuals competed to be regarded as socially desirable perhaps as much or more as they competed to be thought of as tough. It is cheering to learn that information can be passed throughout a society by fun as well as by fiat and that advertising one's amiability may be as natural as flexing one's muscles.

Certainly the human way of life requires sociality. To get the things needed to keep alive we must cooperate with other people, and—unlike, say, desert rodents or adult male elephants—the whole pattern of individual human lives is organized around social activities.[11]

Noting that the most intellectually gifted animals (e.g., gorillas, elephants) seem to lead lives that appear technically rather un-

demanding, N. K. Humphrey (1976:307) has proposed that the creative intellect—the ability to respond appropriately to novel circumstances—has evolved less for practical than for social ends. In the unpredictable life of highly social animals it is important to calculate the effects of one's own behavior as well as the likely behavior of others, to sympathize, bargain, outwit, placate, deceive—social skills that require not only accumulated knowledge but the ability to assess possibilities and plan for contingencies.

The long period of childhood in the human animal has been recognized as an evolutionary adaptation to allow not only enculturation and the learning of skills that will be needed when adult but also socialization. While adults look after his or her vital needs, the child is able to experiment, imitate, explore, pretend—to engage in all the manifestations we call "play." All these activities help it learn how to participate socially as well as practically in the cultural group.

Sociality is so important to our species that human beings are defective if they do not receive certain essential social nutrients, particularly in infancy and early childhood, and to a degree throughout life. Humans are born with a need for regular and mutual affirmation and certification; in normal circumstances this need is met first by the mother, and to a lesser extent by other familiar individuals.

One could say that in many primitive societies childhood dependence on the mother is transmitted into adulthood dependence on the group and thus essentially never ends. The individual is never encouraged or helped to detach himself from the collective that formed him; if this should occur, as has happened recently in societies suddenly experiencing modernization, he feels acute distress. It has been remarked that it seems to be a fundamental need of humans to feel "the psychological comfort of belonging to a tribe, of experiencing even for a short while the warmth of tribal, communal life in huge anonymous gatherings, the unity of oneself with other human beings" (Dubos, 1974:57); certainly it seems likely that early social experience would predispose humans toward communal rather than solitary pursuits. Indeed, it is probably only in our own society that it is not considered abnormal to frequently prefer and willingly choose to be alone.

Selection has favored certain behavioral manifestations that facilitate sociality. The infant's smile, for example, "releases" protective and fond emotion in whoever witnesses it, especially the mother, and smiling becomes one of humankind's most potent

Grandfather and grand-
daughter, East Sepik Prov-
ince, Papua New Guinea

social and communicatory mechanisms. The mutual enjoyment of each other's presence is one of the most important ways in which social interaction is rewarded and perpetuated, and it has its prototype in the infant at its mother's breast.

The deep-rooted human emotional "need" for communication and communion, which is a vestige if not a prolongation of our early dependence on others, impels much of our achievement, and can be considered along with the long immaturity that accompanies and reinforces it as one of the greatest assets of our species in that it has led to our present evolutionary "success." Yet some have bemoaned humans' apparently irresistible biological urge to belong, to attach oneself to a person, a group, an idea or belief that is impervious to reasoning—to transcend the claustrophobic confines of one's self (Koestler, 1973:53). It is evident that this urge or capacity is at once the source of what we feel to be our richest blessings and our most craven despair—the best in humankind as well as the worst.

COMPLEXITY OF AFFECT

In attempting to account for the evolutionary success of human beings, it is usual to cite, as has been done above, their special and complex cognitive abilities. It is important also to remember that human beings are endowed with a complex emotional life, as well, and that far from being mere concomitants of neural activity, emotions (or "affects," which are the subjectively experienced aspects of emotional processes) themselves are integral to behavior.[12] Darwin himself recognized this interdependence, and no one disputes that mental or psychological aspects of behavior cannot really be separated from physiological aspects, nor emotional from mental activity.

As human beings became less dependent on reflexive and instinctive responses, they became more responsive to the way circumstances made them feel. Or—put the other way—as they reacted to their positive and negative feelings about their fellows and their surroundings, they acquired greater flexibility of response, so that one of the supreme and unique characteristics of the human being is his capacity to "feel strongly or weakly, for a moment, or for all his life, about anything under the sun and to govern himself by such motives" (Tomkins, 1962:122). Although emotions may be affected by reflexes beyond conscious control, there are nevertheless many circumstances in which they are joined with reason, deliberation, foresight, and other cognitive abilities, and the result may be passionate clarity, controlled inspiration, informed sympathy, wonder, elation, commitment, ambition—that is, "human" feelings, in which cognitive and emotional strands are combined, that give life color, variety, and significance.

Like human beings, animals defend their lives, exist in proximity with their fellows, and are curious about their surroundings. Our greater complexity of emotion ensures that although we are like animals determined in the larger limits of life, we have considerable choice, lability, and intensity in the way and manner in which we reach these limits and in the felt value that we assign to them.

Because being highly emotional presupposes the potential for instability and immoderation, cultural as well as biological constraints have had to be developed—for example, taboos, or the insistence on certain controlling behaviors (e.g., the British "stiff upper lip," or the injunction against public display of strong feel-

ing in many Asian societies). Yet human motivation is based on a fairly high degree of emotional involvement, so cultures must again somehow ensure the ready availability of the kind of things that arouse emotions and stimulate socially desirable activity. The strength and evolutionary importance of human affect thus require that cultures provide both for its control and its expression. (See also Chapter 6.)

NEED FOR NOVELTY

Earlier the human need for order was discussed; equally intrinsic to the human being appears to be the search for novelty or excitement and the evasion of monotony and boredom. This need may seem more pronounced in Western people than in other members of the human family, but it appears to be a natural and universal general proclivity. Comparative psychologists have found that in almost every species studied, animals will work to be exposed to novel sensory stimuli (Humphrey, 1980:65).

Both human and primate young show "neophilia" or attraction to the novel. Even from birth, the human infant begins actively to seek sensory and cognitive stimulation. In humans and in some animals, mild fear and frustration may even be welcomed or sought (White, 1961:302).

It has been suggested that in some instances social evolution may have been accelerated and perhaps even motivated by efforts to escape from boredom. But it seems equally reasonable to explain these changes less as instances of negative escape from boredom than as originating in the positive predisposition to recognize and fabricate the special. Basic, frequently repeated aspects of human existence (e.g., cooking, sexuality) may be given forms that enliven their routine or endow them with spiritual values. Creativity is one consequence of the desire for adventure, even though the corresponding desire for familiarity and predictability is equally strong. The oscillation between these two poles of being and becoming may in itself be creative, at least in certain human beings who because of their dissatisfaction engage in self-searching and external exploration (Dubos, 1974).

Following the discovery of a "pleasure center" in the brain and subsequently the dramatic disturbed psychological reaction to sensory deprivation, it has been suggested that the human need for novelty is based on a requirement of the limbic system in the brain to be maintained in a state of electric activity (stimulation) (Campbell, 1973). Whatever the cause for the need for novelty,

one of its effects has been to ensure that after a certain degree of physical comfort has been achieved, human beings tend to be curious and easily discontented.

ADAPTABILITY

Adaptability is itself an adaptation. The ability of organisms to tolerate variation and to adjust to it is most certainly a product of evolution, and in turn "adaptability" itself leads to evolutionary success. The human being has been called an "opportunistic mammal" and a "generalist animal," and our ability to cope with and even seek out unfamiliar situations is highly developed. As human groups spread over the earth, encountering new and often hostile environments, flexibility in behavior—rather than knee-jerk reflex responses—would have been extremely advantageous. Enhancing and enhanced by intelligence, adaptability relies on elaborate and complex integrated interconnections in the brain.

MAKING SPECIAL

The uniquely human proclivity that I have called making special (both recognizing and conferring specialness)—apprehending an order different from the everyday—could be added to the list. Allied to curiosity or neophilia and the ability to symbolize, but not reducible to these, the ability to acknowledge specialness (and its hypothetical selective advantage) was described in the previous chapter.

The interrelatedness of these characteristic biological attributes of human beings should be apparent. And each of them has been integral to cultural behaviors—indeed self-evidently so. They have been artificially isolated and described in some detail here so that the following points can be appreciated:

1. They are biological endowments—tendencies and potentials—programmed into every single human being by evolutionary imperatives.

2. In their high degree of development and interrelatedness they enabled evolving humankind to elaborate instinctively acquired behaviors such as play and ritualized activity to a degree far beyond that of other animals in whom these remained essentially stereotyped and automatic. The biologically essential faculties characteristic of the human species have promoted the richness, diversity, complexity, and unique attributes of practices usually thought of as arising solely from cultural differentiation.

3. Art, as we know it and as we are attempting to address it here as a complex behavior, is—like its close associates ritual and play (which also recognize, accept, and manufacture "metarealities")—composed of essential biological attributes and not something of unearthly origin displayed capriciously by individuals or cultures. As such, its evolution will not have been arrowlike and singular but composed of attributes belonging to other behaviors.

The hypothetical account that follows will attempt to weave the various filaments and the features derived from their many combinations into a coherent pattern that depicts the evolution of a behavior of art. We start with the essential filaments first, and describe their contribution to the arts.

Toolmaking and tool use (which may have originated from and certainly would have been enhanced by play) are of course necessary to the dexterity and abstractive power required for making ritual and other crafted objects, and it is often said that one of the earliest human "artistic" acts was to shape tools more than was functionally necessary.

The need for order in humankind infuses all its activities, as does the need for novelty, which manifests itself in curiosity and exploration. Both contribute to the arts, to play, to ritual—indeed to all human activity. They are both the inseparable warp and weft on which the individual progression of every life will be embroidered and the principles that inspire its embellishment.

Symbolization and conceptualization, language and thought are similarly general human abilities that enter into all mental activity and the physical activity it empowers and guides. Whether consciously or unconsciously employed, they are the shaping factors of ritual and the arts.

The culture-creating, culture-using attribute of human beings is a consequence, product, and further condition of their sociality. This essential ingredient of human nature seems to ensure that human beings comprehend their lives and experience in terms of a worldview provided by their culture, finding these significant and full of meaning. The special endowment of our long immaturity and dependence predisposes us to find individual fulfillment in socially shared or self-transcendent experience.

The complexity of our emotional nature means that feeling has a life and importance of its own, and gives color and richness to actions and thoughts that without it would, however complex, be as impersonal and mechanical as the motions of the planets. We equate life with feeling; we act and think and plan because

of the way our actions and thoughts and plans make us feel. From the most primary elementary passions to the chiaroscuro of mature sentiment, feeling is inseparable from life in all its aspects.

The Evolution of a Behavior of Art

It was postulated above that at some point in early hominid evolution, undoubtedly with *Homo erectus* and perhaps even earlier, it became possible to differentiate between artifacts and experiences that were concerned with ordinary daily maintenance and those that for some reason appeared or were made to be special.

It was also said above that the arts (like all human activities and achievements) can be seen as cables or braids made up of interweavings of the various filaments that were just described as integral to human nature. If I can be permitted a complication and extension of this metaphor, it is really more accurate to say that "colored" threads derived from these fundamental filaments are what is woven into the "braids," which are the various arts.

To understand the beginnings of a behavior of art (i.e., what is involved in manifesting the arts), we must combine both the above ideas as follows:

The beginning of art as a behavior can be said to lie in the tendency to make special or recognize specialness, although, as we have seen, it is not always possible, or desirable, to differentiate the arts from the ritual ceremonies in which they often occur. Indeed, ceremonial ritual and specific arts may both make use of the same "colored threads"—such as pattern-making, ordering, making-believe, imitating, dexterity, communicating, persuading—which we can understand as themselves being behavioral manifestations and derivations of one or more of the characteristically human genetically endowed characteristics described above. As these derived abilities developed from the fundamental attributes and were expressed in various contexts, they would become more refined, more integrated in specific behaviors, could be used deliberately in more specifically "artistic" contexts, and appear eventually in essentially emancipated forms.

Picasso is reported to have said: "If it occurred to man to create his own images, it's because he discovered them all around him, almost formed, already within his grasp. He saw them in a bone, in the irregular surfaces of cavern walls, in a piece of wood. . . . One form might suggest a woman, another a bison, and still another the head of a demon" (Brassai, 1967:70). His is the insight

Examples of Paleolithic carved and engraved portable objects of reindeer antler, stone, and mammoth ivory now in the Musée de l'Homme, Paris. Some images seem to have been suggested by the original shape of the material.

of an artist, for indeed the earliest carvings of images appear to have been scratchings of mane, eye, and nostril on bone antlers whose shape without alteration already suggested the profile head and neck of a reindeer (Conkey, 1980).

The ability to see and treat something as something else (e.g., an antler as a reindeer head) is another colored thread, a proto-

type of metaphor, which today we think of as being the essence of art. We have seen how it characterizes play and appears even in young carnivores; it would indisputably have existed in the earliest hominids who would have played as assiduously as any primate. Other behavioral tendencies that were used and developed in play—such as imitating or varying and experimenting for the sake of novelty and the pleasure derived from novelty—would, like metaphor, become available for use in other contexts, including incipient "art."

Similarly, ritualized behavior—with its tendencies to formalize and pattern; redirect behavior from one context to that of another; to emphasize, exaggerate, and distort; to bring together and unify the contradictory or unlike; and to channel emotion—would be a reservoir from which other, potentially "artistic" behaviors might be derived.

Still other potentially artistic elements, such as embellishing, pretending, and metamorphosing, are important in both play and ritualized behavior. Emerging from their original functional nonartistic contexts and augmented by human inventiveness, symbolizing capacity, and so forth, these prototypes of artistic behavior could become progressively refined and relatively independent. Further elements that we now call aesthetic (such as rhythm, balance, ordering and shaping in time or space, improvising) took place and were developed in other practical—even basic—perceptual or physiological contexts before they were used in more specific evolutionarily important behaviors and eventually "for their own sake" in art.

Perhaps it can be said that art, in our species as in the individual child, can be manifested and developed only after a certain stage of maturity is reached. When it appears, it will make use of fundamental, prototypical abilities that were developed in earlier, nonartistic contexts; but when used to make things special, it will begin to give them independence.

If a behavior of art can be meaningfully described and its evolution hypothetically charted, as this chapter has attempted to do, it next remains to ask once more and, one hopes, finally to answer the question we have been tacitly concerned with all along. What was all this for? What did the arts, as individual instances of making special, here gathered together conceptually and called a "behavior of art," do for the evolving human animal? What was art for?

Although we could perhaps now begin to speculate and answer

this question, I will choose to defer it once again until after discussing the emotional aspect of the arts—how they feel. For until now we have treated art as if it were concerned only with performance and activity. This oversight has made exposition a little easier, perhaps, but at the expense of comprehensiveness. For behavior comprises not only action but feeling, and it is undeniable that one of the most characteristic features of the arts is their powerful appeal to feelings. It is now necessary to understand the indispensability of the affective side of art—not only in individual human lives, but in human evolution. For art is not only useful, but pleasurable; and indeed it is primarily because it is the one that it is also the other. After this is accepted and understood we can, at long last, consider what art is (was) for.

6

The Importance of Feeling

Feeling and behavior are inseparable. It is from our emotions that we recognize our values: what moves me is what I seek as good or avoid as bad. Although some would say values are wholly learned, it seems more accurate to say that our biology predisposes us to find pleasure and satisfaction in certain things that are necessary to human survival. Looked at in this way, valued states of mind and body such as self-transcendence, intimacy with our fellows, and making and recognizing order are needs just as much as more "vital" needs for food, warmth, and rest.

The behavior of animals, even though directed by innate drives and tendencies, is influenced by emotion—what is *felt* to be desirable. By making important behaviors enjoyable, selection has ensured that they will be performed. For example, reproductive behavior in humans, as in other animals, is usually engaged in not because we know its result—procreation—is biologically adaptive to the species, but because it is felt subjectively to be individually pleasurable or satisfying.

It is not enough to act rightly. Correct reaction to the beneficent and malevolent actions of others and right responses to the benign and maleficent features of the environment are equally imperative. Along with active social-individual behavior, selection favors appropriate social-individual responsiveness to these behaviors, and the two—action and response—evolve together.

This "feedback" procedure can be illustrated by analogy with a genetically controlled ritualized behavior in human beings—the infant's smile. As we are all aware, the baby's smile brings an immediate response of affect to its mother (and indeed to everyone who sees it). One can argue that this is a mechanism that

was encouraged by natural selection, that babies—who can be considered as a liability with their almost perpetual needs and demands—had to find a way of captivating their mothers so that they would be willing to go to the trouble that is necessary to look after a wholly dependent creature. The lower animals solve this problem almost entirely with hormones; in humans, the smile has developed, and reinforces glandularly affected maternal behavior. But not only did the smile have to evolve, so that special muscles and attachments of nerves were developed to allow it, *the mother's response had to evolve at the same time.* Wiggling the ears instead of smiling might mean the same thing as a smile, but the mother of a baby who rewarded her in this way would not understand it. Presumably there was a readiness in mothers to respond to upward turns of the mouth more than to ear movements; selection could act upon that readiness so that smiling was progressively rewarded by better care, and better care resulted in a preponderance of babies who smiled readily, and so on until the ritualized behavior was well established.

One of the reasons we have presumed that art had selective value is that the arts are pleasurable. Indeed, like babies' smiles, they may evoke intense and quintessential feelings.

But the nature and source of the feelings occasioned by art are problems, apart from the vexed question whether or not there is a distinct "aesthetic" emotion and, if so, how on earth one could describe or explain it. A cross-cultural overview of response to the arts leads to the same disparate array and bewilderment that characterized cross-cultural artistic expression. Purported causes of feeling include the size, opulence, or monetary value of the object, the spiritual power embodied in it, the skill involved in its making, and the status or power of its owner as well as apparent appreciation of more "aesthetic" factors such as form, harmony, or appropriateness. The emotion may appear to be fueled less by the isolated object or event than by sharing the excited response of a crowd, feeling satisfaction at the carrying-out of an important and known practice or observance, or feeling sensual or kinesthetic pleasure, vicarious participation, catharsis, and so forth. Not surprisingly, we find a frequent association of ceremonial ritual and play with the feelings attributed to art, as well as to activities associated with it.

Certainly there are few human groups that might be thought to display the following kind of aesthetic apprehension, described as characteristic of the response to art in some elite circles of contemporary Western society:

One assumes an aesthetic attitude when he perceives an object disinterestedly, sympathetically, attentively, or put differently, contemplatively. In this sort of attitude I direct my attention to what the object has to offer, i.e., as a representation, as a world in itself, and respond to its qualities objectively; I perceive and apprehend them for what they are. I do not allow my own emotional, intellectual, or cultural idiosyncracies [sic] to interfere in seeing, i.e., apprehending, the values pregnant in it; on the contrary, I control, direct my power of awareness, i.e., attention, to respond to all or as much as the object has to offer. For example, if the icon before which I usually pray hangs now in my living room it is possible for me to assume an aesthetic attitude towards it; when this happens I do not perceive it as a religious object but as a representation, i.e., form. I respond to it as a complex of lines, colors, and representations, and I try to apprehend what the unity of these express. (Mitias, 1982)

Once again, the ethological perspective may provide a new, myopia-corrected pair of spectacles with which to view and refocus the disarray. By looking at some simpler and more widely displayed emotional proclivities, we might discover an explanatory kernel that will be relevant to all forms of aesthetic response, not only one peculiar self-proclaimed variety.

Art and the Experience of the Extraordinary

. . . the world is inferior to the Soul. The acts or events of true history have not that magnitude which satisfies the mind of man. Poesie endueth Action and Events with more rareness and more unexpected and alternative variations.

—Francis Bacon (1605)[1]

Intrinsic to the life of all higher animals are two complementary needs—for making order out of experience, and for *dis*order, novelty or the unexpected. These needs, evolved to an unprecedented elaborateness and interconnectedness with other needs and abilities, were described in the previous chapter as being among the distinguishing characteristics of humankind.

In human beings in particular we find highly developed yet another related apparent proclivity, to experience something that is outside order and the ordinary—which we can call the extraordinary. There is an unquestioned human appetite for intensity,[2] and though we can exist without them, intense emotions make us feel that we are living.

Satisfaction of the human need for being *bouleversé*, carried "out

of one's mind," seems to be provided for in most societies and can be traced, in theory at least, back to very early times. One could suggest that where repressed or where not shaped by ritual, it is likely to take aberrant, socially destructive forms.

Acknowledgment of two "worlds"—the ordinary experiences of daily life and other, extraordinary experience—is evident in most if not all primitive societies, and it is interesting that in many contemporary gatherer-hunter societies the "other world" can be entered by means of induced trance. For example, the Australian Mardudjara believe that during special psychic states like trance and dreams important communications are vouchsafed to them by the creative Powers: magical ability may be conferred, or new dances, songs or rites dispensed, and in the Kalahari !Kung, community health, both preventive and curative, is assured by "healing dances," which engender trance states (*!kia*) in which people see God, spirits, and animals (Katz, 1982; Maddock, 1973:110–11).

Indeed, the mental state variously described as ecstasy, trance, or dissociation appears to be an important part of ritual ceremonies and practices in many traditional societies (see also p. 155). This state may be attained by a variety of means including ingestion of alcoholic spirits or drugs, hypnotic suggestion, rapid overbreathing, inhalation of smoke and vapors, music and dancing, mortification, privation, contemplation, and sensory deprivation. According to Peter Freuchen (1961:512), the Eskimos had many methods of slipping in and out of trance, including starvation, thirst, and repetitive rubbing of a stone on ice for hours and days. The state of unconsciousness was so important and familiar that even the children "played" at it, hanging themselves by their hoods, with their friends taking them down when their faces became purple.

A long-accepted means of access to another more intense or spirit-suffused world is through the use of hallucinogenic or other drugs, some of which may therefore be considered to be sacred. It has even been suggested that the ritual use of powerful botanical hallucinogens in conjunction with the practice of shamanism may have been universally practiced in Mesolithic or even Upper Paleolithic hunting societies (LaBarre, 1972:268–79). Many primitive societies of the New World have a shamanistic religion (or show vestiges of having had one) and use hallucinogenic drugs. Unlike the rest of the world, where human beings have been settled agriculturalists or city dwellers for a very long time, these groups in the Americas have a manner of life that is thought to have changed relatively little from that of their Mesolithic hunting

ancestors.[3] In their widespread practices of shamanism and mind intoxication, they may embody a fundamental religious perspective that originated in and perhaps characterized the early period of modern human history. The bird-man or falling sorcerer depicted on the cave wall at Lascaux has been interpreted by some as a shaman in trance (Kirchner, 1952).

Whether or not drug-induced ecstasy or trance was a universal feature of early human society, it is easily observed that modern human beings are attracted to the physical and mental sensations induced by various drugs. More than a century ago, Alexander Bain noted: "every nation has discovered, among the natural productions of the globe, some agent or other, to quicken the cerebral activity, by an action not at all connected with the supply of nutriments. These are the wide class of stimulants, intoxicating drugs, narcotics, which, amid great variety in the manner of operating, have the common effect of exciting for the time the tone of the cerebral and mental life, making all pleasures more intense, and utterly subduing suffering and pain" (Bain, 1859:235).

In the modern Western world, it is usual to consider such drugs as providing an escape from life, rather than an enhancement of it, although William James claimed that the extensive attraction to alcohol was in the first instance "due to its power to stimulate the mystical faculties of human nature, usually crushed to earth by the cold facts and dry criticisms of the sober hour. Sobriety diminishes, discriminates, and says no; drunkenness expands, unites, and says yes. It is in fact the great exciter of the Yes function in man. It brings its votary from the chill periphery of things to the radiant core. It makes him for the moment one with truth. Not through mere perversity do men run after it. To the poor and unlettered it stands in the place of symphony concerts and of literature" (James, 1941:377–78). James, characteristically, looked at the feelings drunkenness releases, and identified what is certainly an important one among the many reasons for taking intoxicants: a wish for intense, extraordinary, if not mystical experience.[4]

Some primitive rituals make no use of drugs to produce trance or possession; psychological suggestibility and the physiological acceleration of excitement seem to suffice. Certainly expectation plays a large part in what is experienced after trance is achieved (Fernandez, 1972:254; Reichel-Dolmatoff, 1972:110). By whatever means induced, ritual ecstasy seems to have been an important avenue for experience of the extraordinary for a great many hu-

man beings throughout our history, and in this state and the means used to achieve it can be recognized prototypes of some of the means and emotional results of art.

Among the Tukano Indians of the northwest Amazon region of Colombia, all visual art is inspired by and based on a ceremonial ecstatic hallucinatory experience that occurs after imbibing *yajé*, a drink prepared from a hallucinogenic plant. In Tukano visual art (large geometric designs or representational paintings that cover the bark walls of housefronts, and are applied on various utensils such as pottery, barkcloths, benches, calabashes, rattles, and other musical instruments) certain decorative motifs are consistently repeated, and the Tukano claim that these are the things they see when they take *yajé*.[5] The appearance of these twenty-odd motifs in the visions of everyone of the tribe suggests that the colors and shapes produced in the individual's mind by the drug are organized or interpreted by him in culturally determined ways (Reichel-Dolmatoff, 1972).

Yet, although the Tukano illustrate an instance in which the visual arts may be directly derived from the experience of the extraordinary, the temporal arts show more interesting and greater similarities to trance-inducing ritual ceremonies. One of the most significant is that both make considerable use of the effect of structure in time. The slow building up in rhythm and intensity, the way the shaman (like some jazz musicians or popular entertainers) "controls" the audience (see example cited in Lewis, 1971:53), and the climactic cathartic release of tension are certainly not dissimilar to some experiences of music, drama, dance, or the recitation of poetry. Even if many ceremonies leading to dissociation or possession are not so subtle or consciously structured as some temporal fine arts of Asia or the modern West, the basic formal principle is the same. In this respect, possession-inducing rituals and the temporal arts resemble each other more than they do jamborees, political and other types of rallies, sports events, television "game shows," and the like, even though all are group events that over a planned period of time incite, release, and display emotion.

Another similarity to temporal art is that trance-inducing ritual ceremony "works" only if the participant knows the rules (Lewis, 1971:186), just as a full response to chamber music or symphonies or poetry or soul music (or ragas or Noh theater) requires prior familiarity with the elements of these arts.

The popular association of madness with shamans, the con-

ductors into ritual ecstasy, is as common and dubious as it is with artists. While it is true that some lunatics are "possessed" and have visions, it is generally agreed that most shamans are no more mad than most artists, and for similar reasons: their activities are their ways of "coping" with their own individual psychic structure and manipulating their audience from the vantage of their privileged status. Shamans rise to the challenge of the disturbing powers, inner and outer; by conquering them they also win over their audience. If genuinely mad they could not do this (see Lewis, 1971:162 for shamans; Rank, 1932:64 and discussion in Storr, 1972 for artists).

It is also the case that in coping with the disturbing powers, shamans disturb them and the regular functioning of society. In addition, in being able to take various vantages and roles they consequently cannot be trusted to be their simple social identities and hence to be unequivocally counted on not to take advantage and not to deceive. The magus deceives minds, and the magician, like the cutpurse, practices sleight of hand. In being deviant they are on the one hand permitted to violate certain social norms while on the other they have correspondingly fewer liens on society and society has fewer liens on them. For shamans, unlike madmen, retribution can occur, especially if they overstep or lose control, thus failing in the claims and limitations of their status.

Mutatis mutandis, the above discussion about shamans may be applicable to artists, not only in popular Western romantic mythology but even in some traditional societies where both are considered to be "outsiders," intimate as they are with "excess." In the Akan of Ghana "this tendency to get violently emotional is common among solo musicians. Hence [some] solo instruments . . . are associated in the popular mind with excesses, particularly with respect to the taking of alcohol, so there has always been a tendency for parents to discourage their sons from learning to play them" (Nketia, 1973:94). It is interesting that among artists in Western civilization, musicians in particular are considered to be marginal members of society.[6] The common belief that music is somehow associated with sexuality has been expressed in literature quite memorably by—to name two writers of eminence—Tolstoy (in *The Kreutzer Sonata*) and Thomas Mann (cf. *Tristan, Doctor Faustus, Buddenbrooks*), whose characters found it to be corrupting, blasphemous, erotic, and devastating. Another form of this association is the barely disguised sexual excitement in the response of ecstatic females to the music of male musical entertainers from Franz Liszt to Frank Sinatra, reaching "possession"-

like pitch in the wild adulation of Elvis Presley, the Beatles, and the Rolling Stones.

The legend of La Vie de Bohème depicts another enduring popular Western conception of the artist's life. The *poètes maudits,* some works of writers like Henry Miller, and the violent "body artists" of today such as Vito Acconci and Chris Burden are a few of many variants on the theme of art as *dérèglement* or deviance.

It is sometimes said that a reason for much violent behavior is the sense of ecstasy it may provide. That many human beings seem to enjoy violence, either directly or vicariously, is well documented. Some societies have recognized and made allowance for destructive, protesting behavior of their citizens, as in Dionysian revels, carnivals, and riotous saturnalia, or have allowed it to find expression and satisfaction in more formalized behavior (e.g., the Spanish bullfight; soccer and football matches). Ritual ceremonies, too, may provide an "escape valve"—overt or covert—for the temporary expression or satisfaction of illicit cravings, of perverse and prohibited wishes.

In times of violence—natural disasters, wartime—ordinary life for a time acquires a dimension of excitement, however terrifying or poignant, that in normal times is lacking. It is significant that individuals who experience these occasions often commemorate them in the future, not only to give witness to the seriousness of their sufferings but to reexperience the heightened sense of personal meaning that permeated the time.

Rollo May (1976) proposes that people in the modern world for whom a sense of personal significance is lacking may turn to individual violent acts in order to feel for a time that what they do has some effect and that they themselves matter. There is, he says, a sort of joy in violence when the individual feels taken out of himself and immersed in something deeper and larger. This is akin to what is felt in ritual ecstasy: a new consciousness, a higher degree of awareness, becomes present, a new self more extensive than the first. According to May, the impulses that drive some people to violence are the same impulses that drive the artist to create. The numerous ends that violent behavior seems to serve— release, communication, play, self-affirmation, self-defense, self-discovery, self-destruction, flight from reality, assertion of "truest sanity" in a particular situation (Fraser, 1974:9)—are very like the motivations that are often proposed to underlie art.

Art and violence are perhaps alike primarily in the fact that both can be considered expressions and agents of feeling. Violence is by its nature shapeless, disorganized, and as such it is

unlike art (as it is normally considered to be). But it does embellish life, and produce for the perpetrator and some spectators—if not always for its victims, though often for them too—a valued sense of intensified reality.

The recognition by most human societies that there are extraordinary emotions and their provision of ways for eliciting and controlling these suggests that human beings have a powerful propensity to attach strong emotions to something they consider to be important (and importance to what they experience as qualitatively and quantitatively intense). In circumstances where nothing seems important, where nothing—ritual or art—shapes their formless flow, these strong emotions will nevertheless be stimulated by or attach themselves to excess or extravagance or the extraordinary in whatever guises these assume.

Sources of Aesthetic Experience in Early Life

Just as the structure of a language by its very nature restricts the conceptual range of those who speak it and therefore are bound to think in terms of its grammar and syntax, so perhaps can it be said that societies determine the general range of emotional responsiveness their members show by the repertoire of acceptable behaviors that they teach and allow (Carstairs, 1966:305). There is a wide latitude in "emotional economy" seen in comparing both individuals and cultures, as for example present-day Eskimos (Briggs, 1970), who aspire to unfailing moderation and equanimity, and more volatile groups such as traditional Eskimos (Freuchen, 1961) or the Cubeo of the Amazon (Goldman, 1964), who consider trance or ecstasy to be a divine state and seek to enter it. The potential to feel and express every known human emotion probably exists in everyone, but what is actually felt or displayed will depend in large measure not only on personal idiosyncrasies of temperament but on cultural expectations.

All human beings share the experience of birth and early dependence, and we can assume that the feelings and sensations of infancy—related as they are to fundamental needs for food, warmth, and care—will be essentially the same for everyone. These universal and compelling experiences of infancy are, I believe, of the utmost importance to aesthetic response, as they are to other subsequent experiences, and I should like to describe some recent thought on the subject that seems relevant to the development of individual aesthetic experience.

ATTACHMENT AND MUTUALITY

> One secret, at least, had been revealed to her, that beneath the
> thick crust of our actions the heart of the child remains un-
> changed, for the heart is not subject to the effects of time.
>
> —François Mauriac, *Thérèse*

John Bowlby has proposed and demonstrated that there is an
inherent appetitive need for the infant and juvenile to form a close
exclusive mutual relationship with its mother or a mother figure,
which he calls "attachment."[7] The mother-child bond has been a
self-evident phenomenon throughout human history; early in the
twentieth century when behavioral psychologists attempted to
explain the nature of "self-evident" behavioral facts like this, it
was proposed that a baby will automatically form an attachment
with the person who feeds it and cares for its bodily needs, be-
cause through "secondary reinforcement" he will associate his
caretaker with pleasure and satisfaction, consider her to be good,
and want to be near her.

Bowlby, a child psychologist and psychiatrist, was acquainted
with the behavior of young children who for one reason or an-
other had been separated from their mothers. He also knew the
results of the experiments with young monkeys that demon-
strated their preference for a cloth "mother" to cling to in un-
certain or fearful situations, even when the wire "mother" that
"fed" them was present.[8] Bowlby postulated that there is a *pos-
itive* need for an attachment figure in human infants, and that
once attachment has occurred it is independent of or unrelated
to whether or not that particular person provides care and ten-
derness and is associated with pleasurable feelings.[9] Indeed,
Bowlby had observed that the young child seeks out the attach-
ment figure periodically in daily life and in times of stress even
when that figure is unloving, and when it is less loving than other
human beings who are nearby. Taking the long evolutionary view
that regards human beings as having been adapted to survive in
small nomadic bands, he assumed that selection would have fa-
vored the survival of young children who had a positive attach-
ment to one protective figure (which in early societies even as
today would most likely be their mother), stayed close to her, and
ran to her without delay when danger threatened. Children who
did not have this propensity—who strayed, or who ran to just
anyone—would be much less likely to survive than those who

India

Chad

Yemen

Senegal

The mother-child bond

did. In support of his claim concerning the power of our evolutionary past, Bowlby points out that young children have a genetically determined propensity to feel fear and seek attachment in situations that would have been dangerous in a feral environment: in the dark, in strange places, at rapid or looming approach, at loud noise, and when alone.[10]

Bowlby contends that the propensity to attachment is an indelible part of human nature, and since we begin life with it, we should not be surprised if it influences later behavior. It is possible that the positive inclination in infants to attach (without the reward of food or other "secondary reinforcement") was selected for not only because it was advantageous to the youngster but because such persons in later life more readily accepted without external rewards the dictates of their social group—that is, were also inclined to find unity with this group rewarding. Certainly we are predisposed toward a social existence—toward finding pleasure and gratification in association with others, in sharing emotion with others, either casually or in communal ritual. In primitive society, it has been claimed, attachment to the mother figure metamorphoses gradually into attachment to the group (Mannoni, 1956:205), and eventual "detachment" was never genetically provided for, though as O. Mannoni has written, "the typical occidental has succeeded in integrating abandonment into his personality" (Mannoni, 1956:206).

Yet to read Bowlby and discover the symptoms of "loss" in children whose attachment is unnaturally broken, one wonders how fully abandonment or detachment can be "integrated," if this means ignored. Anxiety, anger, and withdrawal characterize stages of "adjustment" of the de-attached child, and in various forms they can be observed in lonely, socially deprived adults.[11] It is known, too, that clinically labeled sociopaths frequently were neglected or haphazardly nurtured children.

After reading Bowlby, one has a new perception of the human beings around him—adults going about their business, planning, striving, competing, working, relaxing, enjoying, doing all the hundreds of things that people do. Each of them was of course once a small, dependent child, attached to an older, stronger person. Remaining in that adult that one sees going about his business is a core that resembles that of everyone else—no matter what other differences there are—not a Conradian unknowable and evil "heart of darkness" symbolized by the fearful mystery of tropical, primitive Africa, not Original Sin or polymorphous

perversity, but a universal vulnerability. Criminals, cabinet ministers, colleagues have all shared the same dependence and reliance on a protective figure, an inner propulsion to attach and be safe. In that sense all human beings are alike.[12]

There are culturally fostered and learned as well as biologically determined aspects of attachment. Psychologists have described the temporal patterning of mother-infant interchange in some Western societies from birth throughout infancy, noting that in most cases mothers and babies adjust naturally to each other's individual "styles," and create their own characteristic "dyad" (Stern, 1977; Erikson, 1966). For the infant, learning to respond and to cause response in another is of utmost importance in subsequent development of language and socialization.

In the view of Erik Erikson, biological attachment produces a situation in which psychological attachment can take root and ramify, influenced by the temperamental individuality of the mother and the child and by the social environment in which they live. And this psychological attachment—called by Erikson "mutuality"—is essential to the development of subsequent "psychosocial identity" and inner equilibrium.

Mutuality and attachment can be seen as providing the prototype for, and much of the motivating power behind, later intimate relationships, such as close friendship and sexual union. It is probably not too much to say that the need for attachment (insofar as it predisposes humans to long to transcend their isolate existence and to be reassured that they are not alone) encourages the readiness with which we identify ourselves with suprapersonal ideals, and our capability for experiencing transfiguring and self-transcendent emotion. When emotional responses in later life—in religion, love, or art—are felt to be of this oceanic type, they may be compared with (and their compelling nature derived from) similar blissful states of union with the mother, in the womb or later at the breast.[13]

The impulse to escape or find refuge from an isolate and imperfect reality in transcendent experience is then not to be considered as a weakness or an evasive flight from discomfort and "real life" that is to be apologized for. Rather it is a fundamental consequence and imperative of human biology rooted in our special infant experience whose prolongation makes all our other learned achievements possible. Expression and satisfaction of the longing for transcendence is, if anything can be so described, for humans "the meaning of life."

MODES AND VECTORS

In 1972 the psychologist Howard Gardner published a lucid and bold exploration of underlying affinities in the cognitive theories of Claude Lévi-Strauss and Jean Piaget. In his study Gardner considered how the comprehension and use of symbols might be prepared for in early life, and proposed a model of what he called "modes" and "vectors" of physical functioning that underlie the earliest mental constructions of experience. Modes are "deeply embedded in the biological makeup of the organism [and] constitute the basic developmental matrix out of which more refined behavior and thought evolve" (Gardner, 1972:208). To my knowledge, no one (including Gardner, who has an abiding interest in art) seems to have recognized the plausibility and fecundity of his notion of modes and vectors as a promising model for a truly naturalistic approach to the understanding of aesthetic experience in particular.

In subsequent writings about symbol formation Gardner has further elaborated the notion of modes and vectors. Acknowledging the influence of Sigmund Freud and Erik Erikson, he begins his analysis by recognizing how in the earliest months after birth, an infant's bodily functioning—his somatic experiential states—can be considered to be for the infant the totality of life. In these earliest weeks the nascent human organism fundamentally consists of life-sustaining physiological functions related to drives which themselves imply or presuppose bodily tensions that demand satisfaction (release).

Following a traditional Freudian formulation, Gardner identifies general modes of this physiological functioning: active or passive incorporation (oral), retention or expulsion (anal), and intrusion or inclusion (genital). These *modes* are, in actual experience, instantiated or modified by dimensional or *vectoral* characteristics—that is, by the way in which the mode is realized. It is as if the mode is a verb (or verbal noun) and the vector an adverb describing how it occurs or an adjective that further describes it (see Table 1). That is to say, the specific exercising of a mode involves one or more specific dimensions or vectors pertaining to the way in which the mode has been realized, such as the speed, forcefulness, or conviction with which opening or closing has occurred—readily, reluctantly, widely, narrowly, and so forth.

Gardner suggests that these vectorally realized modes of physiological functioning eventually develop into psychological modes

TABLE 1

Modes and Vectors

Zones	Characteristic Modes	Some Vectoral Properties of Modes
Oral-sensory (mouth and tongue)	Passive incorporation (get, take in) Active incorporation (bite, grasp, investigate)	Speed (quick vs. slow) Temporal regularity (regular vs. irregular) Spatial configuration (wide vs. narrow; curved vs. angular) Facility (ease vs. strain) Repletion (hollow vs. full)
Anal-excretory (sphincter)	Retention (hold onto) Expulsion (let go, release, push out)	
Genital (penis-vagina)	Intrusion (stick into, go into) Inception or inclusion (take into, envelop)	Density (thick vs. thin) Boundness (open vs. closed) Also: directionality, force, depth, comfort, texture

From H. Gardner, *The Arts and Human Development* (1973:101).

of thought, extended and elaborated beyond their original association only with physiology. Gradually, as well, they become molded by cultural frames—given verbal and conceptual labels— and thus circumscribed.

In my view, the primary contribution of Gardner's scheme to our understanding of aesthetic experience is that the primordial bodily experiences (which, as Terence McLaughlin has said, "at the earliest period of our lives . . . *are* our lives") occur before we have any words or verbally mediated mentation to consider them with. Experience literally comes to us *as* open or closed, expanded or contracted, fast or slow, regular or irregular; and, however this is mentally processed and preserved, it occurs experientially in ways that we are not likely to be able to articulate consciously or precisely after we have learned individual words and particular culturally defined ways of discussing, understanding, or explaining them. Later experiences of nonverbal phenomena, particularly the kinds of devices that are traditionally used in the arts, seem especially akin to the processes and qualities of modes and vectors.[14] It is salient that modes are primarily space organizing or configurational (e.g., open-close, extend-withdraw, expand-contract, incorporate-extrude, full-empty) while vectors

have primarily to do with time and quality (e.g., fast, slow, regular, irregular, smooth, jerky, easy, difficult).

Gardner's adherence to a narrowly Freudian model for modes and vectors in my view is a limitation which curtails the breadth of their application. Certainly infants are also aware of quasi-modal-vectoral aspects (of physical "being" if not strictly physical functioning) as contact or proximity and separation; weight or pressure; constriction, resistance, and relaxation (by clothing or confinement); satisfaction and dissatisfaction; active and passive; static and dynamic. Also planes (up-down, head-foot, upright, diagonal, prone, supine) must have their physically associated feeling tones, as well as physical qualities (e.g., hard-soft or warm-cold of bodies, garments, wrappings, objects; sweet-bitter of taste; light-dark of what is seen; loud-soft of hearing; appealingness-unappealingness of smell), or quantities (moreness and lessness), apart from strictly physiological oral, anal, and genital functioning. In any case, I would offer that the genital zone is not normally experienced modally and vectorally as described in Gardner's table (i.e., "intrusion" and "inclusion"), at least until language has been acquired, and that these characteristic genital "modes" themselves when activated will be experienced in terms of earlier incorporation, intrusion, and so forth.

It seems extremely plausible that the year or two we spend as nonverbal and intensely physical creatures must have an enormous residue that carries over into later life, even though we eventually become precise and powerful. The well-remarked "indescribability" of our often most meaningful and emotionally laden experiences could well be at least partly attributable to their striking a preverbal modal-vectoral chord. I also suggest that modal-vectoral associations account at least in part for the "sexual" nature that is often felt to characterize these inexpressible associations and feelings.[15] "Sexuality" (not simply in the narrow sense of reproductive behavior or particular sexual experience, but in the Freudian sense of a kind of libidinous power informing all feeling life) is our "comprehensive" name for feelings of this kind, and it is in our individual sexual life that we experience them most noticeably and densely.

Or we experience them in art: in the shaped expanding and contracting sequences of music, poetry, and dance, their rhythms and contrasts; in the measured extravagance of gesture in sculpture, dance, and drama; in the arabesque of surface and depth in paintings; in the feeling of words in our mouth, their shapes and

weight on our tongue.[16] In all these things our response is immediate, synesthetic, prior to words and concepts. Along with conceptual meaning is somatic meaning, its significance seemingly enlarged because we can find no words for it.[17]

Theorists of a psychoanalytic bent are emphatic about the importance of what is called "primary process thinking" and its influence in all conscious life. Their approach assumes that there is a psychological necessity for keeping ideas in a partly understood form, resisting too clear recognizability (Bott, 1972:280–82). Anton Ehrenzweig (1967) goes as far as to claim that what we respond to in art is essentially the logically incoherent and ambiguous "hidden" meaning behind the formal structure.

Modes and vectors may be equally untrackable to their source, but they possess a tangibility that "primary process thinking" in its vagueness does not, and thus seem to offer more scope for a biologically plausible source for the strongly physical yet undescribable effects that may be aroused by aesthetic appreciation.

There is a close relationship between the child's apperception of the world in terms of modal-vectoral properties and his propensity for attachment. Although according to Bowlby classical attachment does not occur until between the sixth and twelfth month of life, studies of mother-infant interaction have shown essential bonding behaviors beginning right at birth. The intense emotionality of many mother-infant behaviors (e.g., prolonged mutual gaze and temporally contoured interactions of mounting excitement and release, Stern, 1977) combined with the emphatic physicality of the association suggest that later emotional responsiveness cannot help but be colored by this primordial experience. The sensitivity to modal-vectoral properties which would presumably begin at birth or even earlier would itself of course irradiate the formation of mutuality and attachment with multiform associations and perceptions based on physiological and psychological modalities of thought and feeling. Satisfying and pleasant modalities would be associated with intimacy and communion, and would never lose their residue; they would even come to stand for them (as in the well-known substitution of oral satisfactions—as in thumbsucking, eating, smoking—for security or love).

Childhood mutuality and attachment, subjectively perceived in modal-vectoral psychobiological experience, predisposes us toward communion and intimacy which we offer and receive in ever more complex, conscious, precise, and integrated ways, but which at the same time never lose their primordial inexpressible po-

Mother and child, West Sepik Province, Sowanda, Papua New Guinea

tency. We do things *for* others—for their approval, affirmation, or sanctioning of our distinctiveness and valuableness. Art and self-transcendence come together in the experience of the lover who embellishes and makes things special for his beloved, and is predisposed to discern special aspects and significances in everything about him.[18]

149

The Evolution of Aesthetic Experience

Just as the roots of the arts were found to derive from general intrinsic behavioral endowments or "filaments," the primordial sources of aesthetic experience can be said to inhere in reflexive general responses to biologically significant stimuli. As the baby's emotional life begins in its awareness of modal-vectoral properties, one might say that the infant human species first displayed its nascent aesthetic sensibility in reacting to pattern, to repetition, to novelty, variety, rhythmic sequence, intensity, balance, and other effects closely associated with the physiological and psychological processes common to all living creatures. These experiences would have been accompanied by affective overtones attached to their informational meaning—associations that might well have been indissoluble. One thinks of Bowlby's identification of unlearned sources of anxiety in young children as having importance for survival—the fear of darkness, strangeness, isolation, looming movement, fast approach, loud noises. When such elements are utilized even in known contexts (as in ceremonies or, today, works of art), our responses can be reflexive. Even bird songs are faster, louder, and higher in tone when the bird's excitement increases (Koehler, 1972:86–87) and the biological and emotional meaning of a fast tempo is necessarily different from that of a slow one, although the formal pattern remains the same (Platt, 1961:418–21).

While the occurrence in art of such elements would suggest that at least some of our responses are if not automatic then preordained or facilitated by our biology, there is certainly more to aesthetic experience than response to biologically relevant stimuli. In art, loudness and softness or rapidity and slowness are effective not simply in themselves but in a context that is appreciated at least partly at a self-conscious level, and it is misleading to call automatic responses to biopsychological elements "aesthetic."

Yet deliberately considered contexts for the response to specifically aesthetic experience (detached from other considerations) have existed only rarely if at all until the past century in the West. Along the spectrum that stretches from automatic reflex to conscious awareness and appreciation of excellence to detached and self-aware contemplation stretches a vast continuum of human evolutionary history in which ritual ceremony has provided the major occasions for making and emotionally responding to music, drama, visual display, decoration, and the other entities that

today we call art. In the previous chapter were sketched emerging human capabilities that, gradually refined and concentrated, could be used specifically in what are called artistic contexts. Originally, however, these would have been more accurately called "ceremonial" contexts.

One could propose that in humans, ritual ceremony, originally perhaps elaborations of simple ritualized behaviors (as the chimpanzee rain dance seems to be an out-of-context elaboration of male ritualized display and threat behavior), became an activity that had significant adaptive value to the groups that practiced it. A society that performed communal rites that bound its members in common beliefs and values would presumably have been more cohesive and therefore more equipped for survival than one that did not.

We can surmise that early humans, physically weak and mutually dependent, would have felt an increasing need as their intelligence and self-awareness evolved not only to "understand" the mysteries of life but to "control" their world as best as they could. Walter Burkert points out that a concentration and shift of anxiety from reality to a symbolic sphere makes it possible to handle it to some extent (Burkert, 1979:50), in group myth as well as in individual neurosis. Ensuring good hunting, curing illness, and protecting from harm would be major concerns, and as these and other of life's mysteries such as birth, death, and puberty are not explainable or controllable in the arena of everyday life, the idea of another realm where they are to be comprehended would suggest itself—a realm to be approached and affected in special ways, ceremonially. Indeed, an "other world" was already available, at least acknowledged, in play; through need and with developing ability to symbolize, this realm could acquire an impressive and comprehensive reality, supported and elaborated by the penchant for "making special." The careful fashioning of tools and decorating them, the decoration of utilitarian objects, the carrying around of unusual pieces of rock, and the decorating of graves can all be interpreted as manifestations of this desire and ability to make things special, even to sacralize them.

It would have been in ceremonial ritual (as distinct from ritualized behavior) that the activities that we know as art could coalesce, as well as expand and multiply. Ceremony provided times and places for making special, for acknowledging and responding to specialness, and for binding and unifying the persons who took part. Ceremonies made use of the skills and attitudes that originated in isolated instances of recognizing specialness, but en-

couraged their coordination and refinement, and gave them occasion to diversify and flourish.

But one can ask why ceremonies so often evolved into long complicated affairs that required elaborate preparation and execution when a few words and actions would presumably have been more efficient, leaving primitive humans with more time for daily maintenance activities or for rest.

If asked, a member of the society might say that its ceremonies are long and complex because that is the way they must be performed in order to be effective. But an evolutionary view will maintain that longer ceremonies, whatever their participants thought was their reason, more effectively promoted group solidarity than did quick, perfunctory observances. Redundant, memorable experiences would better teach and express and reinforce the values and beliefs of the society and perpetuate knowledge that was essential for group maintenance and survival (Pfeiffer, 1977;1982). Yet, at the same time, a way had to be found that would encourage people to want to engage in these time-consuming and often arduous performances rather than in shorter, less socially advantageous ones.

An important way would have been the incorporation of what we today call aesthetic elements. Activities that are suffused with bodily, sensual pleasure are likely to be repeated, and investing necessary but routine acts with pleasure would increase the likelihood of their being performed. Even for the Mbuti pygmies who do not display much ritual ceremony, singing and dancing are highly regarded and frequently engaged in, socially and individually, for entertainment. Although the singing and dancing do not accompany structured ceremonies, their reinforcement of sociality and the pleasure they engender are unmistakable.

Making socially important activities gratifying, physically and emotionally—this I would claim is what art was for.

What Art Was For

In *Preface to Plato*, Eric Havelock provocatively discusses Plato's famed and puzzling banishment of poets from his Republic. Havelock reminds us that fourth-century Greece was not what we would call a literate society, and that poetry for Plato was accordingly not what it is for us, words on a page, but an oral performance.

In Homeric Greece, as in prehistoric societies generally and in preliterate groups today, political and social institutions were nec-

essarily transmitted and preserved in an oral tradition, a memorized "encyclopedia" of the information that was considered to be essential for the perpetuation of the group. As the only repository of information, poetry had to be a system of indoctrination and therefore be, quite literally, memorable. Accordingly, the task of remembering accurately the body of experience—history, social organization, technical skills, moral imperatives—that was contained in an oral narrative could only be accomplished by conjoining physical with mental capacities. By organizing words in vivid and compelling verbal and metrical patterns and reinforcing these by bodily movement, rhythmic beats, and musical accompaniments, a kind of total personal involvement and emotional identification with the oral performance would be evoked and assist memorization.[19] To the Platonic or literate temperament, of course, such a state of mind would be considered irrational, an obstacle to clear, analytic thinking, and hence to be vigorously repudiated as an instrument of education.

Havelock's reconstruction seems an apt and illuminating one, for it shows how bodily pleasure felt as emotion could have accompanied activities which—though they would be called "art" today—in their historical context as ritual and entertainment served numerous social functions, including the promotion of group unification or one-heartedness, the recitation of important knowledge, and the reinforcement of group values.

The nine Muses (daughters, it will be remembered, of Mnemosyne, memory) can be understood, in Havelock's view, as separately representing different aspects of a single technique, a set of psychosomatic mechanisms exploited for a very definite purpose. Goddesses of heroic poetry, history, love poetry, music and lyric poetry, tragedy, sublime hymns and serious sacred songs, dancing and choral song, comedy and idyllic poetry, and astronomy, they together encompassed history, religious ritual, and cosmology, as well as the arts of poetry, song, and dance.

Havelock's account seems a plausible one, whether it is accurate specifically for Homeric Greece or in fact was developed earlier, say in Magdalenian times. One could surmise that such oral recitatives as he describes would have begun more simply at a much earlier date, and the penchant for ceremonial behavior earlier yet.

In fact, John Pfeiffer (1982) has claimed quite credibly that the paintings and other visual marks in Paleolithic caves are surviving evidence of rituals which not only helped to establish the authority of those who controlled the elaborate rules but also en-

coded and presented parts of the programs in unforgettable ways. This, he proposes, was an adaptive necessity because at the time the volume of information to be transmitted from generation to generation had become in some human societies so large that some kind of indoctrination system was needed. Special encoding and dramatic mnemonic systems had to be devised to make the information more easily and accurately assimilable; what we see in the caves is the residue of what was a planned multimedia event designed to impose upon individuals unforgettable patterns of tribally essential knowledge and explanation.

It is not unlikely that *Homo erectus* and even earlier hominids could have been predisposed toward "ceremonial" behavior in circumstances that elicit it today in humans. Regarding the chimpanzee rain dance, Laughlin and McManus (1979:104–5) hypothesize that because it uses features of aggressive display, it might be considered as serving to orient the action of the group toward possible danger, and the chimpanzee can be said to acknowledge a "zone of uncertainty" to which this display is a response. The same authors also postulate that even *Australopithecus*, with greater brain corticalization than the chimpanzee, would be capable of conceiving of entities and relations beyond immediate perception. Hence they would have been additionally likely to direct "complex, conceptualized and probably even symbolized ritual behavior" toward what was perceived as a zone of uncertainty. Laughlin and McManus also speculate that there may have been seasonal ceremonial gatherings of *Australopithecus*, dependent on fluctuations of food availability—and perhaps even primordial *rites de passage*, and role or status rituals.

Havelock's account accords with what we have earlier surmised about the psychological, environmental, and social characteristics of early humans. The use of ceremonial ritual as an aid to memorization and identification of relationships in the environment can still be observed in preliterate groups, as for example in Australian aboriginal societies,[20] and to transmit tribal genealogy, cosmology, values, and cultural axioms in the Ndembu of Zambia (Turner, 1974:239), the Gelede spectacle in the Yoruba of Nigeria (Drewal and Drewal, 1983), and the *bwami* association of the Congo Lega (Biebuyck, 1973). Poetry in twentieth-century oral societies makes use of such devices as alliteration, assonance, parallelism, chiasmus, and repetitive formulaic song units to enable listeners to remember and repeat traditional tales, and to enable composers to produce new, rememberable songs (e.g., Lord, 1960; Damane and Sanders, 1974; Emeneau, 1971; Strehlow, 1971).

The fact that in an ethnographic survey of 488 human societies some 89 percent showed a form of institutionalized trance or dissociation experience (Bourguignon, 1972:418) would suggest that selection has favored this emotional proclivity. One could propose that groups whose members did not have the capacity for achieving ecstatic possession or some form of self-transcendence would be less cohesive and therefore less evolutionarily successful than groups where individuals periodically were touched by the extraordinary and could feel their one-heartedness confirmed in a numinous, momentous, emotional "totality" experience, as in the Fang of Gabon (Fernandez, 1969) and similar communities that today face massive social change and uncertainty. Where ecstatic rituals are performed, it is said, the ritual experience helps individuals endure otherwise intolerable pressures by lightening their force, suggesting that they are being controlled and coped with (Lewis, 1971:204–5). This would have been no less true millennia ago than today.

The foregoing hypothetical reconstruction emphasizes that it is not only art considered as a collection of activities ("the arts," instances of making special) that can be said to have had selective value. *Our responses to the arts (aesthetic experiences) are of equal and intrinsic importance.*

For only if socially facilitating ritual ceremonies were enjoyable would they be likely to be performed.[21] Selective pressure would act to reinforce the tendency to incorporate into ritual ceremony elements that pleased and satisfied human senses while at the same time reinforcing the readiness of humans to respond to them positively. Discrete and uncoordinated responses to pleasurable sensuous stimuli would gradually but progressively be molded into more affective sequences. As ceremonies developed, they would not only make use of emerging abilities but would stimulate and satisfy more complex feelings.

In a feedback process reminiscent of that in which the baby's smile developed along with the mother's responsiveness to it, humans would have developed, over time, a greater-than-usual liking for aesthetic elements, just as their rituals would have developed a greater-than-usual reliance on them. This circularity would strengthen the ability to manipulate and respond to rhythm, temporal and spatial shape, repetition, variety, and so forth (what came much later to be elements used in independent arts), as well as the social effectiveness of the ceremonies in which these elements were used. The refinement, elaboration, and development both of the sensually pleasing elements in rituals and humans'

responses to them proceeded as a natural evolutionary process, leading to the ability at a much later stage of more detached aesthetic experience.

In an ethological-evolutionary sense one could say that the elements or activities that today are varieties or ingredients of the arts and our strong emotional responses to them can be called *enabling mechanisms* (Wilson, 1978:199) for evolutionary fitness and survival. They were evolutionary means to promote selectively valuable behavior (in this case, ceremonial ritual).[22]

It would seem that it is only as enabling mechanisms that art and the arts can be said to have had selective value. As we learned in Chapter 3, those who have claimed that art is necessary are thinking of one or another aspect of one or another of the arts (e.g., embodying order, permitting make-believe, allowing irrational or immediate experience, and so forth)—and these aspects are to be found in nonaesthetic parts of experience as well.

It seems safe to say that what is usually thought of today in advanced Western society as art and aesthetic experience—a disinterested response to an object or activity for its own sake, or the making of such objects—would not have been selected for in human evolution. In the first place, there has not been time enough for persons with this proclivity to have any effect on the common *Home sapiens* gene pool. Moreover, selection would not have favored nonfunctional proclivities: an art that is truly for its own sake would have to be by definition not (except perhaps fortuitously) *for* the sake, evolutionary or otherwise, of anything else at all.

Aesthetic Experience Now

The previous discussion has left a number of rough edges projecting uncomfortably. If the thesis is correct—that independent, autonomous, aesthetic creation and response are evolutionarily superfluous residue from the activities and feelings that originally accompanied and reinforced selectively valuable ritual ceremonies and other social behavior—how can we explain that some human beings are (and always have been) more endowed with artistic talent or aesthetic sensitivity than others? Without a "latent aesthetic impulse" (see Chapter 2, p. 42) operating throughout human evolution, can we explain how it is that works from traditional societies and from the past may so magnificently reward detached aesthetic contemplation, even though they were made without the intention to provoke or sustain such contem-

plation? Another problem is to explain how modern detached aesthetic experience can possibly be thought to originate in communal ceremonial responses which are so apparently dissimilar.

A useful study for understanding modern aesthetic experience by Marghanita Laski (1961) analyzes reported accounts of "deeply felt, transitory, transfiguring, indescribable states of feeling" and the circumstances in which they occur. Examining fifty written accounts by persons who had experienced these states and described them (either in religious mystical writings or in other forms of literature) and interviewing sixty persons of her acquaintance, she analyzed these experiences (which included responses to works of art) in a number of illuminating and interesting ways, which unfortunately are beyond the scope of—though not without fascinating application to—this discussion. Laski called these states "ecstasy" and defined the word as referring to "a range of experience characterized by being joyful, transitory, unexpected, rare, valued, and extraordinary to the point of often seeming as if derived from a praeternatural source" (p. 5).

Laski found that the words used by ecstatics (the term used to refer to persons who have recounted an experience of ecstasy) to describe their experiences are remarkably similar, as are the individual feelings these words suggest. For example, in ecstasy people report feeling a loss of such things as their sense of difference, time, place, limitation, worldliness, desire, sorrow, sin, self, words and images or both, and sense (p. 17).[23] They feel that they gain unity or "everything," timelessness, an ideal place such as heaven, release, a new life or another world, satisfaction, joy, salvation and perfection, glory, contact, mystical knowledge, new knowledge, knowledge by identification, and ineffability (p. 18). Quasi-physical (as opposed to mental) sensations that are reported are expressed in words and phrases that suggest "up," "inside," light or heat, dark, enlargement and improvement, pain, liquidity, calm, and peace. The shades and ranges of the feelings and their descriptions in Laski's book are rich and illuminating and should be read, not summarized. Because of these similarities, Laski assumed that people in the three groups were referring to feelings that can, for many purposes, be treated as similar to each other and different from other kinds of feelings (p. 38).

Laski posits three "stages" or varieties of ecstasy. The most common, called by her "*adamic*," occur when life seems joyful, purified, renewed. Descriptions of these ecstasies imply feelings of new life, another world, joy, salvation, perfection, satisfaction, and glory (p. 103).[24] Adamic ecstasies do not produce feelings of

"having made contact" or feelings of creativity or knowledge gained through this contact as in *"knowledge"* ecstasies. In this second variety of ecstasy are included experiences where knowledge of God or Reality is felt to have been imparted, whether this knowledge is communicable or not (p. 117). It may be knowledge of "something," or, more commonly, of "everything." Usually the more complete and incommunicable the knowledge, the "better" the ecstasy seems to have been. In the third variety of ecstasy there is a sense of *union,* a complete or almost complete loss of sensibility coupled with a feeling afterward that any contact that was made was complete (p. 92).

Laski found that the circumstances that preceded and appeared to cause the ecstatic experiences of 95 percent of the persons she interviewed could be placed under eleven headings, which were subsequently found to be common in the written accounts of ecstasy as well. These circumstances, which she termed "triggers," included natural scenery, events, and objects; sexual love; childbirth; certain kinds of exercise and movement; religion; art; scientific or exact knowledge; poetic knowledge; creative work; recollection or introspection about something (often one of the above) not physically present at the time; and "Beauty"; there were as well an assortment of miscellaneous circumstances (p. 17).

The frequencies of the triggers named varied among the three groups and between men and women, but nature, art, and sexual love were at the top of the lists of both men and women of the personally questioned group, nature and art in the literary accounts, and nature in the religious writings. The characteristics of the feelings described for ecstasies induced by the different triggers differ in certain respects, which I do not have space to summarize here. It seems, however, that ecstasies induced by nature and religion are most similar to each other.

It is suggestive that music was the most frequently named art ecstasy trigger, and other frequently listed triggers (poetry and drama) are also arts that occur in time. Music in fact was named thirty-five times (and poetry, eighteen), while painting and sculpture together provided only nine instances of ecstasy. The predominance of the temporal arts in inducing ecstasies would support a claim that at least some modern aesthetic experiences could be derived from the evolved capacity to experience self-transcendent ecstasy in temporally structured communal ceremonies.

Other parallels between the Western accounts of ecstasy treated by Laski and what is known about self-transcendent states in traditional societies deserve further study in order to bear out the

contention that the two types of experience may be forms of a common human behavioral proclivity.

For our purposes, however, we can dwell on the perhaps more obvious differences, for these point up the theme of the following chapter, the ways in which modern Western aesthetic sensibility differs from the rest of humankind.

Apart from the fact that modern ecstasies almost without exception take place privately and traditional ecstasies usually occur in group ceremonial settings, the frequencies both of numbers of people who experience ecstasy and the numbers of times individuals have such experiences vary dramatically between traditional and modern people.

Among the people that Laski questioned, half had experienced ecstasy fewer than ten times (and one-third of these said once or twice), 38 percent had experienced it more than ten times (two-fifths of these said twenty-five or fewer times), and only 12 percent reported ecstasy in the hundreds or "constantly." In discussing the latter finding, Laski suggests that persons who report frequent ecstasy are including "lower" (adamic) levels of ecstasy or "response experiences." She concludes that any ecstatic experience is relatively or very infrequent.

Not only was the experience rare, but only a rare person was likely ever to experience it. Laski found that the ability to enjoy adamic ecstatic experience was widespread among "intelligent, well-educated, and creative people." The "higher" ecstasies were experienced, if at all, once or twice in a lifetime and also tended to be confined or to be more common among those people with "developed intellect or creative capacities."[25]

The first reaction to such a claim is incredulity, and the suspicion of an unconscious elitist bias in the study. To be sure, Laski's sample contained only advantaged, articulate people, educated enough to describe their experiences in books and to be among her associates in London intellectual society. Still she found that children (advantaged children) had primarily adamic ecstasies, which suggests that "knowledge" or "union" ecstasies, in Western society at least, *are* experiences accessible only after a degree of psychological or physical maturity is reached.

How can this conclusion be explained? Persons (including children) in societies where trance or dissociation is institutionalized may experience the state frequently (e.g., F. Huxley, 1966; Katz, 1982; Belo, 1960; 1970), even without the aid of drugs. These, however, cannot be described as persons with "developed intellect or creative capacities" in the same sense as Laski's highly

literate and educated informants. Even if we forgo a detailed comparison here of traditional and modern ecstasies, what are we to make of her conclusion about ecstasies of the British upper and lower classes? Perhaps less articulate people in modern societies *do* have ecstasies but do not recognize or know how to describe them.

A biologically grounded view that is concerned to delineate a universal behavior of art must try to understand the way in which the sentiment of the coal miner's wife who pins a calendar reproduction of kittens to the mantelpiece is similar to and different from that of the connoisseur whose walls are bedecked with original paintings he has himself carefully selected. Is the rapture the dowager feels at the matinee performance of Chopin Ballades the same as the experienced listener's response to the Adagio of the Hammerklavier Sonata? After all, our hunger is satisfied by chateaubriand or hamburgers, our thirst by champagne or Coca-Cola—not to mention bread and water. If there are apparently rarefied appetites and tastes inaccessible to most persons, a human ethologist—who champions the universality of behavior—must try to explain how and why such a circumstance could come about.

Consideration of this problem leads to important and interesting observations that may not only assist our understanding of the observed differences in aesthetic responsiveness in individuals but support my suggestion that modern private aesthetic experience could have evolved from a prototypical communal ecstatic response to ritual ceremonies.

If it is agreed that art and aesthetic response could have evolved as described in the previous and present chapters, it can also be allowed that in due course would appear a *tradition* according to which the stories, verses, songs, dances, musical compositions, masks, adornment, costumes and so forth would be made (or performed) and appreciated. It is with the appearance of tradition that along with undifferentiated reflexive or elementary aesthetic response another kind of response to aesthetic phenomena could begin to develop. Tradition, a body of accepted and acceptable ways of performing the activity with its own rules or code,[26] would require that at least some persons appreciate the *way* in which the requirements were met, paying attention to skill, beauty, artfulness.

Thus in primitive groups we find, for example, that what can be called aesthetic distinctions are made between a "good" and a "well-told" tale (Vaughan, 1973), an appropriate and an inappropriate combination of self-decoration and attire in a costumed

display (Strathern and Strathern, 1971; Drewal and Drewal, 1983), or a functionally adequate and an artful resolution in a legal dispute (Fernandez, 1973). Members of groups will be familiar with the established code within which acceptable carvings, dances, versifying, and so forth are produced and will learn to recognize which of these are "better" or more artful as they use or abuse the elements of the code. Thus Australian aborigines (Berndt, 1971), the people of Alor (Dubois 1944), tribesmen of West Africa (Thompson, 1973; 1974; Gerbrands, 1971; Fernandez, 1971; Child and Siroto, 1971; Drewal and Drewal, 1983; Keil, 1979), and the Sepik River (Linton and Wingert, 1971), and many others are prepared to say that one work or one artist is better than another work or artist, and why.

Yet there is, as we know, in many unmodernized societies not much encouragement or opportunity to develop the appreciation of variations and qualitative differences in elements of codes for their own sake, nor for a high degree of "creativity" or innovation to be practiced by individuals. In primitive and traditional societies it is usually in the minor arts (e.g., pottery, storytelling) not directly joined to power and religion that novelty and variation, historically identifiable changes in code, are most evident and in which more individual aesthetic considerations can be developed[27] (though it is disconcerting to see how quickly "natural good taste" in traditional societies can be subverted in their eagerness to imitate the modern West).

Except for tales and recreational verses and similar peripheral activities, the history of art generally does not show until recently great variability of styles in the sense of changes for their own sake. Usually we find that a change of style accompanies a change of ruler, and the change is a political statement of power and prestige implying that old ways are gone. Specifically, from the Renaissance to the present, changes of style have reflected momentous social changes.

Great works of art have been so intimately bound to religion and power until the very recent past that it is in a sense inappropriate to appreciate them purely aesthetically. It was not disinterested aestheticism but the glory of the gods or the rulers that motivated their creation. Even today it is only the elite, conversant with codes, who appreciate (or bemoan the disregard for) "aesthetic" merits. We are told that much of Greek, medieval, and Indian sculpture was originally painted in lifelike colors. In the Menakshi Temple in Madurai, columnar stone sculptures of gods are being "restored," painted with moustaches, lipstick,

eyebrows, realistically depicted jewels, and clothing. Although the restored statues are otherwise exactly the same as adjacent ones that have been whitewashed, and those exactly the same as the ones adjacent to them that so far have been untouched for centuries, only the latter are moving to the contemporary Western observer as works of art: in the unpainted stone can be recognized the masterful and delicate carving, and the contour and sense of volume appreciated. Presumably the worshippers do not find the painted or whitewashed sculptures inferior—one could assume the contrary.

For the pygmies a metal drainpipe was a suitable instrument for their *molimo,* and for the Dinka it is the idea of the spear, not the spear itself, that is considered to be important. Walter Benjamin has remarked of ceremonial objects that what matters is their existence, not their being on view. This attitude, prevalent everywhere until the twentieth century, is receding along with the concept of the sacred that gave rise to it.

A length of drainpipe emerging conspicuously from the carved robe of a new monumental Buddha statue in the south of Sri Lanka would indicate that aesthetic considerations are not particularly essential for worshippers. The contemporary restoration of painted walls of many Buddhist temples in the same country, with garish illustrations reminiscent of film posters or cartoon strips, shows similar obliviousness to refined aesthetic concern.

The high development of a specifically aesthetic appreciative ability in persons not already fitted for it by guild or caste selectivity and training would seem to require leisure in order to cultivate the familiarity with codes that is necessary. The high aesthetic quality of the art that has been preserved from the past—including that in Sri Lanka—can be understood as having developed slowly within a tradition that was guided and maintained by persons who had aptitude and training for it in associations of artists directed by religious and political traditional authority. Much of the excellent secular art from the past (e.g., Indian and Persian miniature painting, European court music from the thirteenth to the nineteenth centuries) was commissioned by leisured cultivated patrons who surely appreciated it aesthetically as we do today.

But we have shown that it has been only a very short time, speaking in evolutionary terms, that art has been detached from its antecedents and affiliates, ritual and play, so that its varied components have coalesced to become an independent activity.

Until less than a hundred years ago, the primary tasks of artists were not to create works of art but to reveal or embody the divine, illustrate holy writ, decorate shrines and private homes, fashion fine utensils or elaborate ornaments, accompany ceremonial observances, record historical scenes and personages, and so forth. Aesthetic considerations were no more important than other functional requirements, though it must be admitted that artists of the past were highly skilled in combining the two.

It is difficult to believe that the artists of Lascaux, not to mention the stonecarvers of antiquity or indeed artists in all ages, did not know exactly what they were doing.[28] The "art" in their works is no accident; familiar with tradition and its pattern of expectations, they knew what was admissible and excellent in their work and the art of others. Their works—still admirable—show an acknowledgment of aesthetic principles that we recognize today as being independent of other motivations for art such as displaying wealth and power, propitiating and glorifying the gods, or teaching by means of stories. Although most of the human race now has and always has had small requirement for the autonomous aesthetic quality in the artifacts that surround them, and although the evolutionary justification for the existence of these artifacts is in their utilitarian, social, nonaesthetic aspects, there have always been a few human beings—artists—who have been innately predisposed to carry on aesthetic tradition and to be concerned, unconsciously or consciously, with nonfunctional aspects of their work. Wanting to make special, after all, implies the intention of doing one's best, and taking pains will result in considered work that embodies the most highly regarded attainments and aspirations of the society.

It is not surprising that as classifying creatures with highly developed discriminatory powers and strong feelings, human beings will rank things, finding some "better" and others "worse." Beauty, like love, is in the mind of the beholder. As we are all the same species, it is likely that we will all agree about the value of many things and—being individuals—we will continue to have idiosyncratic preferences and to disagree. Trying to categorize what is valued precisely according to exact, inflexible rules seems a doomed enterprise, much as our classificatory minds are seduced by the possibility of comprehensive schemes.

Perhaps the most one can say is that just as some persons have always been more agile than they needed to be, or required less sleep than their companions, or had more imagination and in-

telligence than the environment demanded, so has aesthetic aptitude and concern been retained among the myriad qualities that give humans their great variability and adaptability.

We may now return to a consideration of the admitted dissimilarity between modern aesthetic response and its alleged prototype, tribal or communal ecstatic response.

By examining his own personal aesthetic experiences, the reader can perhaps recognize that his tastes have changed over the years, and that his responses as they develop over time become more complex and complete. If an evolution in the taste or receptivity of one person is granted, then it need not be claimed that all responses to art are identical or that there is a kind of aesthetic need or deficit which, when satisfied like hunger or thirst, presumably results in the same sensation of fulfillment for everyone.

Although the child of five can appreciate artistically, this is not a capability that once established, like bicycle riding, requires no further elaboration. In a deeper sense than even the scientist's, says Howard Gardner (1973:23), the artist's development continues throughout life. In Gardner's view, this development consists of deepening one's feeling life through experience, through knowledge of particular artistic codes used in various art forms, and through experience in interpersonal relationships so that one can better appreciate embodiments of specific affects and modes. These abilities would be necessary for "purely" aesthetic experience to develop in the human species as well. As *Homo sapiens* developed a more stable and at the same time more complex existence, some persons with a high inherent inclination and aptitude for artistic making and receptivity would have the leisure or social encouragement to indulge and develop their talents. Although there must have been countless mute inglorious Miltons in the history of humankind, others would have been acknowledged and rewarded by their fellows.

The two[29] kinds of appreciation ("ecstatic" response to sensual, psychophysiological properties in the artwork, and the "aesthetic" response to the manipulations of the code or pattern of expectations embodied in it) are not to be separated in aesthetic experience, but the "untrained" response is closer to the first type. The person who knows little about "classical music" can still be gloriously affected by a symphony's rhythm and dynamic contrasts and flowing melody and repeated developments of intensity, just as an unknowledgeable Western listener to Indian classical music may respond powerfully to the performance of a raga, recognizing the skill of the performers and reacting to the ma-

nipulated elements of rhythm and intensity. In these cases the response can be compared to the "programmed" reaction to increasing intensity in a ritual ceremony: it would not be truly "aesthetic."

To respond aesthetically to an artwork one must be familiar with the code that stands behind it, which tacitly establishes its limits. Although it is true that ritual ceremonies (and indeed all communicatory phenomena) also follow a sort of pattern of expectations with which the participants are familiar, such codes are less flexible or open to manipulation than in art. Also, in serious music aesthetic response is engendered by deviations from the anticipated course of the music (Meyer, 1956), while in ritual ceremony it is predominantly based on the satisfactory repetition of the code as it is preordained. Although music likewise cannot deviate too greatly from its code, or it becomes unrecognizable (the code is obliterated), the difference between the two should be clear: ritually induced emotion is an affect that accompanies the proper performance of an activity (which even while manipulating emotions does so rather directly, and generally has a clear progression from a known beginning to a known climax to a known end) within a group of like-minded people. In contrast, the emotion produced by listening to serious music is an affect that accompanies educated expectation of an imperfectly known progression, with emotion suffusing the surprises and recognitions along the way. In other words, there is a much more specific and pervasive *cognitive* or *intellectual* element in aesthetic response to serious music than in an ecstatic response to ritual ceremony.[30]

Obviously persons who are well acquainted with the limits and possibilities of musical codes will have a richer experience as listeners than those who do not; and, as Gardner pointed out, a wide acquaintance with human relationships and ranges of emotional and imaginative thought—both learned through education and acquired through experience—will enrich one's experience of art in a way that may not be strictly necessary for emotional experience of nature, sexual love, religion, and so forth, where acquaintance with a complex traditional "code" is less involved in receptivity and response.

It is in art where such codes seem to be necessary, and insofar as we respond *aesthetically* we are aware (at some level; it may well be inarticulate) of the code—of *how* not only *that* something is said. This awareness, which is cognitive, makes our fuller response possible, as we discriminate, relate, recognize, and otherwise follow the code's manipulations.[31]

While code following and appreciation are abilities shared by all humans, traditional or modern, the frequent use of abstractive or disembedded modes of thought is rare and relatively recent. The modern Western habit of regarding personal lived experience with detachment and objectivity affects art as well as life. In the final chapter I would like to trace briefly the development of this trend in Western cultural evolution, and mention its implications for our subject, the question of what art is for.

7

From Tradition to Aestheticism

In the preceding pages I have described, not without initial false starts, a "behavior of art" and shown how it could have arisen and evolved to exhibit the varieties displayed in its ubiquitous and multiform existence across space and time. Rather early it became necessary to disregard, deny, or heavily qualify contemporary received Western ideas about art, since these were found to obscure more than enlighten the understanding of art as a universal and necessary characteristic of the human species. Instead I spoke about art as "the arts," a collection of describable activities (and responses to these activities) based on the proclivity to make special. What this behavior of art was "for" in human evolution was to facilitate or sugarcoat socially important behavior, especially ceremonies, in which group values often of a sacred or spiritual nature were expressed and transmitted.

Art does not appear to be for this any longer. Although in the sense in which we have discussed it as a behavior art is as ubiquitous today as ever, the complex and diverse nature of modern Western society is such that there are few group values that are widely shared and transmitted by means at least of the fine arts. It is also generally true that those values that might be called widely regarded and which the arts, often as not, express and transmit (e.g., ideas about success and achievement, power, importance of the self and self-expression) tend to be more pragmatic than spiritual.

In any case, as I have repeatedly emphasized, art as it is thought of today is not considered to encompass the often banal and inept activities that an ethological view such as the present one includes as instances of a behavior of art (e.g., home decor, per-

sonal adornment, window displays). Rather, the word and concept has acquired a tacit capital A, and as such is regarded as an elite activity performed and appreciated by the few and existing only "for its own sake."

In this final chapter I would like to discuss the implications of the fact that those who are among this elite nevertheless feel and proclaim that in some fundamental way they need art—in which case art is "for" something besides itself after all. Even the much larger number of people who do not themselves pay much attention to "high" art do not question that it denotes something rarefied and perhaps even spiritual. The British government was quite prepared during World War II to spend an enormous sum of money to air-condition a Welsh cave and transport all the paintings from the National Gallery there for safekeeping until the danger of bombing raids was over (Clark, 1977). This was not because they valued the subject matter of the works—Mars and Venus, Arcadian revelries, Dutch burghers—or that the material worth of the old canvases and paint was so great, but because of the aura of sanctity the works themselves possess. This aura comes from nothing more and nothing less than being "Art."

In the quasi-spiritual connotations of capital-A art, it is as if there is a sort of archetypal group memory of what the arts did for us. Ironically, we pay homage to the concept in a way that would be incomprehensible to people for whom art—like religion, economics, education, magic, and sex—is an integral, inseparable part of life and for whom the arts still shape and embody its verities. Intimations of what art was for still cling to it, and the sacredness art helped to transmit now seems to be projected onto the empty vehicle itself.

How has this come about? I would like to end my study of the behavior of art by considering certain features of the development of this advanced Western mentality, in which although art is apart from life, it has come to stand for what was sacrificed when "the traditional" became "the modern."

Art: A Part of Life

I have noticed that others who like myself have entered with some permanence (that is, through extended travel, study, or marriage) the world of a traditional society have often recorded their admiration for the apparent inner consistency or wholeness of that way of life. Anthropologists, regarding groups as diverse as the Eskimos,[1] Australian aborigines,[2] Balinese,[3] Javanese,[4]

Trobriand Islanders,[5] and Hopi Indians,[6] have described these peoples' lives as being concerned with aesthetic as much as practical ends. They acknowledge the way that in traditional societies actions, beliefs, customs, and values seem to refer to, complement, and complete each other. Although advanced Western society doubtless displays a kind of internal consistency and uniformity to outside observers, we who view apparently "simpler" ways of life from the peaks of our more highly evolved and advanced society, find them *aesthetically* attractive, possessing a purity and unself-conscious harmony that our lives appear to lack.[7]

One might suspect that Western individuals who respond positively to and find aesthetic aspects of life in traditional societies are projecting their own wishes into what they observe—that having "gone native" they see what they want to see. But the large number of accounts of this type suggests that, even if romanticized, *something* is discerned that is absent from modern society, a something that is lost when societies become modern.

This integrity of life existed in Western culture itself until relatively recently. Until about the eighteenth century in their preindustrial state, Europe and America would have been classed, had such a concept existed, as part of the Third World. And until well into the present century they were, generally speaking, traditional (i.e., "unmodernized") as well.

Posttraditional or modern society is a new phenomenon, the subject of an increasing literature as people all over the world rush to modernize or become modernized (a state from which they cannot return) and thereby partake of the benefits of modern technology.

As ethologists we should be concerned with charting what happens when a species leaves the environment for which it was adapted for another one which it then tries to adapt to its own ends. In the case of our own species this is the story of human civilization, which summarized in the remaining pages of this final chapter may seem an overweening endeavor. The evolutionary view of the ethologist is bold as well as broad, however, and hazards to try. For it seems that although the potentialities for adapting (exploiting) the environment have been given more than enough attention, the human ends to which we should be trying to adapt these remain insufficiently explored. By noting some of the changes in human thought and behavior that modernization seems to compel, we might better appreciate the inner distance we have traveled from the original way of life that our species led not really so very long ago.

The Civilizing Process

Every human tribe or village, no matter how remote or globally insignificant, considers itself to be at the center of the world, and its ways to comprise the best and truest imaginable. In exactly the same way, we of the modern West have tended to assume that the meaning of the whole of the past is the unfolding of the undoubted preeminence of our "European" civilization—its attainments and values.

Thus we assume that personal achievement, logical analysis, questioning, dissent, progress, innovation, new experience, change, efficiency, individuality, competition, self-knowledge, and independent thought, which seem natural to us, are ideals that the rest of the world should emulate. Like ourselves, other people, if shown how to do so, will want to try new ways and seek to improve themselves. It is "natural" for people to want to be free, to be individuals—and we design our foreign policy with such convictions in mind.

But acquaintance with traditional societies reveals how parochial these preconceptions are. Their rule is to follow tradition and custom, to be suspicious of novelty, to accept the explanations provided by authority.

How did we get to be the way we are? We can examine certain historical trends or changes from the past to the present, if and only if we guard against the hidden assumption often implicit in such views—that later stages are an improvement over earlier ones. By the same token, we will not claim that they are worse. As objectively as possible we will describe some of the changes in human life and mentality that have accompanied what Norbert Elias (1939) calls the "civilizing process" in Western European history from the Middle Ages to the present. It will be implied, also, that the behavior and affective life of people in primitive and traditional societies today in other parts of the world are in general more like the earlier than the most recent stages of Western society. These people may be "highly civilized" in the sense of being refined or decorous in their manners. But they will not have undergone the full "civilizing process"[8] that Elias alludes to which has led to contemporary advanced Western society, a very different concept of civilization.

A number of historians in recent years have described certain trends in European or Western social life, addressing specific subjects such as changing attitudes toward death (Aries, 1979), the family, sex, and marriage (Stone, 1977), insanity (Foucault, 1973),

sexuality (Foucault, 1978), shame and delicacy (Elias, 1939), public and private behavior (Sennett, 1977), aesthetics and art theory (Osborne, 1970; Gablik, 1976) and narrative (Kahler, 1973) as Western society has evolved from its "birth" in classical civilization to the present day, and as it has been affected by demographic, economic, religious, technological, and other interrelated developments.

Although they deal with very different aspects of life, these and other studies have demonstrated the same directional sequence, which for the sake of simplicity can be resolved as the gradual development of two related general trends. One trend is from the reliance on social authority or group consensus to increasing individualism and privatization; the other is the change from what can be called a global or prelogical to a highly abstractive and self-conscious mentality. These trends are to be understood as occurring in a general sense both in societies and in individuals, though they will have slightly different manifestations and though not every person or society will show them to the same degree. For my purposes here it is enough if the reader acknowledges that such very broad trends have occurred, throughout the societies that now make up the "advanced West" (and in others insofar as they emulate the West), in a demonstrably cumulative fashion. And they continue to grow.

Thus, for example, two thousand years ago in European history persons grew up acquainted with death and deathbeds. Dying persons generally accepted their fate calmly and expired calmly, according to custom. Family and friends, who were usually at the bedside, similarly accepted bereavement as an unavoidable part of mortal existence. Certain charms or actions might delay death, but when it came it was considered to be inevitable. By the twelfth century in Europe, at least among the intellectual and spiritual elite, a realization of a personal and lonely destiny can be discerned and—primarily because of the possibility of hellfire and damnation—death might be feared. At deathbeds the priest began to represent and replace the family and close community. Gradually, until the present century, with complicated and interesting influences and effects along the way, death has become a stranger, pushed back to the margin of a pampered and protected life. When it comes, it is a private matter that takes place rarely in the bosom of the family, but in a clinical setting. Strangers undertake the funeral arrangements and, in enlightened communities, even administer therapy to the grief-stricken family, who are usually unfamiliar with death, occurring as it does offstage.

The self-conscious individual cherishes the idea of a long and rich life, with disease and accident being in large part preventable, avoidable, and treatable. Realizing that this is his only life, he wishes passionately not to die (Aries, 1979).

Not only in dying, but in all aspects of human existence, the trends toward increasing individualism and objectified, context-independent thought can be detected as the "civilizing process" proceeds.

Many scholars have written about these same trends much more commandingly than I am able to do. My justification for presenting the reader with what might seem to be a glorified sophomore essay is that these trends take on an added depth and interest when viewed even cursorily in bioevolutionary as well as historical perspective.

For I think it is accurate to point out that both individualism and abstract thought have been extensively promoted by the acquisition of "literacy"—understood as the habits of mind, modes of thought, and patterns of human relationships that a high degree of literacy engenders and encourages. Although the development of these (the two trends and literacy) is undoubtedly one of mutual feedback, even chicken and egg, one must start somewhere.[9] And it seems to me insufficiently appreciated that literacy (even more than advanced technology) is the major possession that separates modernized from unmodernized persons, as well as history from prehistory. The unqualified tacit emphasis placed on literacy and the high value accorded to the "literate mind" is perhaps what differentiates advanced Western man most from other civilizations and other people, past and present.

Concomitants of Literacy: Habits of Mind Lost and Gained

The acquisition of literacy (the ability to record, store, and retrieve knowledge outside the individual head) would appear to have important and irreversible effects on the human mind (McLuhan, 1962; Ong, 1982; Hallpike, 1979; Goody, 1977).[10] Although for the past several thousand years some persons have been able to read and write, and the division between history and prehistory is based on whether or not there are written records, it is only in the past few hundred years that reading and writing are—in the West—common, almost universal skills, and society is so constructed that a nonliterate person is seriously disadvantaged. In traditional societies this was and is not so.

Simply learning to read and write no more establishes the "literate mentality" than learning how to ride a bicycle makes one rely entirely on wheeled transport and stop walking altogether. But there is a real danger that once riding becomes habitual, the rider will no longer be content to walk, and even when he is walking will retain the habits of mind acquired on wheels. Also, just as the extent to which a person comes to use and rely on his literate mode of mental transport determines whether he is a "habitual literate," the number of persons who possess this predilection will affect the degree of literateness ascribable to a whole society (Havelock, 1976). Hence, societies where only a small elite are educated can be characterized as essentially nonliterate, as the concomitants of literacy are diluted by not finding much resonance in the larger group. By this token, only during the last few hundred years and only in the advanced Western nations[11] can the literate mind be said to have become characteristic or even strongly influential.

Literacy as an accomplishment is commonly considered to be an unquestioned benefit to the individual who acquires it, and it is a necessity for participation in modern life. With our dispassionate ethologist's gaze, however, we can look at some of the consequences of this bequest and become aware that learning to read and write is an initiation into a state of mind from which one cannot return, a loss of virgin innocence that cannot be restored. Like acquiring maturity or losing one's virginity, it can be said that one gains more than is lost; still it is salutary to appreciate the sea change that occurs.

To begin with, literacy allows people to ask themselves (and answer) certain kinds of questions that were not asked (and could not even be thought of) before records were kept. Because facts can be isolated and recorded, then looked at later and all at once and then compared, inquiry and analysis are stimulated. Literacy leads to critical, reflective thinking because when things are written down they can be "turned around and around" to be examined; analogies and relationships that would not be apparent inside the head "jump out" from the page.

"Data" are collectable. Since particular forms of storing them are favored—lists, tables—particular forms of thought about these data are also favored: classification into categories, abstractions from the particular (e.g., corn, wheat, oil) to the general (e.g., items of trade, items for taxation). Writing and storing information also encourages the notion of hierarchy, of outline form with topic headings and subheadings. Thought is further clarified and

communicated by separation into categories and subcategories: meanings are explicit rather than implicit, uniform and lineal rather than discontinuous and simultaneous, symbolically embodied rather than hermeneutically deciphered.

Abstractions such as equations and calculations—that is, mathematical relationships—become thinkable for the first time. With lists of data, one needs more words for number than "one," "two," and "many." Exactness and quantification are refined, as recipes and prescriptions can be preserved in what comes to be thought of as the one standard or best or most accurate way. Disorder becomes a source of disturbance and discomfort rather than expectable and even pleasurable diversity.

In nonliterate, "oral" societies, the verbal arts are public and participative, relying on an inspired poet and a receptive audience.[12] Language must be vivid and inspirational to hold the audience's attention then and there. But in literate societies prose or discourse may lie around until needed, and therefore can be dull, prolix, and figuratively as well as literally unmemorable. After all, one can ponder it until its meaning emerges. The stuff of experience more and more tends to be communicated as a parade of sequential, logically successive elements rather than a collection of images and ideas that could be apprehended by means of associations other than logical, successively apprehended ones.

Only to the literate mind is a word a discrete thing. We who have been reading for decades find it astonishing to discover that sound spectrographs show speech to be a continuous uninterrupted movement without individual isolatable words standing out from the flow of sound. Most languages do not, however, have a word for "word" (though most have one for "utterance"). Consequently, if one asks a nonliterate person a question of definition, such as "What is an elephant?" ("What does the word 'elephant' mean?"), the response will most likely be laughter or incredulity, assuming that one asks because he does not know and is trying to find out.

It is only when we go to school that we learn there are meanings for words that can be explicitly stated and formally recorded—meanings which are fixed across all possible contexts of a word's use and thus are greater than or different from an individual speaker's meaning on an individual occasion:

TEACHER: "What is a lullaby?"

CHILD: "It helps you go to sleep at night."

TEACHER: "But what *is* it?" (i.e., its general fixed meaning)

CHILD: "It's a song."

TEACHER: "That's right."

Plato's forms and Aristotle's common denominators or "defining properties" of a class are both artifacts of the literate mind. Earlier, however, Homeric epics portrayed abstract concepts such as "courage," or "justice," not through definitions and principles, but through deeds and expressions of gods and heroes, with an emphasis on the effects or functions of these qualities, similar to the child's idea of a lullaby as something that helps her to go to sleep. ("What was the beauty of Helen's face?" "It launched a thousand ships.")

Like the notion of a word, the idea of a sentence or proposition is an artifact of written language. Syntax and textual organization are quite different in writing and speaking, and each requires different competences (Kress, 1982). The former cannot be said to be natural, in the sense of the latter.

Through reading and writing, also, words come between things and our experience of them. Jean-Paul Sartre (1964) has described his first childhood experience (before he could read by himself) of being read aloud to, in contrast to being told stories.

> Anne-Marie [Sartre's mother] made me sit down in front of her, on my little chair; she leant over, lowered her eyelids and went to sleep. From this mask-like face issued a plaster voice. I grew bewildered: who was talking? about what? and to whom? My mother had disappeared: not a smile or trace of complicity. I was an exile. And then I did not recognize the language. Where did she get her confidence? After a moment, I realized: it was the book that was talking. Sentences emerged that frightened me: they were like real centipedes; they swarmed with syllables and letters, spun out their diphthongs and made their double consonants hum; fluting, nasal, broken up with sighs and pauses, rich in unknown words, they were in love with themselves and their meanderings and had no time for me; sometimes they disappeared before I could understand them; at others, I had understood in advance and they went rolling on nobly towards their end without sparing a comma. These words were obviously not meant for me. The tale itself was in its Sunday best: the woodcutter, the woodcutter's wife and their daughters, the fairy, all those little people, our fellow-creatures, had acquired majesty; their rags were magnificently described, words left their mark on objects, transforming actions into rituals and events into ceremonies. Someone began to ask questions. . . . It was as if a child were being quizzed: what would he have

done in the woodcutter's place? Which of the two sisters did he prefer? Why? Did he agree with Babette's punishment? But this child was not entirely me and I was afraid to reply. I did reply, though; my feeble voice grew faint and I felt I was turning into someone else. Anne-Marie, too, with her blind soothsayer's look, was someone else: it was as if I were every mother's child, and she were every child's mother. When she stopped reading, I quickly took back the books and carried them off under my arm without a word of thanks (Sartre, 1967:31–32)[13]

As Sartre's account makes plain, even listening to reading aloud causes an awareness of distance between a happening and the utterance with which it is directly related. Experience becomes more and more abstract and remote as we learn for ourselves to read about experiences we never had by people we do not know, and to read books about these books and people. Sartre, like many of us, overcame his initial shock at the otherness of print and "came to enjoy this release which tore me out of myself."

Literacy gives us more and more the opportunity for detached, mediated and isolate experience. Apart from the inherent solitary nature of reading and writing, the literate person, knowing she can "look it up" or "write it down" will be much less likely to rely on personal observation, memory, or the teaching of another, but will use cookbooks for recipes, maps for getting places. The nonliterate, however, has no choice but to watch or listen or remember—all much more direct kinds of involvement.

These effects are occasioned not only by books and print but can come from recorded information of all types, including today the ominously omnipresent, omniscient, and omnivorous computer. Moreover, literate persons become easily accustomed to and thereby dependent on external devices for amusement and distraction—mechanically produced sights, sounds, and events that are selected and provided by someone other than themselves, usually a stranger.[14] Persons in most traditional societies, however, consider indolence to be a natural part of life, not a state to be automatically avoided or replaced by useful or amusing activity. To the nonliterate, the notion of boredom has little meaning; existence itself demands neither justification nor cultivation. If nothing is distracting it, the mind finds occupation in its inner life or directly in the surroundings. The immediate world is more likely to be noticed—colors, smells, sounds, appearances of things, as well as their relationships to each other and to the mental and imaginative life.

We can suppose that before experience becomes recorded (and

recordable) in print or in photographs and tapes—when it is unrepeatable and impermanent—the human mind has a different attitude toward it. Without a camera, for example, one might see and make an effort to remember much more about one's vacation.

Literate knowledge, though vast and multiform, is often disconnected, both from the immediate situation and from other bits of knowledge. To nonliterates, on the other hand, what one knows tends to be lore—that is, bodies of integrated useful knowledge rather than for example isolate "subjects" in a school curriculum or the bits of odd, often useless information that purl in meaningless arbitrary sequence from the modern radio or television set.

With the acquisition of a literate mentality both the form and the content of knowledge change dramatically. When there is less reliance on words, and fewer words, those aspects of one's life for which there is no precise description are not lost, ignored, or dismissed but instead (coded in other, nonlinguistic ways) tend to be integrated and expressed in socially shared symbols. In preliterate culture, a pictorial or visible symbol *becomes* a fact: it simultaneously stands for, defines, and manifests its referent (Otten, 1971). In such cultures, ritual rather than books serves as the locus of knowledge and operates on many levels. In this way one could say that the experience of the human perceivers is more of a piece, although to the literate view the symbols which embody it appear multifaceted and ambivalent, even expressing contradictory things simultaneously. Posttraditional persons, on the other hand, with their large vocabularies and reliance on clearcut distinctions, are uncomfortable with immanence, preferring that important things be spelled out precisely as in legal documents, with footnotes. We may even tacitly assume that whatever can be thought or felt can be said in print, and conversely, what we say or write becomes what we think we mean or what we think is the case. Much more than ourselves, preliterate people have conceivably been sensitized to apprehend and respond to many kinds of information that are never verbalized but only expressed in action—in rituals, emotional gestures, and so forth. According to Malinowski (1922:239), "The native feels and fears his belief rather than formulates it clearly to himself. He uses terms and expressions, and thus, as used by him, we must collect them as documents of belief, but abstain from working them out into a consistent theory; for this represents neither the native's nor any other form of reality." Although it is not to be denied that posttradi-

tional people also possess inconsistent beliefs and feelings, may act in "magical," nonrational ways, and may at times feel a continuity between themselves and their surroundings, they generally apply a more objective kind of thought and expect a more rational kind of explanation for many conditions and desires in their experience. As the civilizing process proceeds, belief is, in general, increasingly replaced by knowledge, and literates learn to be persuaded by reason rather than emotion.

In highly literate society, where words and language can be treated as entities in themselves, concepts also may be regarded as distinct abstract entities capable of manipulation, irrespective of any particular referent. At this level of literacy, ethical, moral, and political statements in a literary text may be "deconstructed" or analyzed in terms not of their meaning but of their linguistic function. Some modern philosophers have even demonstrated by their logical and linguistic analyses that the perennial human problems are illusory. They reformulate the quest for the "meaning" of things to the quest for the meaning of words (Marcuse, 1968:68).[15] The immemorial discourse on the universe is transfigured by and into the concern for an adequate universe of discourse.

By contrast, for preliterates, the word for a thing or action is not separable from that to which it refers (Hallpike, 1979:487). Things and persons belonging to the same verbal category may even become conceptually fused together in a manner that to the literate mind is unacceptably mystical or nonlogical (Leach, 1966:408). Also, in oral cultures there is no "original text." The ethnographer who goes around collecting versions of a tale in order to find the basic original version is obeying the imperatives of his literate mentality. What is stable is the *story*, which is much closer to something to be apprehended than something that can be anatomized or deconstructed.

For posttraditional humans whose thinking—and even fantasy and daydreams—is largely occupied with instrumental, pragmatic concerns, it is perhaps difficult to appreciate the more embedded, enactive, and symbolic type of thinking that is characteristic of nonliterates. Such persons may forget after they leave childhood that there are ways of knowing other than the rational, and that the world can be well and deeply experienced without being dissected and analyzed.

Immersion in a datum or experience to the exclusion of other thought, and unmediated by words, may be a kind of natural human experience that persons renounce once they attain a high

level of literacy and abstract thinking ability. One of the triggers of ecstasy in Marghanita Laski's study was called by her "poetic knowledge"—ideas without exact reference which nevertheless have a compelling force of truth. Such ideas may play a much larger part in the mental life of primitive, nonliterate persons where they are not automatically dismissed as illogical, irrational, or unamenable to words.[16] Those in modern society who find this kind of thought natural may be more receptive to art and more apt to be artists themselves.

It may also be more "natural" and of more consequence to interpret the world as primitives and children do in terms of oneself and one's associates. When experience is personal and particular, and when explanations are magical or otherworldly, both are intense with significance.

The literate mentality has had a long fledgling period, and only very recently has been able to detach itself from the earthbound elements that gave birth to it, and fly unimpeded. The freedom of the wide view, of being able to see the forest as well as the trees, to appreciate the sheer vastness of the numbers of trees and to classify them and trace their relationships, has resulted among other things in the scientific and technological eminence whose undeniable benefits Western society enjoys and sports seductively before its still terrestrial kinsfolk.

While not denigrating either the attainment or the benefits of Western reason and critical thinking, it seems apposite also to point out that from an evolutionary point of view these are very recent and relatively untried proclivities, apparently dependent on discarding and deemphasizing certain modes of being and understanding that have characterized our species from its earliest beginnings. The preceding pages should have made it clear that the logico-deductive manner of thought characteristic of advanced Western civilization is a highly specialized acquisition, different not only in degree but for all practical purposes in kind from other kinds of mentality. It is difficult for habitually literate Westerners to learn and accept that people who are not born into a rational milieu evolved over a long period of time[17] do not automatically or deliberately aspire to be logical or rational in this specialized Western sense.

Utilizing a wide body of ethnographic data, and paying careful attention to primitive peoples' systems of classification and their concepts of causality, number, time, and space, C. R. Hallpike (1979) has recently offered with great convincingness and thoroughness a description of the nature of "primitive thought." He

notes that the man-centered world of primitive people embedded in the natural world fosters subjectivization, where the thing-centered world of modern man encourages objectivization (p. 486). Showing how "abstraction" as a mode of thought can occur at different levels of mental practice (p. 170) (it is even demonstrated by animals), he analyzes concepts of mental functioning with considerable rigor, placing them within Jean Piaget's theoretical model of the developmental dynamics and structure of human mental processes.

According to Hallpike, primitive thought is in Piagetian terms "preoperatory" or "prelogical." He concludes that to the extent that primitive thought is bound up in imagery and the concrete phenomenal properties and associations of the physical world, permeated by moral values and affective qualities, uncoordinated, dogmatic and unsubstantiated by argument, static, relying on perceptual configurations and prototypes and the reification of process and realms of experience, it is not "rational" according to modern scientific criteria of rationality (Hallpike, 1979:490).

Yet, he hastens to emphasize, this does not mean that primitive thought is conceptually simple, inherently mistaken, or incapable of profundity. Rationality and scientific thought are narrow aspects of mental functioning and can all too easily allow their user to ponder his postulates in a solipsistic ivory tower detached both from concrete experience and from the concern for quality rather than instrumentality in his life and his associations with others. There are many respectable forms of thought and knowledge that need not be considered "irrational" even though they may be "nonrational"—music, art, and imagination in general; elaboration of symbolism; inarticulate mechanical knowledge; spiritual insight. Saying that primitive thought is prelogical does not imply that it cannot be true, practical, creative, aesthetic, and wise, or that its users are childlike or inferior forms of humanity.[18] In the face-to-face society in which primitives live and for the life their environment requires, preoperatory thought works just fine (Hallpike, 1979:489–90),[19] while in our faceless, interchangeable society where recombinant prosthetics and genetics is the only limit, self-interest the only commitment, and the "bottom line" the only responsibility, emancipated operational thought is correspondingly suitable.

Rather than discrediting primitive people, Hallpike's assertion that primitive thought is largely preoperational or prelogical is a warning to us that what we have come to regard as our superi-

ority over the rest of the people of the world (the formal-operational or logico-deductive thought which has enabled our technological and hence economic domination over them) may be ours at the expense of suppressing other equally significant aspects of mental functioning that were evolved over hundreds of thousands of years to be workable and satisfying. For most of our evolutionary history, we were all primitive nonliterate peoples who lived in a man-centered rather than thing-centered environment, and had no more need of formal-operational thought than they. The ability to perform formal operations is attained by us not because we are so intrinsically bright, or because it is so natural a type of mental functioning, but because we have been born into a "carpentered," objectified world and have undergone years of formal schooling where the literate habits of mind I have just been discussing have been indoctrinated.

The author of a book called *Children's Minds* claims that some of the skills we value highly in our educational system are thoroughly alien to the spontaneous modes of functioning of the human mind (Donaldson, 1978). "Disembedded" thinking has proved for many to be defeating and repugnant; many intelligent children find reading and writing difficult or unnatural. We for whom reading and writing are easy and enjoyable can be glad that we were born into a society that rewards these skills rather than those of cross-rhythm drumming or tracking seals across a featureless expanse of ice.

Certainly present-day Western attitudes toward art have been affected by what we have gained, and lost, by our emphasis on literacy and its concomitants.

A provocative study by Suzi Gablik (1976) correlates changes in the history of art with Piaget's general laws, implying that changes in pictorial representation in art have accompanied and reflected changes in the way that human beings have mentally conceived their world.

The early "egocentric" or "prelogical" stage that Piaget observes in infants and very young children is shown by Gablik to correspond with that described for many preliterate societies, where reality is distorted to satisfy the emotional needs and desires of the thinker: "For this 'pre-logical,' or mystical, mentality, the visible and the invisible world form one, everything is fluid, categories are not separate, the individual does not experience himself as separate from the group. The fact that there is no line of demarcation between natural and supernatural worlds, between

the material and the spiritual, results in a very different picture of the world from that which our modern scientific world-view gives us" (Gablik, 1976:40–41).

In the characteristic mode of art at this mystical or "pre-operational stage of cognitive development," pictorial representations are characterized by static imagery and space is subjectively organized. Psychical and physical ideas are not yet dissociated. The distance between objects is based on their proximity to one another on a two-dimensional plane which takes only height and breadth into account. There is an absence of depth and no unified global space which conserves size and distance. Such a mode characterizes art of the ancient and medieval West, including Greco-Byzantine, of the ancient Orient and of Egypt (Gablik, 1976:43).

Later stages in the history of art correspond to Piaget's "concrete operational stage" and the "formal operational stage," and are marked by progressive separation between subject and object, increasing differentiation, objectivization, and logico-mathematical coherence.

But as Gablik well recognizes, this kind of "progress" in art does not imply "improvement" but only continuous (or progressive) change. Just as an adult is not "better" than a child, modern art is not "better" than Egyptian or Oceanic art. The later entity is more "developed" in certain respects; in both cases—people and art—one could well perform the exercise of listing what has been lost as well as what has been gained with age.

Critics of Piaget have frequently pointed out that his "stages" do not account for the development of nonintellectual aspects of mental functioning. What is not widely appreciated is that if Piaget disregards art, art also disregards Piaget. Howard Gardner, who has made an admirable study of the development of artistic behavior and appreciation in children, finds that knowledge derived from the operation of artistic skills and abilities is of a different order from that derived from cognition as studied by Piaget. Gardner contends that formal operational thought, which according to Piaget's investigations is usually not achieved until adolescence, if at all, is not a vital part of artistic development and may indeed sometimes interfere with it (Gardner, 1973:305).

Gablik points out that wherever conceptual thought has developed there is more attention given to objective and logical relations than to affective and emotional ones, which are disregarded as being imprecise, unquantifiable, unpredictable. The penchant for analysis, abstraction, and taking multiple points of view certainly does seem to interfere with the immediacy of ex-

perience that urgently quickens the heart or tearducts. What moved traditional man is seen by his successor to be "corny." Standards of appreciation rise: one is suspicious of and learns to "cut through" unwarranted exaggeration, contrivance, syrupy sentiment, and other similar "old-fashioned" melodramatic emotional conventions in literature, drama, or cinema.[20]

Art in its most conventional modern sense, the kind of art that is bought and sold or appreciated in museums, has become increasingly a private predilection, separated from primary lived experience. Whereas in nonliterate society virtually everyone was a participant in and appreciator of art, in modern society, even when the public has learned that art is a good and desirable thing and dutifully throngs to certain well-advertised extravagant exhibitions, art remains an elitist activity, made and, more important, consecrated by the few.

The required response to what is regarded as art in modern times is not direct psychophysical reaction to rhythm, tension and release, or association with powerful cultural or biological symbols (the "ecstasy" of communal participation), but a detached, cognitively mediated "appreciation" of its internal relationships, its place in a history and tradition, and its implications and ramifications outside itself (the "aesthetic experience"). The modern perceiver is quite willing to appreciate constructions of pure forms that admittedly lack any referential content. Abstraction, having become a mode of thinking, has become a mode of art as well.

It has even become the case that what can be thought about or said (or written and read) about some recent art is integral to its full appreciation (Wolfe, 1975). Arthur Danto (1981) makes a telling point when he claims that artworks as a class contrast with real things in just the way in which words do. Seeing an artwork without knowing it is an artwork is like experiencing print before being able to read.

The Wages of Literacy

THE MULTIPLE WORLD

The obvious outcome of our total experience is that the world can be handled according to many systems of ideas, and is so handled by different men, and will each time give some characteristic kind of profit, for which he cares, to the handler, while at the same time some other kind of profit has to be omitted or postponed. . . . And why, after all, may not the world be so complex as to consist of many interpenetrating spheres of

> reality, which we can thus approach in alternation by using different conceptions and assuming different attitudes, just as mathematicians handle the same numerical and spatial facts by geometry, by analytical geometry, by algebra, by the calculus, or by quaternions, and each time come out right?
>
> —William James (1941:120–21)

Enlightenment philosophers were perturbed by the realization that we must rely on our senses for knowledge of the world. According to Piaget's theories, it would seem that the reality behind appearance is not perceived by the senses at all, but conceived by the intelligence (Gablik, 1976:77).[21] That very recognition implies that there is no one reality. There is no such thing as *the* way the world is, says Nelson Goodman (1968). There are instead "ways of worldmaking": "If I ask about the world, you can offer to tell me how it is under one or more frames of reference; but if I insist that you tell me how it is apart from all frames, what can you say? We are confined to ways of describing whatever is described. Our universe, so to speak, consists of these ways rather than of a world or of worlds" (Goodman, 1978).

It has recently been persuasively claimed that philosophy for the past four centuries has operated under a grievously mistaken assumption—that there is such an entity as "the mind." On the contrary, the prevailing climate of philosophy insists that there is no general metaphysical reality specifiable independently of the contexts of particular practices (Rorty, 1980).[22]

A similar denial of knowable independent reality is evident in literary and art criticism of the past decade (e.g., in the work of Derrida, Barthes, Ingarden, and others) in the process called "deconstruction" of the text and in the declaration of the contingence or stipulated labeling of art objects. But a preoccupation with relativism can be detected from the early years of this century, as when Henry James championed his brother's "law of successive aspects"[23] or "the planned rotation of aspects," which if followed gave to its practitioners a "fullness of felt-life" and consciousness that was denied to one who believed in absolute values (Appignanisi, 1973:26–31).[24]

The abstruse pronouncements of the most avant-garde intellectuals hardly affect the ordinary person who—in keeping with the dictates of countless generations of evolutionary imperative—continues to believe in a consistent reality. Such authoritative truths as God's will, the ideal of universal brotherhood, convictions of racial or religious or national supremacy, the Millennium, self-realization, the Revolution—these magnetize, mobilize, and give

meaning to the lives of millions of people who do not doubt the efficacy of such pathways to truth as reason, revelation, the scientific method, dialectical materialism, or transcendental meditation.

Still, as the trends described above continue and spread it seems possible to imagine a time when large numbers of people will accept that worlds and worldviews are individual and relative, that each person has a right to his own worldview, and that there are no objective standards to prove one to be better or truer than another.

What might this mean? We have seen that human beings and their societies evolved together, throughout millennia—small groups that survived in part because they could construe the world satisfactorily and comprehensively. Without cultures—agreed-upon systems of explanatory beliefs, or "directions for performance" (Peckham, 1977)—our species could not have survived. Today this is an anthropological truism. Whether contemporary anthropologists call these cultural frameworks "belief systems" or "systems of significant symbols" or *"epistemes,"* they assume that the persons who are governed by these are not conscious of the system—being formed by it, so to speak.

Today, for the first time in human history, people are becoming aware of their dependence on cultural frameworks, hence the relativity of these frameworks. They know that there *are* different realities—not only cultural, but psychological (between individuals) and physical (in the intricacies of matter and our limitations in understanding its ultimate or fundamental nature). Human beings may have always been aware of their vulnerability, their precarious position as individuals, but there is no evidence that until relatively recently they deliberately questioned on a large scale the collected wisdom of their group or positively granted the worldview of others coeval status with their own.

The end point of liberalism is agreeing to acknowledge the admissability of a simultaneous plurality of truths and realities. Can a society survive whose only commonly-agreed-upon belief is that no commonly-agreed-upon belief is universally applicable and defensible? That truth and reality are both matters of points of view? Looking at human evolutionary history one would expect the answer to be no. It may be a biological and psychological necessity for human beings to enact "logico-aesthetic integration" in their lives. Perhaps, as Australian aborigines and traditional Eskimoes silently and unwittingly testify, human life can and is meant to be a work of art.

THE KALEIDOSCOPIC SELF

And out of what one sees and hears and out
Of what one feels, who could have thought to make
So many selves, so many sensuous worlds,
As if the air, the mid-day air, was swarming
With the metaphysical changes that occur,
Merely in living as and where we live.

—Wallace Stevens, *Esthétique du Mal*

. . . every one of his answers is a part-answer, every one of
his feelings only a point of view, and whatever a thing is, it
doesn't matter to him what it is, it's only some accompanying
"way in which it is," some addition or other, that matters to
him.

—Robert Musil, *The Man Without Qualities*

. . . one can make the most contrary judgments about the same
person, and yet be right—. . . it is all a question of the way
the light falls, and . . . no one form of lighting is more re-
vealing than another.

—François Mauriac, *Thérèse*

It would seem that only persons from a society of habitual lit-
erates could hold the attitude toward the self that permeates
Western society. Elias traces the development of the image of *homo
clausus* (the human being as isolate, enclosed, self-contained) from
its beginnings in antique philosophy through Descartes' *cogito ergo
sum*, Kant's individual as the subject of knowledge who can never
break through to the *Ding an sich*, and Leibniz's windowless mon-
ads, to its modern proliferation in existentialism; and one could
add contemporary pop psychology with its techniques for self-
assertion, self-realization, self-actualization, and self-gratification
ad infinitum.

Certainly the act of conceptual distancing or objectivity so char-
acteristic of the literate mentality encourages the sense of isola-
tion of self from the world. "I am a camera" looking at others
and their existences; they in turn can view me and mine.[25] Far
from being a universally held concept, says Elias, the idea of a
distinct and separate self is not held by persons outside post-
Renaissance modern society. The Fulani may hold the more tra-
ditional view: for them, the personality is not considered to be
localized in the body and mind of the person, but involves the
others with whom he has relations—that is, without others he
lacks part of himself (Riesman, 1977).

Emphasis on the self at the expense of the larger family or group, or as an entity whose expression and satisfaction is considered to be a desirable goal or a virtue, is unknown to members of traditional societies. There men and women generally find satisfaction in performing well the role that custom and authority assign to them. In modern Western life, however, we distinguish between having to and wanting to do things, and try to fashion our lives so that the latter is preponderant. We feel favored to have the freedom to choose our own "life style"—something that was unthinkable until quite recent times.

Yet along with this freedom to design one's life is the accompanying and inseparable other side of the coin—isolation. Not only is contemporary posttraditional man alienated, as Marx observed, in the depersonalized commodified world of technological culture, he is unable to rely on the security provided by ties to others. Others, like himself, place a high value on their own self-knowledge, self-development, and self-fulfillment—which are seen to lie not, as in the past, in the service of a communal end but in inner personal well-being. As a consequence, no union—either that of parent and child or of lovers (not to mention kin or tribe)—is considered permanent and unbreakable, and the individual must learn to accept that he is connected to the world and other people by tenuous threads of chance, circumstance, and even caprice.[26]

The isolate self does not look for a grand scheme by which to live, but rather for an individual route to spiritual and sensual happiness. Wishing not to be constrained by others, he does not seek to impress his demands on them. For belief in the supremacy of the individual renders all other values relative or contingent. There are examples where ancient moral transgressions such as adultery, lying, stealing, abandonment of children or family, even murder are sometimes necessary or right; each individual case, it is proclaimed, must be viewed according to its own special features. Those who would believe in absolute or universal values, at least in the sense that they continue to act in terms of them or to seek them, are challenged by individual justifications by others of what they do. Privately we may condemn, but more and more it is admitted that before judging a person we should walk a mile in his or her shoes.

Twentieth-century psychology teaches that our actions are not reducible to a single motivation or explanation, that we have many conflicting desires, that our self is a patchy structure of disparate and even precarious aspects. Our apparent feelings may well be

masks for their opposites: excessive love, we are told, means excessive hate; generosity is often a disguise for meanness. As in the theater, nothing is what it seems, or everything means its opposite.

Truth is replaced by interpretation; universality, by point of view. In living with others we become aware that our truths are not necessarily shared by others, and that we are not only the intimate self we know so well but the strangers that others think we are. Their views of us are as valid as our own, in that they affect us, and—upholding our belief in the worth of the individual—we cannot dismiss their interpretations as incorrect. These join the multitude of coexisting interpretations that compose the kaleidoscope of each person's life with others, the fragments changing in relationship to themselves as well as in relation to the whole. The truth about an incident can be told from any of many perspectives, and its construction depends on which of the actors or spectators relates it, and upon their state of mind at the time. Such possibilities have been the subject matter for the past three-quarters of a century of painting, literature, poetry, drama, and they are part of our own musings on our lives and the lives of others.

But this has not been the case until quite recently. Although autobiography as a literary form is exclusively an expression of European culture, unknown in non-Western societies (Pascal, 1960), and thus might be called an outgrowth of the trends we are here concerned with, the attitude toward the self that this form reflects has itself evolved. While Benjamin Franklin, Gibbon, and Rousseau presented their lives as the unfolding of an innermost personality through encounters with the outer world, they wrote as if this self they were depicting embodied some fundamental and true reality. By the time of Stendhal, however, one discerns uncertainty about the self ("What am I?"), and the utter lack of any metaphysical certainty and feeling of destiny.

In posttraditional life, psychology—whose aim is clarity and information about oneself—has replaced religion, whose aim was salvation and transformation of oneself. As Sheldon Wolin (1977:19) has written, the "dark night of the soul" is today referred to as the "disorders of the personality." Religion, love, and art are explained to be all forms of consoling illusions;[27] the sacred is identified as the externalization of an infantile wish—to be sought if one is so inclined not in the outside world but in the labyrinths of one's innermost self.

THE NEW AESTHETICISM

> Here we must try to reconstruct the influence of myth upon this vast landscape, as it colours it, gives it meaning, and transforms it into something live and familiar. What was a mere rock, now becomes a personality; what was a speck on the horizon becomes a beacon, hallowed by romantic associations with heroes; a meaningless configuration of landscape acquires a significance, obscure no doubt, but full of intense emotion. . . .
> It is the addition of the human interest to the natural features, possessing in themselves less power of appealing to a native man than to us, which makes the difference for him in looking at the scenery.
>
> (Malinowski, 1922:298)

Human life has always been unpredictable, difficult, unjust, dashed with pain and suffering. Literacy and the habits of the literate mind if anything have helped to make it less so, and we should not rush to burn the libraries or waste our energies on unrealistic yearning for a gatherer-hunter life. But we should try to appreciate that what our forebears had that we do not may still be a need—resembling, say, a nutritional deficiency that the modern organism is not aware of (not ever having known it to have been satisfied) and thus does not really consciously miss. Nevertheless, its *being* is not complete, and this shows in its behavior as well as its subjective longings or moods.

In Chapter 3 were discussed (and discarded as being ethologically untenable) common reasons given by humanistic thinkers for the indispensability of art. We can now discern a common pattern to most of these answers—they pertain to areas of human experience that the literate mentality has effectively banished: art as an echo of the natural world (now at several removes, what with concrete, central heating, and air-conditioning); art as provider of direct, immediate, unself-conscious experience (now conveyed to us through several layers of analysis and abstraction, not to mention proliferating "media"); art as integrator of experience, as therapist, as provider of order, meaning and significance (now disintegrated, illusory, fragmented, multiple).

It is increasingly common for people to attribute to art what in former days would be attributed to religion,[28] just as it is common to call "aesthetic" that type of experience that heretofore in humankind's history was given either by active intense perceptual involvement in one's surroundings or embodied in ritual cere-

mony.[29] Our unmet need for shaped experience or significance has become for Rollo May (1975:135) "the urgent need in everyone to give form to his or her life."[30]

With all the banalities and crudities of mass society, it may seem strange to say that the twentieth century can be characterized by a preoccupation with the aesthetic.[31] Yet the obvious outcome of the analysis and self-preoccupation endowed by our highly literate minds is that our world and our selves have fragmented to a degree unimaginable in earlier human history, and if there is to be any coherence at all in our lives, it is up to us to put it there. To this extent, we are all called upon to be artists—to shape, find significant aspects of, impose meaning upon, discern, or state what is special about our experience. Response to the mystery of life becomes a personal aesthetic gesture rather than the acting out of a communal and confirmatory ceremony.

There would seem to be a tacit agreement among members of Western avant-garde society that since reality is unobtainable, appearance will have to do. When it is agreed that there are many interpenetrating spheres of reality, approached in alternation by using different conceptions and assuming different attitudes, the whole of life can be an occasion for the aesthetic sensibility. Playing over the field of experience, it selects what seems arresting or suggestive—words, movements, events, ideas, colors, shapes— and then combines, transposes, arranges, and modulates, offering the result as a significant verity, more true and real than the formless accidents and prosaic facts from which it was composed.

The individual sensibility becomes paramount as we recognize its indispensability in constructing or interpreting the world. Everything in the world becomes potentially interrelated and interrelatable. One man's reality is another man's work of art; one man's reality today may be ingredient in his work of art tomorrow. Instead of the counterbalanced poles of Beauty and Truth, today's poet finds his own momentary interpretation to be all he knows on earth, or is able to know.

Collage becomes a kind of emblematic art for the aestheticization of a worldview.[32] Anything when juxtaposed with anything else can, when regarded aesthetically, become "significant." If the apparent nonsense of dreams really conceals ever-deeper layers of coherent meanings, then any two or three or several images, ideas, or sense data may well contain within themselves hidden resonances, correspondences for the receptive perceiver. The Imagination, crowned Queen of the Faculties by Baudelaire (1863), is if anything, more elevated today as an *epistemological* endow-

ment, the ability that can make sense of the surrounding social and cultural chaos, and that can reveal "poetic truth" and even become the agent of personal freedom (Marcuse, 1972:70–71).

The natural interpenetration of life and art in traditional society finds oddly enough a leaden echo today in the twentieth century, as art and life confusedly appropriate each other. Although art is no longer a part of life as in the past, when it was the hand-maiden of significant and vital activities, much avant-garde art today is concerned with giving art back to life, rather than rele-gating it as in the past few centuries to the remote and special worlds of the museum or concert hall, where it is intended to be experienced by an elite sporadically and self-consciously as "works of art."

There is little evidence that increased material welfare (whether provided by socialism or capitalism) automatically brings a grow-ing cultural need or a rise in the level of culture (Gedin, 1977).[33] Mass society may no longer need bourgeois values and bourgeois art. Yet metamorphosed and self-consciously regarded so that it bears scant resemblance to what it was in former times, art today is or can be an integral part of contemporary life.

The sentiment behind Oscar Wilde's notorious statement that life imitates art has been replaced by a number of contemporary artists to suggest that life can be or *is* art, as for example when John Cage suggested that "one could view everyday life itself as theatre," or Regis Debray considered a political revolution to be a coordinated series of guerrilla "Happenings" (both cited in Ber-leant, (1970b:163). An Italian professor has reported that his stu-dents who are sympathetic to the Red Brigades talked about it not as politics but as some kind of futurist art form of constant provocation and outrage (Brennan, 1979:99).

Robert Rauschenberg has denied any division between sacred art and profane art, and insists on working "in the gap between the two." He has said, "There is no reason not to consider the world one gigantic painting" (Berleant, 1970b:163). Even Claude Lévi-Strauss, whose attitudes toward "modern art" could be de-scribed as conservative, is able to reply when his interviewer sug-gests that perhaps reality itself is a work of art: "I would be pre-pared to envisage the possibility of all art disappearing completely and reality itself being accepted by man as a work of art" (Char-bonnier, 1969:94–98).

The modern ideas about art that we have been discussing— either the established idea that it is a sacred essence deserving a capital A, or the growing appreciation that it is potentially to be

self-consciously discerned in everything—are unshared by and would be incomprehensible to any other human society. Yet in these modern formulations, reactions to the changes brought about when literacy replaced art-ritual as the means of embodying and transmitting communal knowledge and values, I see evidence that under our shiny modern cultural veneer we are still vulnerable, biological *Homo sapiens*. To those who value it, capital-A art is a way of possessing sacredness and spirituality in a profane world; art-in-everything or everything-potentially-art is a way of imposing coherence (shape, integration) on selves and experiences that have fragmented.

The "new aestheticism" is really a last-gasp attempt by individual humans to make for themselves what their society, aided by the arts, presented in earlier times to them as a birthright. The new aestheticism is, like the arts before, a means (for those who profess it) to the satisfaction of fundamental human needs.

Epilogue

"D'où venons-nous? Que sommes-nous? Où allons-nous?"

—Paul Gauguin

The myths that for millennia have explained the world and themselves to humankind are evaporating, one by one, as societies undergo the civilizing process and acquire a rootless, unsettled sameness. Yet roots are there. We do not come from a world of heroes and an age of gold, but from an essentially timeless panoramic landscape peopled by beings resembling ourselves whose existence seems now unimaginably brute and even inhuman. To understand ourselves, however, we must try to understand them. Their way of life has made us what we are, even though today we wear a very superficial (if striking) outer garment that deceptively serves as a disguise.

If we survey the generations of human beings who have preceded us, looking for evidence of a continuity in preoccupations and concerns, the discovery of a piece of "starrystone" in a dwelling site is satisfying. This evidence of a magical—call it even aesthetic—appreciation throws a bridge of affinity across the millennia, for it suggests that these beings, like us, felt wonder and attachment to special objects. Such a predilection seems somehow even more "human" than the stones flaked and chipped to be tools and weapons, or the remains of fires used for cooking and protection.

Most of us must be very glad to live today rather than twenty or two hundred centuries ago. Not only are there the comforts and pleasures of modern life, but—hardly imaginable before—the opportunity to fashion one's own life and even to join with others to create a dreamed-about world of the future. Once everyone recognizes that customs are made by humans themselves rather than divinely ordained, perhaps the world—derinded of

superstition and fatalism—can be taken into human hands and molded to human needs. If all can accept that there is no absolute justification for suffering, that pain and misery are arbitrary and not supernal punishments for wrongdoing or natural inferiority, we will perhaps be better able to reduce their ubiquity. If we agree that neither love nor light nor certitude nor peace nor help for pain occur in the nature of things, but exist only by virtue of our willing them into being, we might then ourselves create and maintain these qualities rather than bemoan a lost paradise.

When confronted as today with the massive evidence of human limitations and folly, optimists take refuge in the possibilities held out by our adaptability. This argument claims that although humans, like all creatures on the planet, have attained their present form and circumstances by impersonal and largely deterministic evolutionary processes, we have in many respects "escaped" evolutionary restrictions. Our large and intricate brain has enabled us to remember and learn and plan and adjust and communicate and control ourselves and our surroundings to a degree far beyond the capability of any other animal. To a great extent, humankind has appropriated the powers of natural selection and created itself, bypassing the dangers that affect less clever creatures. Adapting oneself to the world as well as adapting the world to oneself is something that *Homo sapiens* does better than anyone else. We have reached our present evolutionary pinnacle precisely by transcending our environment, goes this line of argument, so that the fact that we are living lives far different from our predecessors is no cause for worry.

Looking at groups of humans existing today one can indeed only marvel at their divergent and ingenious responses to the common denominators of life: getting a living; protecting themselves from harmful or uncomfortable parts of nature; dealing with sickness, death, birth, deviance; explaining the unexplainable. Truly our brains are wonderful, our adaptability and tolerance for change stupendous, our achievements without peer. We are fragile, sensitive, precious, protected chiefly by our abundant wits. Surely we will be capable of improving, of inventing better devices for survival, of ensuring with our brains what other living creatures have not a hope of getting under natural circumstances: peace and plenty and individual fulfillment for all.

It is a noble dream. Yet I question its attainability, and fear that in terms of human evolutionary history and human biology, which have molded each other, we on the summit of the evolutionary

pinnacle are in the unprecedented position of going against our own nature.

And what is that nature? Although as posttraditional people we are too sophisticated today to create God in our own image, we mistakenly infer the nature of human nature from our own. Yet it seems self-evident that one cannot expect to understand the nature of any creature by considering it only as it appears at one minute on one day—the most recent—of its life, and ignoring its previous history (its infancy, childhood, youth, and early maturity), assuming that none of that matters to the reality of the creature at, say, 6:50 P.M. on July 7 of his fortieth year. The evolutionary history of human beings, when their biological and psychological needs were being formed and refined, is so long that the last two or even ten thousand years, which is what we mean by "human history," is no more than one minute of a late afternoon in the total life of a mature person—the rest of human evolution occupying the two million or so minutes that preceded it.

It is precisely all those millennia in the background that give me pause. How can we contravene 99.9 percent of our history? Our society and values and way of life are unquestionably unlike those of the thousands of generations that made us, and what we have become seems to have a life of its own that no one appears able to redirect or decelerate.

In the history of our species, human nature and a way of life evolved together, ensuring that both would be congruent, that people would find their life acceptable, and life would be amenable to people. This natural congruence has now, especially on its highest slopes, gone awry. Not only is advanced man no longer fitted for human life; modern life is no longer fitted for human nature.

Those who would transform the world or solve its problems must choose whether to begin first with the society or the individual. Because art is today divorced from the communally shared rituals that once maintained and reinforced society, those who call upon art to effect social improvement are taking up an instrument as outmoded and irrelevant to modern needs as a hand ax.

And although art in its present Western sense can indeed affect individuals—by intimating to them "universal meanings" and by enriching, deepening, and ramifying their experience—it is questionable whether, abstracted from social life, it will have any ef-

fect on the evolutionary fitness of the species. Because human beings have evolved to live together committed to one another in social groups, it would seem that individual attempts to find only individual fulfillment perilously ignore the constraints of the human heritage.

And indeed, except for a few singular persons who have somehow achieved the goal of needing no commitment to truth and have accepted their own isolation, the mass of posttraditional persons remain—in spite of their "freedom" and "self-knowledge"—pitiably unfulfilled. We are increasingly lonely, because increasingly self-absorbed, and a momentum no one can check or retard relentlessly pushes yet others into this chasm of apartness that is concealed by the alluring blandishments of self-fulfillment.

Such seems the inevitable end result of the literate mentality—the modern isolate individual aware that everything comforting is an illusion, that there is no one truth or one reality, that if truth exists it is individual (inner) and must be individually created through self-knowledge, that art (coherence) and truth are where individual self-aware persons find and create them.

Yet one could suggest that there is a further point that analysis and detachment can take us, and that is to something like the view described in Chapter 1. There I outlined what was called the "bioevolutionary view" and called for a new "heliocentrism," which might be better termed "species centrism." That is, rather than taking oneself and one's immediate kind as the norm for human nature and looking for fulfillment in the aggrandizement and exaltation of oneself (and kind), try to detect that ideal construct and that fulfillment, insofar as it is possible, in the lives of humans who are closer than we to our original environment of adaptedness.

This might sound like a late twentieth-century version of "noble savagism"—looking to the lives of primitive and prehistoric peoples with respect and the expectation of enlightenment about our own nature and proper direction. Like Rousseau's, our modern version of the myth is based on a troubled awareness of the discontents that accompany civilization. Fortunately, we have in addition a much broader understanding of the range of complexity and variation of "man in a state of nature"—detailed descriptions of the lives of hundreds of human groups, as well as knowledge of evolutionary biology and prehistory. We may be more needful than Rousseau, but we are certainly less naive.

Does it not seem reasonable to presume that all humans pos-

sess certain deep-seated needs and predilections, reinforced by emotion, which guide and constrain their behavior—needs and predilections that were adaptive in the environment in which the species was evolved. As with other animals, these needs and the unique species' way of life would have developed through a mutual feedback, so that the needs would be filled directly by the forms in which daily life was led.

Although critics of this view concede that there may be some trivial and uninteresting general biological needs (e.g., for sleep, for security), they are reluctant to admit the possibility that psychological "needs," which are so obviously amenable to cultural conditioning, could be biologically programmed.

But I suggest that it is neither trivial nor farfetched to presume that humans are biologically predisposed to certain tendencies that would have been evolutionarily advantageous and that are to be seen in all human groups, for example:

• Humans tend to construct, accept, and share with others systems that explain and organize their world as perceived and known, and feel uneasy without such explanation and organization.

• Humans tend to require the psychological (as well as physical) security of predictability and familiarity of knowing and accepting their role and place in life, and feel uneasy without such predictability and knowledge.

• Humans require psychological ratification or certification by others—by being an integral part of a group or family—and feel uneasy without this certification.

• Humans tend to bond or attach to others, and feel incomplete without this attachment.

• Humans recognize and celebrate with others of their kind an extraordinary as opposed to ordinary dimension of experience, and feel unsatisfied without it.

• Humans tend to engage in play and make-believe, and feel deprived if unable to do so.

What is wrong with calling these tendencies biologically endowed needs? Part of human nature? All over the world, individuals in social groups, particularly those closer to the environment in which we were evolved, display them and satisfy them to greater or lesser degrees. In historic times, after the rise of civilizations, we can see that in many societies these needs are not filled so completely or comprehensively, resulting in what

might be called deformations of a fairly stable, universal human nature (an ideal construct, perhaps, and never completely realized, but an entity like a "species" or "model" with identifiable, specifiable, fairly uniform characteristics).

It seems safe to say that the greatest difficulties humans struggle with today are to be found in areas where we have diverged the most from the environment in which humankind evolved—from the ease with which we put on weight while living our individual affluent and sedentary lives to our scandalously irresponsible squandering and ignoring of the earth's resources, including the rest of the people on it, as we and the Russians perform our vain, insane, dangerous, and improvident ever-escalating display of who is bigger and better, mightier and righter.

As individuals we can eat less and exercise more, though it is not easy to contravene powerful urges. But it seems that humankind as a whole is not yet able to go beyond narrow chauvinism to the essential recognition (apparently contrary to "human nature" and therefore accessible only to the detached literate mentality) that *it is our specieshood, not our nationhood or race, that unites us.*

The lingua franca in Papua New Guinea (Tok Pisin or "pidgin") contains a much-used word, *wontok,* which refers to those who speak the same language ('one talk'). In a country with seven hundred separate languages, one's *wontok* is a close ally, someone who is like oneself, someone to trust and rely on. Can we all come to realize that the language of our DNA makes us all *wontoks,* and that until we become allies, proud of our similarities, willing to share our possessions, unafraid to trust and be trusted, nothing will change or can change?

Although the bioevolutionary view attributes our greatest human problems to living with pre-Paleolithic needs and tendencies in a postindustrial world, it must recognize the impossibility and undesirability of returning to the days before hospitals and anesthesia, before Gutenberg, before Beethoven, before the internal combustion engine. But it reminds us that our basic nature evolved without these things, and a much simpler way of life than ours has been satisfying and rewarding to multitudes. If we look anew at our problems (which are products of unmet or conflicting needs now expressed in inappropriate and therefore perilous circumstances), we might see why we feel we can improve things only by acquiring or consuming more, exercising more power by showing off and threatening our "enemies," seeking more thrills and novelty, and so forth. These "solutions" seem to be taking

us nowhere in our present environment, innocuous and "natural" as they may have seemed in a less crowded, less potentially explosive, less resource-depleted, less interdependent world. It is not that we have to be slaves of our needs—different cultures shape them so they are satisfied in multifarious ways. But until we see them for what they are, they can and will cause unnecessary, perhaps damaging suffering to ourselves and others.

In the dangerous modern world, the bioevolutionary worldview seems especially appropriate. The comprehensive systems of explanation that have satisfied humans in other times and places are today seen by some of us as oversimplified, partial, if not touchingly naive. The usual answers to "Why" (the world is as it is, we are as we are)—because it is God's will or a divine plan, because of fate, because of tradition ("the way it always has been"), because of historical necessity or manifest destiny, because of economic determinism, because of the innate superiority or inferiority of one or another group of people—no longer seem relevant or plausible. Yet we still hunger for an acceptable myth to take the place of the old explanations, something by which we can live.

If we cannot look to God or the gods for guidance—the bioevolutionary approach says—then look to what is eternal and needful of satisfaction in ourselves. "Know thyself," said a wise man—many wise men. Today it seems impossible to know oneself without also knowing other humans, humankind as a whole.

Never before have people in one time and place known so much about other people in other times and places. Never before has the amazing diversity of human customs and beliefs, worldviews and ways, been so apparent. Although this pluralism of human possibility, the evident workability of numerous belief systems, is one cause of our confusion (because it calls into question the unassailability of any one belief system), it is as well the most realistic and promising source, says the bioevolutionary view, in which to seek our salvation.

Granted, it was more comfortable when people knew only their own tribe and its traditional ways. Then there was no doubt about the wisdom of the way we led our lives or the correctness of our answers. Most people still occupy this haven, but it seems to be the incubator for our present untenable and ultimately perilous global inequality and instability.

The bioevolutionary worldview suggests that there is an alternative to blinkered parochialism (epitomized by the linked lunacies of nationalism, racialism, greed, and the arms race) or the

despair (*angst*, nausea, absurdity) of limitless choice (the "Everything is possible" of Dostoevsky). Among the multitudinous human possibilities and individual differences, we might still discern regularities, similarities, universals. A knowledge and understanding of fundamental human nature, and a respect for it, could guide our behavior and serve as the model for a truly "humane"—though individually varied—life for all.

Whether or not we personally or professionally are engaged in the study of human nature (and by extension, our own nature), it seems clear that knowledge about the nature of human nature lies behind the majority of today's pressing concerns: How can we get along together? How can we control human aggression? Wherein lies happiness? What is the "good life" that we should try to achieve for our children? And for the rest of the world that we feel obliged to help in its "development"?

We have moved far from the immediate question dealt with in this book. I will venture to conclude, however, that what the arts were for, an embodiment and reinforcement of socially shared significances, is what we crave and are perishing for today.

Notes

Introduction

1. I generally use the prefix "bio-" to avoid the misunderstanding that might attend talking about simply the "evolution of art," which has a tradition of being discussed in terms of cultural evolution.

2. James (1941:27–28) said that knowledge of existential facts is not sufficient for assigning value; to do that, one must start from a separate theory of value about what is and is not good, and fit the existential facts into that.

3. My opinion, however, is that this is unlikely. What is generally called "aesthetic" response seems more complex than a one-to-one response to a color or even a configuration. Indeed, it is now thought to be based on at least tacit acquaintance with a "code" of symbolic representations (i.e., requiring a learned or cognitive element); this in itself suggests that reflexive or innate actions would be of limited significance in the total response, though they may well influence its general outlines. (See also Chapter 6, p. 160 and note 26.)

Chapter 1. The Biobehavioral View

1. Writers who have listed essential components of human nature include Barash (1979), Midgley (1979), Tiger and Fox (1971), Wilson (1978), and Young (1978).

2. It is interesting that Darwin did not even use the word "evolution" (Gould, 1977:34–38).

3. Critics of sociobiology such as Stephen Jay Gould (1977:238), who should be more perspicacious, often aim their spears at its "crude biological determinism." Those who "attempt to reintroduce racism as re-

spectable science," "fob off the responsibility for war and violence upon our presumably carnivorous ancestors," or "blame the poor and hungry for their own condition" (Gould, 1977:239) deserve to be quashed or ignored, but do not keep company with any sociobiological thinkers I know (including the writers Gould cites in this particular critique).

4. For an expanded discussion of the concomitants and consequences of "civilization" see Chapter 7.

Chapter 2. What Is Art?

1. For the above synopsis and subsequent comments on the history of Western ideas about art, I am much indebted to Osborne (1970). Boas (1927), d'Azevedo (1958), and Maquet (1971) have made thoughtful, well-informed, and valuable contributions toward a universally applicable aesthetics, but since these are not conceived within a biobehavioral, evolutionary framework, I have not attempted to integrate their ideas with my own.

2. See, for example, Kreitler and Kreitler (1972). Definitions of art usually include at least some of the following claims: art is the product of conscious intent; art is self-rewarding; art tends to unite dissimilar things; art is concerned with change and variety, familiarity and surprise, tension and release, bringing order from disorder; art creates illusions; art uses sensuous materials; art exhibits skill; art conveys meaning; art conveys a sense of unity or wholeness; art is creative; art is pleasurable; art is symbolic; art is imaginative; art is immediate; art is concerned with expression and communication. None of these, however, is characteristic only or primarily of artistic behavior. The present analysis of art does not deal with such traditionally ascribed attributes.

3. Biological bases for responding to certain specific details and not others in matters of preference and taste are among the most baffling questions in psychological aesthetics. If our basic premise is true—that behavior originates in the brain, that the brain evolved, therefore the behavioral choices it mediates should generally be selectively better than the ones it does not—then there must be selective reasons for at least the most widely shown and recurrent aesthetic choices. The question will be addressed more closely in Chapter 6.

For the present it is enough to point out that life is choice. It is essential for every living creature to be able to classify external objects and circumstances into positive and negative, good and bad, helpful and harmful, pleasing and displeasing, and so forth. That we have such an ability is not the least surprising. That it should be refined to the degree it is, and that perception of such small differences should have such strong effects, are perplexing, as well as sources for wonder and gratitude (see also note 3 of Introduction, above).

4. Again, I am indebted to Osborne (1970). Recurrent stereotyped notions of "the artist" from late classical civilization to the present are surveyed in Kris and Kurz (1979). See also Malraux (1954:53): "The Middle Ages were as unaware of what we mean by the word "art" as were Greece and Egypt, who had no word for it."

5. I concede that during the whole spectrum of the existence of the human species some persons may have made aesthetic objects or performed aesthetic activities solely for their own sake, for detached aesthetic contemplation. I would surmise that these would have occurred in "minor" arts without great social import—perhaps in the arts of women, which have not received much anthropological attention. (See also the section on Play.) The institutionalization of such a practice or attitude by the most influential persons of the society, however, has been confined to the past century or so in the modern West.

6. Other societies that are well known for a high degree of integration of art with life are Bali (Geertz, 1973; 1980; Covarrubias, 1937; Belo, 1970); Java (Geertz, 1959); Maroon (Price and Price, 1980); the Australian aborigines (Strehlow, 1971; Maddock, 1973); Eskimo (Carpenter, 1971); Trobriand Islanders (Malinowski, 1922:146–47). See also Chapter 7, pp. 168–69 and notes 1–6.

7. An admirably comprehensive survey of "aesthetic" activities and propensities in nonhuman animals can be found in Sebeok (1979).

8. The subdivisions of the Paleolithic—a period of about one million years—are based on techniques of stoneworking and on the principal types and shapes of stone tools. The Lower Paleolithic lasted for the greater part of the Ice Age (until about 100,000 B.P.), followed by what is called the Middle Paleolithic. The Upper Paleolithic began during the last of the four major periods of glaciation, about 30,000 years ago (Ucko and Rosenfeld, 1967:9). Fully modern man, *Homo sapiens sapiens*, arose about 40,000 years ago and lived for the next ten thousand years side by side with more archaic and now extinct hominid communities.

9. I am grateful to Desmond Morris (pers. comm.) for this superb analogy.

Chapter 3. What Does Art Do for People?

1. Two investigators concerned with the psychology of art, Hans and Shulamith Kreitler (1972), have compiled a list of different things that art has been said to do by writers on philosophy, history, criticism, and aesthetics, as well as novelists and poets. These include assertions that art reveals immanent truth; makes concrete an ideal or metareality; presents naked reality; creates a blissful fantasy world; confronts and resolves private contradictions and conflicts; revives lost time and repressed childhood; promotes self-knowledge; delineates ethical norms

and religious modes of acting; presents values; enunciates social rules; and reveals eternal laws. Many of these proposed functions of art are of course irrelevant to a concern with evolutionary significance, and most can be performed by other kinds of experience and behavior. It is clear also that many assertions of function are normative, concerned with prescribing what art *should* do, and thereby defining what is to be considered as "true," "good" art. According to the interests and values of their authors, they emphasize ethical, political, theological, and other systems that are or should be served by art.

2. See, for example, Victor Turner's (1969) discussions of liminality and communitas.

3. Such as, for example, *ludruk,* a kind of proletarian drama in modern Java (Peacock, 1968).

Chapter 4. "Making Special": Toward a Behavior of Art

1. The best-known proponents of "play theories" of art, in various forms, are Schiller (1795), Herbert Spencer (1880–82), Freud (1908), and Johan Huizinga (1949). Such theories assume that an adult's art is somehow an extension of his play in childhood, that an artist substitutes artistic fantasy for the make-believe and play he enjoyed as a child. Although this observation has some validity, it is much too limited to serve as the basis for an entire aesthetic. Play theories of art, like early theories of play, are inadequate, because they isolate one strand in the total phenomenon and neglect or ignore the rest.

2. For example, the history of a championship game may be permanently recorded and studied later as a significant entity in itself, unique, unrepeatable, a model of its kind, and so forth.

3. An example is the infant's smile that automatically releases maternal behavior and protective behavior in others (Huxley, 1966:264), and is reciprocated by them. Facial expressions of pleasure and displeasure are in large measure considered to be innate (they appear in born-blind children who have not been able to see these expressions in others). Well-known innate expressions that unambiguously indicate the mood or probable behavior of humans to each other are frowning or staring (indicating aggression) or smiling (friendliness), which call forth responses from others and thereby serve to maintain distance and consequently reduce aggression, or to express friendliness and receptivity and consequently facilitate and strengthen social ties. (See also Ekman, 1977.)

4. For example, James Fernandez (1969:12) states that the group unity that is produced in Bwiti cult ritual is "sorely lacking in kin affairs in the larger . . . society." A forceful statement of the entire position is the following: "The real objective [of Nkula ceremony in the Ndembu]

is to reintegrate a conflict-riven social group. . . . In the rites ideal values and standards are brought vividly before the people in a situation where this model or blueprint was being challenged or threatened. . . . The organizing principles behind society are stated in the symbols and in their exegesis by adepts to candidates, under the stimulating circumstances of dance, song, sacrifice, the wearing of special dress, and the performance of stereotyped behaviour" (Turner, 1966:302).

5. For example, when the Lega of the eastern Congo Republic decide to use an artifact (which we would call, from its appearance, an *objet d'art*) in their *bwami* ritual, they thereby consecrate it, changing its status from ordinary to special (*"isengo"*) (Biebuyck, 1973:157–58).

6. One can also get involved in the labyrinth of making already special things more special—but this is carrying criticism to an absurd and unavailing degree.

7. Thus I would call the Acheulean hand axes on page 54 an instance of "making special"—or perhaps even art.

8. One can, of course, make the observation that successful present-day artists or collectors of the arts may by their activities enhance their status and prestige, display their superiority in ability, wealth, or power, and so forth, thereby affecting their fitness. The refreshment, and therapeutic benefits, afforded by various contemporary arts may also be life enhancing. But to evolutionists who use a time scale of hundreds of generations, speculations based on the predilections of and benefits to a few atypical individuals in a small area are of little value for suggesting species trends—the subject, after all, that human ethologists are concerned with.

Chapter 5. The Evolution of a Behavior of Art

1. This view is held by numerous investigators of Upper Paleolithic cave painting. See the discussion in Ucko and Rosenfeld, 1967.

2. These theories may be found in Frances Dahlberg, (ed.), *Woman the Gatherer* (New Haven: Yale University Press, 1981) and Nancy M. Tanner, *On Becoming Human* (Cambridge: Cambridge University Press, 1981).

3. Monkeys and apes are usually indifferent to which hand they use, and the acquisition of greater skill in one hand is a human trait linked with the dominance of one side of the brain, and doubtless connected with the habitual use of tools (Oakley, 1972:38).

4. Alexander Marshack stresses the importance of this ability in human evolution, an ability that he calls a "cognitive [time-factored, time-factoring] ability to think sequentially in terms of process within time and space" (Marshack, 1972:79). According to Marshack: "Every process recognized and used in human culture becomes a story, and every story

is an event which includes characters . . . who change or do things in time. . . . Since every story can potentially end in a number of ways, efforts would be made to participate in the story, and therefore, to change or influence the story or process or to become meaningfully a part of it" (p. 283).

5. The question of priority or significance apart, speech can justifiably be called a kind of tool (Oakley, 1972:31).

6. The inferior frontal convolution (Broca's area) of the brain of *Australopithecus* was minimally developed, and it is hypothesized by some that he had no complex verbal language (d'Aquili and Laughlin, 1979:166). The same authors conclude that *Homo erectus* would probably have been a complex mythmaker and practitioner of religious ritual, implying that language was by then well established.

7. d'Aquili and Laughlin (1979:166) postulate that the world of *Australopithecus* was probably ordered in rudimentary conceptual opposites.

8. Alexander Marshack (1972) identifies the generalized ability to understand and communicate the time-factored meaning of a process or story as being the basic humanizing intellectual skill. For communication, he says, "it is not merely a matter of understanding or meaning that is important, but memory, capacity for comparing, learning, mimetic and kinaesthetic understanding, synthesizing and abstracting relational concepts and concepts in a time-factored geometry" (Marshack, 1972:177), that is, a development of a complex mental process that includes many interrelated abilities, among which Marshack includes the capacity for expression and recognition of feelings and states in others (p. 117).

9. See Lumsden and Wilson (1981) for a recent discussion of what is called "gene-culture coevolution."

10. See Dawkins (1978), Chapter 11, for a model of how units of culture (ideas, tunes, technological practices, etc.) might replicate and evolve.

11. Darwin himself recognized the importance of social factors in addition to specifically biological ones in human development. He mentioned that the necessity to rely on one's fellows would not be likely to arise in a ferocious and strong creature, so that man's "higher mental qualities, such as sympathy and love of his fellows" are probably due to his being relatively weak (cited in Weiner, 1971:44), and he explained the acquisition of social qualities in humans as in many lower animals by natural selection (pp. 53–54).

12. Affects have been defined as "sets of muscle and glandular responses located in the face and also widely distributed through the body which generate sensory feedback which is either inherently 'acceptable' or 'unacceptable.' These organized sets of responses are triggered at subcortical centers where specific 'programs' for each distinct affect are stored. These programs are innately endowed and have been genetically inherited. They are capable when activated of simultaneously capturing such widely distributed organs as the face, the heart, and the endocrines and

imposing on them a specific pattern of correlated responses" (Tomkins, 1962:243–44).

What we are accustomed to call "emotions" have very definite and localized physical determinants (Young; 1974:479), and therefore can well be acted on by natural selection.

Chapter 6. The Importance of Feeling

1. From *The Advancement of Learning* (see Carritt, 1931:54).

2. See also John Dewey (1958:255).

3. They are thought to have migrated from northeast Asia and settled the New World between fifteen and ten thousand years ago, or perhaps even earlier.

4. Also cf., "Perhaps the emotional state sought for by those who turn to alcoholic spirits is *au fond* a spiritual state access to which is not available otherwise" (Hillman, 1962:236).

5. The motifs appear to be fixed in interpretation and, according to G. Reichel-Dolmatoff (1972), refer to aspects of sexual physiology which in their turn refer to the Tukanos' laws of exogamy and other primary concerns of the group that are reflected in myth and ritual.

6. Artists other than musicians can also be considered to be deviants (although in at least one society, the Gola, artists are rather admired for their association with the mysterious—see d'Azevedo, 1973). Pertinent to this subject is the recent recognition in the West of what is called *l'art brut*, "raw art" or "outsider art," which comprises works by lunatics, prisoners, mediums, and other "marginal members" of Western society, and which now has its own public museum in Lausanne (see Thevoz, 1976; Cardinal, 1972).

7. I am aware of the controversy that surrounds Bowlby's position on the importance of a single mother figure (attachment figure) to a child. I am not prepared to join in the battle, except to point out that from an evolutionary point of view his observations seem remarkably sound. However, children are human beings, and human beings are adaptable, so they may learn to cope—for better or worse—with maternal deprivation or maternal substitution in early life; their evolutionary heritage would not be likely to have made this coping either simple or easy.

8. More recently, close and long-lasting mother-infant association in great apes has been described for chimpanzees (van Lawick-Goodall, 1975) and orangutans (Galdikas, 1980). Goodall sees these as "enduring relationships" and has witnessed signs of considerable distress and mourning by the young chimpanzee when its mother dies.

9. The person to whom the baby attaches is of course usually its mother, who also cares for and feeds it. Institutionalized children form attachments to one person, regardless of whether that person feeds them and looks after their bodily needs.

10. Bowlby (1973:84) points out that these fears are displayed in some degree throughout life and are shared with animals of many species. They are a natural disposition of man and not to be considered infantile or neurotic.

11. People in societies other than our own show symptoms of impaired attachment. In her description of the people of Alor, Cora Dubois (1944) gave evidence of the emotional impoverishment that attends the discouragement of attachment by an entire society. She found that there was a shallowness of positive affect (p. 160), little feeling of sacredness attached to any idea or paraphernalia (p. 47), a slipshod casualness toward ritual observances (p. 129), and a lack of interest in intoxication or abandon (p. 154). An analysis of drawings by Alor children (compared with those by children in another primitive tribe, the Naskapi, who also had never before drawn with pencil and paper) revealed them to be poor at seeing or establishing relationships, unimaginative, and poor at showing design, composition, and action (pp. 583–84).

12. I cannot here discuss anomalies in Western adolescents or adults of this propensity to attachment—such as fear of attachment or a close relationship, avoidance of possibilities for losing "control" or "losing the self." These would however be explicable by the theory as perversions of the original propensity to attach.

13. See Erikson (1966), Rank (1932:113), Stokes (1972), and Freud (1939) for discussion of the "oceanic feeling" and "restoration of lost union."

14. W. T. Jones (1961) proposes that various cultural products (intellectual and material) can be understood as expressing positions taken (unconsciously) in respect to these axes: static-dynamic, order-disorder, discreteness-continuity, spontaneity-process, soft-sharp focus, inner-outer, this world–other world. Edmund Leach (1972) remarks that in our categorization of what is considered to be normal or abnormal, we often metaphorically use geometric shapes, such as straight-honest or crooked-dishonest. J. Z. Young (1978:234) contends "that works of art satisfy in proportion as they epitomize and bring to the surface . . . basic features of our life programs" (i.e., the neurologically organized ways in which the brain guides the human organism in order to maintain its life). See also Lakoff and Johnson (1980).

15. Cf. George Santayana (1896, sec. 13): "The whole sentimental side of our aesthetic sensibility—without which it would be perceptive and mathematical rather than aesthetic—is due to our sexual organization remotely stirred."

It would be interesting to make a collection of unsubstantiated statements linking art and sex. There is, for example, Freud's rather astonishing statement that "a [sexually] abstinent artist is hardly conceivable, but an abstinent young scholar is certainly no rarity" (Freud, 1908). Freud (1905) also considered that the concept of the beautiful has its roots in sexual excitation, a statement with which Roger Fry (1924) agreed but

with the rider that the two have become remote in the course of development. Apparently the "excess" that is traditionally associated with artists is presumed to include sexual manifestations.

16. See Robert Greer Cohn (1962), "The ABC's of Poetry," *Comparative Literature* 14(2):187–91.

17. I am certainly not denying that an often very great intellectual component is integral to artistic behavior and appreciation, particularly in what are considered to be the "greatest works of art." Here I am concerned to emphasize the sensuous components of all art, features that can be responded to sensually apart from their formal coherence, intricate combinations and the other factors that are necessary to fuller and more complex aesthetic satisfactions.

18. Herbert Benoit (1955:8) has mentioned the remarkable creativity and excellence of expression that appear in quite ordinary people when they are in love. See also Barzun (1974:75–76) for comments on the similar effects of love and art.

19. Marcel Jousse (1978) has shown the intimate linkage between rhythmic oral patterns, the breathing process, gesture, and the bilateral symmetry of the human body in ancient Aramaic and Hebrew targums, and thus also in ancient Hebrew.

20. T. G. H. Strehlow's (1971) impressive and comprehensive study of Central Australian song presents a contemporary example of the combined arts serving communal purposes like those Havelock suggests for Homeric Greece, and by similar means.

21. I am aware that not all rituals are pleasurable and that elements of some rituals may be distinctly uncomfortable. There are other routes than aesthetic pleasure to effectiveness and memorability. In addition, other fundamental human requirements, such as the need for explanatory power, for a sense of meaning or significance, and for attachment to others could also have predisposed humans to establish rituals. Yet it seems reasonable to say that, in general, ritual ceremonies would tend to develop concurrently with pleasurable aesthetic satisfactions that ensured an enjoyable as well as effective, accurate performance.

22. Just as one can assume that societies whose members performed their rituals perfunctorily would be less cohesive and less selectively successful than those that did not, it seems likely that groups or individuals who joined aesthetic pleasure to adaptively dysfunctional ends presumably did not survive to perpetuate them.

23. Not every ecstatic felt all these things; these, and the others that follow, were commonly reported feelings.

24. Laski calls otherwise significant and memorable but less-than-ecstatic experiences "response experiences."

25. Incidentally, the Indian view would agree with this. It maintains that while *gunas* (the pleasurable sensuous elements of art) and *alamkaras* (the conscious decorative elaboration and technique) which relate to the

external body of art are within the appreciative reach of everyone, only a cultivated aesthetic sensibility can enjoy the supreme delight of *rasa* (Krishnamoorthy, 1968).

26. The concept of "code" permeates contemporary thought in every field whether or not the approach is semiological. Although I too find the notion of code useful, I am aware that my use of the term may not satisfy semiologists or other specialists in information theory. The use of the notion in this present context is no doubt imprecise but adequate for my general statement. Leonard Bernstein, in his Norton lectures at Harvard (1976), has persuasively illustrated the way a musical code may operate, a formulation that has also been called by Leonard B. Meyer (1969) a "pattern of expectations" (that such a tone or chord is likely to follow another, and when it does—or does not, with a difference—emotional response is engendered).

27. In Tikopia society, the only plastic art in which there is variety is in the carving of headrests. Raymond Firth (1973:32) says, "One may speculate that in this field, where the objects are of a highly personal character, traditional form is on the whole less important, and [individual] initiative and aesthetic interest can find play." Yet in the highly important Gelede spectacle of present-day Yoruba society in Nigeria, individual participants in the ritual do shape it to reflect their own concerns, situations, and aesthetic preferences, thereby encouraging and incorporating innovations (Drewal and Drewal, 1983:247).

28. By this statement I do not mean to deny that there may be unconscious factors that direct or influence artistic creation, nor that artists may be unaware of certain implications of their works that a later perceiver or critic might be able to discern and establish. But the artist "knows" when he has "got it right"—whatever the nature of this "knowing" or "it" may be.

29. Art can, of course, be responded to in many ways—not only aesthetic-intellectually and sensual-automatically: it can evoke memories, stimulate associations, soothe, excite admiration or awe, and so forth. Here I am concerned with two major modes of appreciation of the elements of a work *in themselves*.

30. What has been said about music can be applied *mutatis mutandis* to the other arts. Music is most relevant to our discussion because it resembles ritual ceremony in its structure and manner of effect. Also, being nonreferential, music requires by its nature a "detached" or more "purely aesthetic" form of appreciation unlike visual arts, which may appeal more directly to practical, nonaesthetic life.

31. It is now generally agreed that at a very early age children have an inherent predisposition to acquire the elements of the language that is in use about them, appearing to understand its rules, as it were, unconsciously and intuitively. The capacity to use and understand artistic codes may be a similarly endowed ability, occurring in a way that would seem to be inherent and not requiring reason as that faculty is usually

understood. The operations of code following and code use in the arts, as in language, resemble an unconscious appreciation of the working out of a sequence in a grammar and syntax that are recognized intuitively, not rationally and consciously constructed (see Bernstein, 1976, for a provocative reconstruction of the "deep grammar" underlying musical construction and appreciation).

If we accept this general picture of the way in which the appreciation of a code is acquired, there is no contradiction in asserting that there is a cognitive or intellectual element in aesthetic experience, even though at the same time it is claimed that in ecstatic experience reason is suspended.

Chapter 7. From Tradition to Aestheticism

1. "Eskimo . . . do not put art into their environment; they turn the environment itself into an art form" (Carpenter, 1971:203).

2. "The plan of life itself, it is believed, is communicated in the configuration of the landscape, the events narrated in myths, the acts performed in rites, the codes observed in conduct, and the habits and characteristics of other forms of life" (Maddock, 1973:110).

3. "Balinese social relations are at once a solemn game and a studied drama. This is most clearly seen in their ritual and (what is the same thing) artistic life, much of which is in fact but a portrait of and a mold for their social life. Daily interaction is so ritualistic and religious activity so civic that it is difficult to tell where the one leaves off and the other begins; and both are but expressions of what is justly Bali's most famous cultural attribute: her artistic genius" (Geertz, 1973:100; also see Geertz, 1980).

4. ". . . the ascent from the uncivilized animalistic peasant to the hyper-civilized divine king takes place not only in terms of greater mystical achievements, more and more highly developed skills of inward-looking contemplation and refinement of subjective experience, but also in greater and greater formal control over the external aspects of individual actions, transforming them into art or near-art. In the dance, in the shadow play, in music, in textile design, in etiquette, and, perhaps most crucially of all, in language, the aesthetic formalization of the surfaces of social behavior permeates everything the *alus* Javanese does" (Geertz, 1959:233–34).

5. "These natives are industrious and keen workers. They do not work under the spur of necessity, or to gain their living, but on the impulse of talent and fancy, with a high sense and enjoyment of their art, which they often conceive as the result of magical inspiration" (Malinowski, 1922:172). ". . . in gardening, fishing, building of houses, industrial achievements, there is a tendency to display the products, to

arrange them and even adorn certain classes of them, so as to produce a big aesthetic effect" (Malinowski, 1922:146–47).

6. See the account in Chapter 2.

7. Some of the American university students who in the 1960s violently demonstrated and protested against the authoritarian methods of established social institutions, such as the "military-industrial complex," showed at the same time a perhaps surprising interest in the novels of Jane Austen. What they seemed to find so attractive, explained Lionel Trilling (1976), was that the world portrayed in these books presupposed a kind of formal beauty and gentle proportion in life, a satisfying predictability based on a commonly accepted communal framework of beliefs and values and manners of conduct. One might expect that Jane Austen's polite art and world would have seemed stifling and repressive to these young people, so concerned to question authority, disdain etiquette, and demand the right of individual expression. It is both ironic and suggestive that the unbuttoned inheritors of democratic pluralism, who expected inside and outside the classroom to "do their own thing," at the same time found admirable and attractive the tightly controlled depiction of a tightly controlled, stratified society.

8. The concept of "civilization," like that of "evolution" in Chapter 1 and "primitive" in Chapter 2, should not have a value connotation.

9. I am aware that an adequate discussion of the history of Western culture should certainly incorporate economic factors, which many would say are the fundamental ones. My omission of this crucial aspect of the subject is due to lack of space and competence, rather than to lack of appreciation of their integral importance to any account that aspires to be comprehensive.

10. Plato may have been the first person that we know of to recognize the difference between a preliterate and a literate mentality when he vehemently attacked poets and poetry as being subversive. Poetry, to Plato, was oral recitative that could be used by tribal society to work up its members to an irrational state of psychological surrender and receptivity to indoctrination. To the literate mentality, represented by philosophers such as Plato, the "poetic" mind of the early Greeks would have been disruptive to the rational conduct of the state (Havelock, 1963:156–57).

11. Japan would appear to be an interesting exception to this generalization. Discussion of the reasons why Japan, though a highly literate society, has not acquired all the concomitants of the literate mentality (and of the acquisitions that may be unique to the Japanese) would take us too far afield here.

12. Jazz and rock concerts and performances of Indian and Indonesian music, where composition and performance are the same, resemble preliterate "entertainment." They can be adjusted to the context (a restive audience, an unexpected guest or recent incident) and elaborated or shortened accordingly. In literate Western society, however, "classical"

music relies on a written, well-rehearsed score which must not be deviated from. Signs of audience approval are restricted to applause at the conclusion of the performance.

13. Cf. also Roger Caillois (1978) who, in *Le fleuve Alphée*, explicitly proclaims that whatever is good and authentic in his life has survived from his earlier years before he learned to read. Although like Sartre, once he began to read he read compulsively, his reading did not confirm him in the imaginative pleasures in which he was already practiced, but rather alienated them—in that words and names for things and other people's ideas about them replaced the things themselves.

14. For a fascinating history of the development of the reading habit and of fiction, see Leavis (1932). Also see "The Work of Art in the Age of Mechanical Reproduction" (Benjamin, 1970), "La Conquète de l'ubiquité" (Valéry, 1964), and Malraux (1954).

15. Or, carrying this pursuit to its ultimate length, they proclaim that clarity of language or thought is an illusion, for the writer or thinker himself can never be entirely aware of the entire meaning of his thought while he is thinking it: there will always be uncertain and contingent and hidden factors in language that give it a "polyvalent elusiveness" (Montefiore, 1980).

16. Recently we have learned about the kinds of mentation that are associated with the right and left hemispheres of the brain. It has been cogently argued (see Jaynes, 1977) that in early human history the two hemispheres were more cooperative than at present and that the kind of thought referred to here as undifferentiated, global, nonverbal, and poetic was the normal human mentation. Our account of the civilizing process based on Elias's analysis would substantiate and be an extension of Jaynes's views.

17. Several centuries according to Pieris (1969:27).

18. To be disabused of such notions, see, for example, Griaule (1965).

19. Until very recently, advanced operational thought has not been necessary for postprimitive life, and even today many Western people rarely have need to employ it to a high degree. Modern schooling does, however, put a premium on the ability to examine and analyze things critically outside their concrete context. See Howard Gardner (1983) for an engrossing examination of mental abilities ("intelligences") other than the verbal and logico-mathematical.

20. Compare the Indian cinema of today, or the majority of Western movies of the 1930s and 1940s (the stereotyped "Hollywood" variety), with current Western taste in film.

21. Such an assertion is the logical conclusion of current discoveries about the structure of the human brain, particularly what is known about sense perception—for example, "feature detectors" in the visual cortex that limit what can be perceived (Young, 1978:40 ff.). Thus "It [the cerebral cortex] constructs a *description* of outside reality, a *model* in which it has confidence and sufficient faith to speak. . . . What our perception

provides us is an 'image of truth,' which we trust as a measure of reality" (Blakemore, 1977:65).

Piaget emphasizes the cognitive character of perception, demonstrating that it is not, as commonly thought, a mirror image of the world: "To know is to assimilate reality into systems of transformations: it is to transform reality in order to understand how a certain state is brought about. . . . Our notion of reality is not an empirical given but is a continuous mental construction, an interaction between the knower and the known. Understanding is thus constitutive of the world. It is a characteristic of all such organizing activities, however, that the individual is unaware of his own part in constructing what he sees" (Gablik, 1976:26–27).

Also: "Ordinary consciousness, then, is each individual's private construction" (Ornstein, 1977:71).

The structuralists, mostly in France, are exceptions to this general epistemological position, as they posit and look for basic universal structural principles for all forms of human mental activity.

22. Philosophers whose work is consistent with this view, says Richard Rorty (1980), are Quine, Sellars, Davidson, Kuhn, and Goodman.

23. William James, in the quotation at the beginning of this section, was willing to propose that there might be many interpenetrating spheres of reality, but the analogy he used, that of mathematics, presumed that there was one basic reality with a number of perspectives from which to experience and explain it. Today, however, many go further than James and question whether one can postulate one basic reality.

24. Similarly, Ulrich, the hero in Robert Musil's *The Man Without Qualities* (written during the 1920s), followed a personal philosophy of "essayism," which means seeing everything from many points of view without ever comprehending it fully, "for a thing wholly comprehended instantly loses its bulk and melts down into a concept" (Appignanisi, 1973:83).

25. From the time of the Renaissance, historians have noted an increasing tendency for Western people to observe themselves and others (Elias, 1978:79). Both Dürer and, later, Rembrandt are well known for painting numerous self-portraits in different poses and guises. Literary forms also have reflected the increasing concern with private opinions and personal expression: in the seventeenth and eighteenth centuries personal correspondence developed both in volume and in idiosyncratic interest, as did memoirs and diaries. With increasing interest in psychological interpretation, the novel too evolved. Autobiography, viewing and constructing the self historically through the distancing medium of written words, was also established in the Renaissance, becoming an acknowledged literary form in the later eighteenth and the nineteenth centuries.

26. In a recent best-seller, *Passages* (Sheehy, 1976), the fact that one is alone and ultimately bears responsibility for one's own personal hap-

piness and fulfillment is offered as the acme of wisdom—a truth that would give scant comfort, if it could be comprehended, to the vast majority of human beings today who do not aspire to the values of modern America and whose cultures teach the opposite.

The teachings of the Buddha, however, are strikingly similar to those of the author of *Passages,* who so accurately speaks to the needs of the time. The present Western interest in Buddhist and other meditative practices, then, is not surprising. The person wishing to learn contemplation is advised to develop "mindfulness," observing his feelings and the contents of his mind in a detached way. The Buddha also teaches that the individual's destiny is in his or her own hands.

27. Cf. Freud (1939:92): "consolation . . . at bottom that is what they are all demanding—the wildest revolutionaries no less passionately than the most virtuous believers"; Otto Rank (1932:100): "I believe . . . that everything that is consoling in life . . . can only be illusional."

28. This has been done by at least three eminent anthropologists. In 1924 Robert H. Lowie wrote: "I shall not be afraid to suggest that sometimes the ostensibly religious is rather to be traced to an esthetic source than vice versa" (quoted in d'Azevedo, 1973).

Because it is a mode of "arranging human experience in cognizable patterns," religion is called by Raymond Firth "a form of human art" (Firth, 1971:241). Similarly, James Fernandez suggests that artistic activity precedes as much as it succeeds religious meanings and considers that the religious emotion may be a kind of aesthetic appreciation in respect to an ordering of symbols created through artistic activity (Fernandez, 1973:216).

The psychiatrist Ludwig Binswanger (1963:33), observing man's need for explanation and communion, posits "something like a basic religious category" in humankind, while Edwin Shils (1966:449) proposes that there is a "serious" dimension or category of experience in human life—a profound impulse to acknowledge and express the appreciation of which in words and actions of symbolic import, thereby showing commitment to it.

Philip Rieff (1966) refers to the "religion of art." See also Barzun (1974, Chapter 4) for a discussion of art as a substitute for religion and for direct, unself-conscious experience.

29. For example, Iredell Jenkins (1958) defines "aesthetic experience" as the awareness or recognition of the particularity of things. For Arnold Berleant (1970a:180), the function of aesthetic experience is to give us the opportunity "to *be* experience itself, more fully, more intensely, more purely, and with greater qualitative subtlety and variety than in any other situation." He admits that to the extent that worship, sport, and sociality may do this they merge with art: "Aesthetic experience is but life lived most richly, most completely. To that extent, it is not apart from life, an escape from life. Life, on most occasions, is rather an escape from art; it is usually alienated from itself."

30. ". . . my experience in helping people achieve insights from un-
conscious dimensions within themselves reveals [that] insights emerge
not chiefly because they are 'intellectually true' or even because they are
helpful, but because they have a certain *form*, the form that is beautiful
because it completes what is incomplete in us" (May, 1975:132).

31. Apart from the examples given in the text, one can discern in many
of this century's artists and thinkers a concern with what can be called
as well as anything "aesthetic questions." Among these one can men-
tion: the existence and nature of a universal human creative urge or im-
pulse (Prinzhorn, 1922; Rank, 1932; Jung, 1928), the psychology of the
artist (Rank, 1932), the preoccupation with the elaboration of emotional
experience, especially that given by art that is considered to be partic-
ularly potent (Richards, 1925; Berenson, 1896; Walter Pater's famous
pronouncement concerning "art for art's sake" in Carritt, 1931:187), the
construction of a personal reality, and the primacy of the individual
imagination (e.g., Wallace Stevens's poetry).

32. Walter Benjamin hoped one day to assemble a collage of quota-
tions, fragments torn from their context and arranged in such a way that
they illustrated one another and displayed their associative affinity with-
out additional commentary. According to Hannah Arendt (see her in-
troduction in Benjamin, 1970), Benjamin believed that the spiritual and
material manifestations of an age were so intimately connected that it
seemed permissible to discover everywhere Baudelairean correspon-
dences that clarified and illuminated one another if they were properly
correlated, so that finally they would no longer require any interpretive
or explanatory commentary. He was concerned with the correspondence
between a street scene, a speculation on the stock exchange, a poem, a
thought—with the hidden line that holds them together and enables the
historian or philologist to recognize that they must all be placed in the
same period (Benjamin, 1970:11, 47). Similar collage effects have been
used by John dos Passos, for example, in the novel, and in pictorial
essay form in Berger (1972).

33. Samuel Lipman's review of a recent history of the phonograph
(1977) points out that since only 5 percent of all phonograph recordings
are of classical music, it is "unreal to see in the phonograph primarily
a tool of high culture." He concludes that the grip serious music, and
by extension all great culture, has on our minds is limited and tenuous.

References

Alexander, Christopher. 1962. "The Origin of Creative Power in Children." *British Journal of Aesthetics* 2:207–26.

Alexander, Richard D. 1980. *Darwinism and Human Affairs*. Seattle: University of Washington Press.

Alland, Alexander, Jr. 1977. *The Artistic Animal*. Garden City, N.Y.: Anchor Books.

———. 1983. *Playing with Form*. New York: Columbia University Press.

Andrjewski, B. W., and I. M. Lewis. 1964. *Somali Poetry*. Oxford: Clarendon.

Appignanisi, Lisa. 1973. *Femininity and the Creative Imagination*. London: Vision Press.

Aries, Philippe. 1979. *L'homme devant la mort*. Paris: Seuil.

Armstrong, Robert P. 1971. *The Affecting Presence*. Urbana: University of Illinois Press.

Arnheim, Rudolf. 1949. "The Gestalt Theory of Expression." *Psychological Review* 56:156–71.

———. 1969. *Visual Thinking*. Berkeley: University of California Press.

Bain, Alexander. 1859. *The Emotions and the Will*. London: Parker & Son.

Barash, David P. 1979. *The Whisperings Within: Evolution and the Origin of Human Nature*. New York: Harper & Row.

Barzun, Jacques. 1974. *The Use and Abuse of Art*. Series 35. Princeton: Bollingen.

Baudelaire, Charles. 1964 (orig. 1863). "The Painter of Modern Life," in *The Painter of Modern Life and Other Essays*. London: Phaidon.

Belo, Jane. 1960. *Trance in Bali*. New York: Columbia University Press.

———, ed. 1970. *Traditional Balinese Culture*. New York: Columbia University Press.

Benjamin, Walter. 1970. *Illuminations*. London: Cape.

Benoit, Herbert. 1955. *The Many Faces of Love*. New York: Pantheon.

217

Berenson, Bernhard. 1909 (orig. 1896). *The Florentine Painters of the Renaissance*, 3d ed. New York: G. P. Putnam's Sons.

Berger, John. 1972. *Ways of Seeing*. London: British Broadcasting Corporation.

Berleant, Arnold. 1970a. *The Aesthetic Field*. Springfield, Ill.: Charles C. Thomas.

———. 1970b. "Aesthetics and the Contemporary Arts." *Journal of Aesthetics and Art Criticism* 29(2):155–68.

Berlyne, Daniel E. 1971. *Aesthetics and Psychobiology*. New York: Appleton-Century Crofts.

Berndt, R. M. 1971 (orig. 1958). "Some Methodological Considerations in the Study of Australian Aboriginal Art," in Jopling, pp. 99–126.

Bernstein, Leonard. 1976. *The Unanswered Question*. Cambridge, Mass.: Harvard University Press.

Berry, John W. 1976. *Human Ecology and Cognitive Style*. New York: Wiley.

Bibikov, Sergei N. 1975. "A Stone Age Orchestra." *The UNESCO Courier*, June, pp. 28–31.

Biebuyck, Daniel. 1973. *Lega Culture*. Berkeley: University of California Press.

Binswanger, Ludwig. 1963. *Being-in-the-World: Selected Papers*. New York: Basic Books.

Blakemore, Colin. 1977. *Mechanics of the Mind*. London: Cambridge University Press.

Boas, Franz. 1955 (orig. 1927). *Primitive Art*. New York: Dover.

Bohannon, Paul. 1971. "Artist and Critic in an African Society," in Otten, pp. 172–81.

Bonner, John T. 1980. *The Evolution of Culture in Animals*. Princeton: Princeton University Press.

Bott, Elizabeth. 1972. "Reply to Edmund Leach's Article," in J. S. La-Fontaine, ed., *The Interpretation of Ritual*, pp. 277–82. London: Tavistock Publications Ltd.

Bourguignon, Erika. 1972. "Dreams and Altered States of Consciousness in Anthropological Research," in F. K. L. Hsu, ed., *Psychological Anthropology*. 2d ed. Cambridge, Mass.: Schenkman.

Bowlby, John. 1969. *Attachment and Loss*. Vol. 1: *Attachment*. London: Hogarth.

———. 1973. *Attachment and Loss*. Vol. 2: *Separation, Anxiety and Anger*. London: Hogarth.

Brassai. 1967. *Picasso & Co*. London: Thames and Hudson.

Brennan, P. 1979. "Sontag in Greenwich Village." *London Magazine* 19 (1 & 2):99–103.

Briggs, Jean L. 1970. *Never in Anger*. Cambridge, Mass.: Harvard University Press.

Brothwell, Don, ed. 1976. *Beyond Aesthetics*. London: Thames and Hudson.

Bruner, Jerome S. 1972. "Nature and Uses of Immaturity." *American Psychologist* 27:687–708.

Burkert, Walter. 1979. *Structure and History in Greek Mythology and Ritual.* Berkeley: University of California Press.

Burnshaw, Stanley. 1970. *The Seamless Web.* New York: Braziller.

Caillois, Roger. 1978. *La fleuve Alphée.* Paris: Gallimard.

Campbell, H. J. 1973. *The Pleasure Areas.* London: Eyre Methuen.

Campbell, Jeremy. 1982. *Grammatical Man.* New York: Simon & Schuster.

Cardinal, Roger. 1972. *Outsider Art.* London: Studio Vista.

Carpenter, Edmund. 1971. "The Eskimo Artist," in Otten, pp. 163–71.

Carritt, E. F., ed. 1931. *Philosophies of Beauty.* Oxford: Clarendon.

Carstairs, G. M. 1966. "Ritualization of Roles in Sickness and Healing," in J. Huxley, pp. 305–9.

Cassirer, Ernst. 1944. *An Essay on Man,* Chapter 9: "Art." New Haven: Yale University Press.

Chance, Michael, and Clifford Jolly. 1970. *Social Groups of Monkeys, Apes and Men.* New York: Dutton.

Charbonnier, G., ed. 1969 (orig. 1961). *Conversations with Claude Lévi-Strauss.* London: Cape.

Child, I. L., and L. Siroto. 1971. "BaKwele and American Aesthetic Evaluations Compared," in Jopling, pp. 271–89.

Chipp, Herschel B. 1971. "Formal and Symbolic Factors in the Art Styles of Primitive Cultures," in Jopling, pp. 146–70.

Clark, Kenneth. 1977. *The Other Half: A Self-Portrait.* New York: Harper & Row.

Cohn, Robert Greer. 1962. "The ABC's of Poetry." *Comparative Literature* 14(2):187–91.

Conkey, Margaret. 1980. "Context, Structure and Efficacy in Palaeolithic Art and Design," in Foster and Brandes, pp. 225–48.

Covarrubias, M. 1937. *Island of Bali.* New York: Knopf.

Crook, John H. 1980. *The Evolution of Human Consciousness.* Oxford: Oxford University Press.

Cross, H., A. Holcomb, and C. G. Matter. 1967. "Imprinting or Exposure Learning in Rats Given Early Auditory Stimulation." *Psychosomic Science* 7:233–34.

Crowley, D. J. 1971. "An African Aesthetic," in Jopling, pp. 315–27.

Dahlberg, Frances, ed. 1981. *Woman the Gatherer.* New Haven: Yale University Press.

Damane, M., and P. B. Sanders. 1974. *Lithoko: Sotho Praise Poems.* Oxford: Clarendon.

Danto, Arthur. 1981. *The Transfiguration of the Commonplace.* Cambridge, Mass.: Harvard University Press.

d'Aquili, E. G., and C. D. Laughlin, Jr. 1979. "The Neurobiology of Myth and Ritual," in d'Aquili et al., pp. 152–82.

d'Aquili, E. G., C. D. Laughlin, Jr., and J. McManus. 1979. *The Spectrum of Ritual.* New York: Columbia University Press.

Dark, Philip. 1973. "Kilenge Big Man Art," in Forge, pp. 49–69.

Davenport, W. H. 1971. "Sculpture of the Eastern Solomons," in Jopling, pp. 382–483.

Dawkins, Richard. 1978. *The Selfish Gene.* London: Paladin.

Dawkins, R., and J. R. Krebs. 1978. "Animal Signals: Information or Manipulation?" in J. R. Krebs and N. B. Davies, eds., *Behavioral Ecology*, pp. 282–309. Oxford: Blackwell.

d'Azevedo, Warren L. 1958. "A Structural Approach to Aesthetics: Toward a Definition of Art in Anthropology." *American Anthropologist* 60:702–14.

———. 1973. "Sources of Gola Artistry," in d'Azevedo, pp. 282–340.

———, ed. 1973. *The Traditional Artist in African Societies.* Bloomington: Indiana University Press.

Deng, Francis Mading. 1973. *The Dinka and Their Songs.* Oxford: Clarendon.

Deren, Maya. 1970. *Divine Horsemen: The Living Gods of Haiti.* New York: Chelsea House.

Dewey, John. 1958 (orig. 1934). *Art As Experience.* New York: Capricorn.

Donaldson, Margaret. 1978. *Children's Minds.* London: Fontana.

Drewal, Henry John, and Margaret Thompson Drewal. 1983. *Gelede: Art and Female Power Among the Yoruba.* Bloomington: Indiana University Press.

Dubois, Cora. 1944. *The People of Alor.* Minneapolis: University of Minnesota Press.

Dubos, Rene. 1974. *Beast or Angel? Choices That Make Us Human.* New York: Charles Scribner's Sons.

Ehrenzweig, Anton. 1967. *The Hidden Order of Art.* Berkeley: University of California Press.

Ekman, Paul. 1977. "Biological and Cultural Contributions to Body and Facial Movement," in J. Blacking, ed., *The Anthropology of the Body*, pp. 39–84. New York: Academic Press.

Elias, Norbert. 1978 (orig. 1939). *The Civilizing Process.* New York: Urizen.

Ellis, John M. 1974. *The Theory of Literary Criticism.* Berkeley: University of California Press.

Emeneau, M. B. 1971. *Toda Songs.* Oxford: Clarendon.

Erikson, Erik. 1966. "Ontogeny of Ritualization in Man," pp. 337–49, and "Concluding Remarks," pp. 523–24, in J. Huxley.

Fagan, Robert. 1981. *Animal Play Behavior.* Oxford: Oxford University Press.

Faris, James C. 1972. *Nuba Personal Art.* Toronto: University of Toronto Press.

Feld, Steven. 1982. *Sound and Sentiment: Birds, Weeping, Poetics and Song in Kaluli Expression.* Philadelphia: University of Pennsylvania Press.

Fernandez, James W. 1966. "Unbelievably Subtle Words: Representation and Integration in the Sermons of an African Reformative Cult." *History of Religions* 6(1):43–69.

———. 1969. "Microcosmogony and Modernization in African Religious Movements." Occasional Paper Series 3. Montreal: Centre for Developing-Area Studies, McGill University.

———. 1971 (orig. 1966). "Principles of Opposition and Vitality in Fang Aesthetics," in Jopling, pp. 356–73.

——. 1972. "Tabernanthe Iboga: Narcotic Ecstasies and the Work of the Ancestors," in Furst, pp. 237–60.

——. 1973. "The Exposition and Imposition of Order: Artistic Expression in Fang Culture," in d'Azevedo, pp. 194–220.

Figes, Eva. 1976. *Tragedy and Social Evolution*. London: Calder.

Firth, Raymond. 1971 (orig. 1951). *Elements of Social Organization*. London: Tavistock.

——. 1973. "Tikopia Art and Society," in Forge, pp. 25–48.

Forge, Anthony. 1971. "Art and Environment in the Sepik," in Jopling, pp. 290–314.

——, ed. 1973. *Primitive Art and Society*. London: Oxford University Press. Introduction, pp. xiii–xxii; "Style and Meaning in Sepik Art," pp. 169–92.

Fortune, Reo. 1963 (orig. 1932). *Sorcerers of Dobu*. London: Routledge & Kegan Paul.

Foster, Mary LeCron. 1980. "The Growth of Symbolism in Culture," in Foster and Brandes, pp. 371–97.

Foster, Mary LeCron, and Stanley H. Brandes, eds. 1980. *Symbol As Sense*. New York: Academic Press.

Foucault, Michel. 1973. *Madness and Civilization: A History of Insanity in the Age of Reason*. New York: Random House.

——. 1978. *The History of Sexuality: An Introduction*. Vol. 1. New York: Pantheon.

Fox, Robin. 1971. "The Cultural Animal," in John F. Eisenberg and Wilton S. Dillon, eds., *Man and Beast: Comparative Social Behavior*, pp. 273–96. Washington D.C.: Smithsonian Institution Press.

Fraser, John. 1974. *Violence in the Arts*. Cambridge: Cambridge University Press.

Freuchen, Peter. 1961. *Book of the Eskimoes*. London: Arthur Barker Ltd.

Freud, Sigmund. 1924. "The Economic Problem of Masochism." *S.E.* 19:160.

——. 1939. *Civilisation and Its Discontents*. London: Hogarth.

——. 1948 (orig. 1908). "The Relation of the Poet to Daydreaming," in *Collected Papers*, 4:173–83. London: Hogarth.

——. 1955 (orig. 1920). *Beyond the Pleasure Principle*. London: Hogarth.

——. 1962 (orig. 1905). *Three Essays on the Theory of Sexuality*. New York: Basic Books.

Fry, Roger. 1924. *The Artist and Psycho-analysis*. London: Hogarth.

Fuller, Peter. 1979. "The Crisis Within the Fine Art Tradition." *London Magazine* 19(1 & 2):40–47.

——. 1980. *Art and Psychoanalysis*. London: Writers and Readers Publishing Cooperative Ltd.

Furst, Peter T., ed. 1972. *Flesh of the Gods: The Ritual Use of Hallucinogens*. London: George Allen & Unwin Ltd. Introduction, pp. vii–xvi.

Gablik, Suzi. 1976. *Progress in Art*. London: Thames and Hudson.

Galdikas, Birute M. 1980. "Living with the Great Orange Apes." *National Geographic* 157(6):830–53.

Gardner, Howard. 1972. *The Quest for Mind*. London: Coventure.

——. 1973. *The Arts and Human Development*. New York: John Wiley & Sons.

——. 1980. *Artful Scribbles*. New York: Basic Books.

——. 1983. *Frames of Mind*. New York: Basic Books.

Gardner, R. A., and B. T. Gardner. 1978. "Comparative Psychology and Language Acquisition," in K. Salzinger and F. L. Denmark, eds., *Psychology: The State of the Art*, Annals of the New York Academy of Science, 309:37–76.

Gedin, Per. 1977. *Literature in the Market Place*. London: Faber.

Geertz, Clifford. 1959. *The Religion of Java*. Glencoe, Ill.: The Free Press.

——. 1973. *The Interpretation of Cultures*. New York: Basic Books.

——. 1980. *Negara: The Theatre State in Nineteenth Century Bali*. Princeton: Princeton University Press.

Gell, Alfred. 1975. *Metamorphosis of the Cassowaries*. London: Athlone.

Gerbrands, Adrian A. 1967. *Wow-Ipits: Eight Asmat Carvers of New Guinea*. The Hague: Mouton.

——. 1971. "Art as an Element of Culture in Africa," in Otten, pp. 366–82.

Glaze, Anita J. 1981. *Art and Death in a Senufo Village*. Bloomington: Indiana University Press.

Goldman, Irving. 1964. "The Structure of Ritual in the Northwest Amazon," in R. A. Manners, ed., *Process and Pattern in Culture*, pp. 111–22. Chicago: Aldine.

Gombrich, Ernst. 1980. *The Sense of Order*. Ithaca: Cornell University Press.

Gombrowicz, Witold. 1970 (orig. 1965). *Cosmos*. New York: Grove.

Goodale, Jane. 1971. *Tiwi Wives*. Seattle: University of Washington Press.

Goodman, Nelson. 1968. *Languages of Art*. Indianapolis: Hackett.

——. 1978. *Ways of Worldmaking*. Indianapolis: Hackett.

Goodnow, Jacqueline J. 1977. *Children's Drawing*. Cambridge, Mass.: Harvard University Press.

Goody, Jack. 1977. *The Domestication of the Savage Mind*. Cambridge: Cambridge University Press.

Gould, Stephen Jay. 1977. *Ever Since Darwin*. New York: Norton.

——. 1980. "Sociobiology and the Theory of Natural Selection," in G. W. Barlow and J. Silverberg, eds., *Sociobiology: Beyond Nature/Nurture?* Boulder, Colo.: Westview.

Griaule, Marcel. 1965 (orig. 1948). *Conversations with Ogotemmeli*. Oxford: Oxford University Press.

Groos, Karl. 1901 (orig. 1899). *The Play of Man*. New York: Appleton.

Grosse, E. 1897. *The Beginnings of Art*. New York: Appleton.

Gunther, Erna. 1971. "Northwest Coast Indian Art," in Otten, pp. 318–40.

Hallpike, C. R. 1979. *The Foundations of Primitive Thought*. Oxford: Clarendon.

Hardy, Barbara. 1975. *Tellers and Listeners: The Narrative Imagination*. London: Athlone.

Hartshorne, Charles. 1973. *Born to Sing.* Bloomington: Indiana University Press.

Havelock, Eric. 1963. *Preface to Plato.* Cambridge, Mass.: Belknap.

———. 1976. *Origins of Western Literacy.* Toronto: Ontario Institute for Studies in Education.

Heider, Karl G. 1979. *Grand Valley Dani: Peaceful Warriors.* New York: Holt, Rinehart and Winston.

Hillman, James. 1962. *Emotion.* rev. ed., London: Routledge & Kegan Paul.

Hirn, Yrjö. 1900. *The Origins of Art.* London: Macmillan.

Holubar, J. 1969. *The Sense of Time: An Electrophysiological Study of Its Mechanisms in Man.* Boston: MIT Press.

Huizinga, J. 1949. *Homo Ludens.* London: Routledge.

Humphrey, N. K. 1976. "The Social Function of Intellect," in P. G. Bateson, and R. A. Hinde, eds., *Growing Points in Ethology,* pp. 303–17. Cambridge: Cambridge University Press.

———. 1980. "Natural Aesthetics," in B. Mikellides, ed., *Architecture for People.* London: Studio Vista.

Huxley, F. J. H. 1966. "The Ritual of Voodoo and the Symbolism of the Body," in J. Huxley, pp. 423–27.

Huxley, Julian, ed. 1966. *A Discussion of Ritualization of Behaviour in Animals and Man.* Philosophical Transactions of the Royal Society of London. Series B. Biological Sciences 772. 251:247–526. Introduction, pp. 249–71.

James, William. 1941 (orig. 1902). *Varieties of Religious Experience.* New York: Longmans, Green.

Jaynes, Julian. 1977. *The Origin of Consciousness in the Breakdown of the Bicameral Mind.* Boston: Houghton Mifflin.

Jenkins, Iredell. 1958. *Art and the Human Enterprise.* Cambridge, Mass.: Harvard University Press.

Jones, W. T. 1961. *The Romantic Syndrome.* The Hague: Nijhoff.

Jopling, Carol F., ed. 1971. *Art and Aesthetics in Primitive Societies.* New York: Dutton.

Jousse, Marcel. 1978. *Le parlent, la parole et le souffle.* Paris: Gallimard.

Joyce, Robert. 1975. *The Esthetic Animal: Man, the Art-Created Art Creator.* Hicksville, New York: Exposition Press.

Jung, C. G. 1945 (orig. 1928). "On the Relation of Analytical Psychology to Poetic Art." *Contributions to Analytical Psychology,* pp. 225–49, London: Kegan Paul, Trench, Trubner & Co. Ltd.

Kahler, Erich. 1973. *The Inward Turn of Narrative.* Princeton: Princeton University Press.

Kapferer, Bruce, 1983. *A Celebration of Demons: Exorcism and the Aesthetics of Healing in Sri Lanka.* Bloomington: Indiana University Press.

Katz, Richard. 1982. *Boiling Energy: Community Healing Among the Kalahari Kung.* Cambridge, Mass.: Harvard University Press.

Keil, Charles. 1979. *Tiv Song.* Chicago: University of Chicago Press.

Kellogg, Rhoda. 1970. *Analyzing Children's Art.* Palo Alto: Mayfield.

King, Glenn E. 1976. "Society and Territory in Human Evolution." *Journal of Human Evolution* 5:323–32.

———. 1980. "Alternative Uses of Primates and Carnivores in the Reconstruction of Early Hominid Behavior." *Ethology and Sociobiology* 1:99–109.

Kirchner, H. 1952. "Ein archäologischer Beitrag zur Urgeschichte des Schamanismus." *Anthropos* 47:244–86.

Kitahara-Frisch, Jean. 1980. "Symbolizing Technology as a Key to Human Evolution," in Foster and Brandes, pp. 211–24.

Klinger, Eric. 1971. *Structure and Functions of Fantasy*. New York: Wiley Interscience.

Koehler, Otto. 1972 (orig. 1968). "Prototypes of Human Communication Systems in Animals," in H. Friedrich, ed., *Man and Animal*, pp. 82–91. London: MacGibbon and Kee.

Koestler, Arthur. 1973. "The Limits of Man and His Predicament," in J. Benthall, ed., *The Limits of Human Nature*, pp. 49–58. London: Allen Lane.

Kramer, Edith. 1979. *Childhood and Art Therapy*. New York: Schocken.

Kreitler, Hans, and Shulamith Kreitler. 1972. *Psychology of the Arts*. Durham, N.C.: Duke University Press.

Kress, Gunther. 1982. *Learning to Write*. London: Routledge & Kegan Paul.

Kris, Ernst. 1953. *Psychoanalytic Explorations in Art*. London: George Allen and Unwin Ltd.

Kris, Ernst, and Otto Kurz. 1979. *Legend, Myth and Magic in the Image of the Artist*. New Haven: Yale University Press.

Krishnamoorthy, K. 1968. "Traditional Indian Aesthetics in Theory and Practice," in *Indian Aesthetics and Art Activity*. Simla: Indian Institute of Advanced Study.

LaBarre, Weston. 1972. "Hallucinogens and the Shamanic Origins of Religion," in Furst, pp. 261–78.

Lakoff, George, and Mark Johnson. 1980. *Metaphors We Live By*. Chicago: University of Chicago Press.

Lamp, Frederick. 1978. "Frogs into Princes: The Temne Rabai Initiation." *African Arts* 11(2):38–39, 94–95.

———. 1985. "Cosmos, Cosmetics, and the Spirit of Bondo." *African Arts* 18(3):28–43, 98–99.

Lancy, D. F. 1980. "Play in Species Adaptation." *Annual Review of Anthropology* 9:471–95.

Laski, Marghanita. 1961. *Ecstasy: A Study of Some Secular and Religious Experiences*. London: Cresset.

Laughlin, C. D., Jr., and J. McManus. 1979. "Mammalian Ritual," in d'Aquili et al., pp. 80–116.

Leach, Edmund R. 1966. "Ritualization in Man in Relation to Conceptual and Social Development," in J. Huxley, pp. 403–8.

———. 1972. *Humanity and Animality*. 54th Conway Memorial Lecture. London: South Place Ethical Society.

Leavis, Q. D. 1968 (orig. 1932). *Fiction and the Reading Public*. London: Chatto & Windus.

Leroi-Gourhan, A. 1975. "The Flowers Found with Shanidar IV, A Neanderthal Burial in Iraq." *Science* 190:562–64.

Lévi-Strauss, Claude. 1963 (orig. 1958). *Structural Anthropology*. New York: Basic Books.

Lewis, I. M. 1971. *Ecstatic Religion: An Anthropological Study of Spirit Possession and Shamanism*. London: Penguin.

Lienhardt, Godfrey. 1961. *Divinity and Experience: The Religion of the Dinka*. Oxford: Clarendon.

Linden, E. 1976. *Apes, Men and Language*. London: Penguin.

Linton, R., and P. S. Wingert. 1971. "Introduction, New Zealand, Sepik River and New Ireland," in Otten, pp. 383–404.

Lipman, Samuel. 1977. "Both Sides of the Record," *The (London) Times Literary Supplement*, November 7, p. 1282.

Lomax, Alan. 1968. *Folk Song Style and Culture*. Publication 88. Washington, D.C.: American Association for the Advancement of Science.

Lord, Alfred B. 1960. *The Singer of Tales*. Cambridge, Mass.: Harvard University Press.

Lorenz, Konrad Z. 1966. "Evolution of Ritualization in the Biological and Cultural Spheres," in J. Huxley, pp. 273–84.

Lumsden, C. J., and E. O. Wilson. 1981. *Genes, Mind and Culture*. Cambridge, Mass.: Harvard University Press.

McLuhan, Marshall. 1962. *The Gutenberg Galaxy*. Toronto: University of Toronto Press.

McNeill, D. 1974. "Sentence Structure in Chimpanzee Communication," in K. Connolly and J. S. Bruner, eds., *The Growth of Competence*, pp. 75–94. New York: Academic Press.

Maddock, Kenneth. 1973. *The Australian Aborigines: A Portrait of Their Society*. London: Allen Lane, The Penguin Press.

Malinowski, Bronislaw. 1922. *Argonauts of the Western Pacific*. London: Routledge & Kegan Paul.

Malraux, André. 1954. *The Voices of Silence*. London: Secker and Warburg.

Mandel, David. 1967. *Changing Art, Changing Man*. New York: Horizon Press.

Mannoni, O. 1956 (orig. 1950). *Prospero and Caliban: The Psychology of Colonization*. London: Methuen.

Maquet, Jacques. 1971. *Introduction to Aesthetic Anthropology*. Reading, Mass.: Addison-Wesley.

Marcuse, Herbert. 1968 (orig. 1964). *One-Dimensional Man*. London: Sphere.
———. 1972. *Counterrevolution and Revolt*. Boston: Beacon Press.

Marshack, Alexander. 1972. *The Roots of Civilization*. London: Weidenfeld & Nicholson.

May, Rollo. 1976 (orig. 1972). *Power and Innocence*. London: Fontana.
———. 1975. *The Courage to Create*. New York: Norton.

Meyer, Leonard B. 1956. *Emotion and Meaning in Music.* Chicago: Phoenix.

―――. 1969. *Music, the Arts and Ideas.* Chicago: University of Chicago Press.

Meyer-Holzapfel, Monika. 1956. "Spiel des Säugetieres." *Handbuch der Zoologie* 8(2):1–26.

Midgley, Mary. 1979. *Beast and Man.* London: Harvester.

Millar, Susanna. 1974 (orig. 1968). *The Psychology of Play.* New York: Jason Aronson.

Mitias, M. 1982. "What Makes an Experience Aesthetic?" *Journal of Aesthetics and Art Criticism* 41(2):157–69.

Montefiore, A. 1980. "Signs of the Times." *The (London) Times Literary Supplement,* September 5, p. 959.

Morris, Desmond. 1962. *The Biology of Art.* New York: Knopf.

―――. 1966. "The Rigidification of Behaviour," in J. Huxley pp. 327–30.

―――. 1977. *Manwatching.* London: Cape.

Munn, Nancy. 1969. "The Effectiveness of Symbols in Murngin Rite and Myth," in R. F. Spencer, ed., *Forms of Symbolic Action,* pp. 178–207. Seattle: University of Washington Press.

Nietzsche, Friedrich. 1872. *Die Geburt der Tragödie.*

Nketia, J. H. K. 1973. "The Musician in Akan Society," in d'Azevedo, 1973, pp. 79–100.

Oakley, Kenneth P. 1971. "Fossils Collected by the Earlier Palaeolithic Men," in *Mélanges de préhistoire, d'archéocivilisation et d'ethnologie offerts à André Varagnac,* pp. 581–84. Paris: Serpen.

―――. 1972. "Skill as a Human Possession," in S. L. Washburn and P. Dolhinov, eds., *Perspectives on Human Evolution,* pp. 14–50. New York: Holt, Rinehart & Winston.

―――. 1973. "Fossil Shell Observed by Acheulian Man." *Antiquity* 47:59–60.

―――. 1981. "The Emergence of Higher Thought 3.0–0.2 Ma B.P." in *The Emergence of Man, Phil. Trans. R. Soc. London* B 292:205–11.

Ong, Walter J. 1982. *Orality and Literacy.* New York: Methuen.

Ornstein, Robert E. 1977. *The Psychology of Consciousness.* 2d ed. New York: Harcourt Brace Jovanovich.

Osborne, Harold. 1970. *Aesthetics and Art Theory.* New York: E. P. Dutton.

Otten, Charlotte M., ed. 1971. *Anthropology and Art: Readings in Cross-Cultural Aesthetics.* New York: The Natural History Press. Introduction, pp. xi–xvi.

Paddayya, K. 1977. "An Acheulian Occupation Site at Hunsgi, Peninsular India: A Summary of the Results of Two Seasons of Excavation." *World Archaeology* 8(3):344–55.

Pascal, Roy. 1960. *Design and Truth in Autiobiography.* London: Routledge & Kegan Paul.

Paulme, Denise. 1973. "Adornment and Nudity in Tropical Africa," in Forge, pp. 11–24.

Peacock, James L. 1968. *Rites of Modernization.* Chicago: University of Chicago Press.

Peckham, Morse. 1965. *Man's Rage for Chaos.* Philadelphia: Chilton.

———. 1977. *Romanticism and Behavior.* Columbia: University of South Carolina Press.

Pfeiffer, John. 1977. *The Emergence of Society.* New York: McGraw-Hill.

———. 1982. *The Creative Explosion.* New York: Harper & Row.

Piaget, Jean. 1951 (orig. 1946). *Play, Dreams and Imitation in Childhood.* New York: Norton.

Pieris, Ralph. 1969. *Studies in the Sociology of Development.* Rotterdam: Rotterdam University Press.

Pitcairn, T. L., and I. Eibl-Eibesfeldt. 1976. "Concerning the Evolution of Non-Verbal Communication in Man," in Martin E. Hahn and E. C. Simmel, eds., *Communicative Behavior in Evolution,* pp. 81–113. New York: Academic Press.

Platt, J. R. 1961. "Beauty: Pattern and Change," in D. W. Fiske and S. R. Maddi, eds., *Functions of Varied Experience,* pp. 402–30. Homewood, Ill.: Dorsey Press.

Plekhanov, G. V. 1974. *Art and Social Life.* Moscow: Progress Publishers.

Premack, D. 1972. "Two Problems in Cognition: Symbolization, and From Icon to Phoneme," in T. Alloway, Lester Krames, and P. Pliner, eds., *Communication and Affect,* pp. 51–65. New York: Academic Press.

Price, Sally, and Richard Price. 1980. *Afro-American Arts of the Suriname Rain Forest.* Berkeley: University of California Press.

Prinzhorn, Hans. 1972 (orig. 1922). *Artistry of the Mentally Ill.* New York: Springer.

Radcliffe-Brown, A. R. 1948 (orig. 1922). *The Andaman Islanders.* Glencoe, Ill.: Free Press.

Rank, Otto. 1932. *Art and Artist.* New York: Tudor.

Rapoport, Amos. 1975. "Australian Aborigines and the Definition of Place," in Paul Oliver, ed., *Shelter, Sign and Symbol.* London: Barrie & Jenkins.

Rappaport, Roy A. 1971. "The Sacred in Human Evolution." *Annual Review of Ecology and Systematics* 2:23–44.

———. 1984. *Pigs for the Ancestors.* New Haven: Yale University Press.

Read, Herbert. 1955. *Icon and Idea.* London: Faber and Faber.

———. 1960. *The Forms of Things Unknown.* London: Faber and Faber.

Reichel-Dolmatoff, Gerardo. 1972. "The Cultural Context of an Aboriginal Hallucinogen: *Banisteriopsis caapi,*" in Furst, pp. 84–113.

Richards, I. A. 1925. *The Principles of Literary Criticism.* London: Routledge & Kegan Paul.

Riefenstahl, Leni. 1976. *The People of Kau.* London: Collins.

Rieff, Philip. 1966. *The Triumph of the Therapeutic.* London: Chatto & Windus.

Riesman, Paul. 1977. *Freedom in Fulani Social Life: An Introspective Ethnography.* Chicago: University of Chicago Press.

Ristau, C. A., and D. Robbins. 1982. "Cognitive Aspects of Ape Language Experiments," in D. R. Griffin, ed., *Animal Mind—Human Mind.* New York: Springer.

Rorty, Richard. 1980. *Philosophy and the Mirror of Nature.* Oxford: Blackwell.

Rosch, Eleanor, and Barbara B. Lloyd. 1978. *Cognition and Categorization.* Hillsdale, N.J.: Lawrence Erlbaum Associates.

Rosenstein, Leo. 1976. "The Ontological Integrity of the Art Object from the Ludic Viewpoint." *Journal of Aesthetics and Art Criticism* 34(3):323–36.

Santayana, George. 1955 (orig. 1896). *The Sense of Beauty.* New York: Random House.

Sartre, Jean-Paul. 1967 (orig. 1964). *Words.* London: Penguin & Hamish Hamilton.

Schechner, Richard. 1985. *Between Theatre and Anthropology.* Philadelphia: University of Pennsylvania Press.

Schiller, Friedrich. 1967 (orig. 1795). *Letters on the Aesthetic Education of Man.* E. H. Wilkinson and L. A. Willoughby, eds. Oxford: Oxford University Press, 14th Letter.

Schneider, H. K. 1971. "The Interpretation of Pakot Visual Art," in Jopling, pp. 55–63.

Sebeok, Thomas A. 1979. "Prefigurements of Art," in Irene P. Winner and Jean Umiker-Sebeok, eds., *Semiotics of Culture,* pp. 3–74. The Hague: Mouton.

Sennett, Richard. 1977. *The Fall of Public Man.* New York: Knopf.

Sheehy, Gail. 1976. *Passages.* New York: E. P. Dutton.

Shils, Edwin. 1966. "Ritual and Crisis," in J. Huxley, pp. 447–50.

Smith, E. E., and D. L. Medin. 1981. *Categories and Concepts.* Cambridge, Mass.: Harvard University Press.

Spencer, Herbert. 1949 (orig. 1857). "On the Origin and Function of Music," in *Essays on Education,* London: Dent.

———. 1880–82. *Principles of Psychology,* 2d ed. London: Williams and Norgate. Chapter 9: The Aesthetic Sentiments.

Stern, Daniel. 1977. *The First Relationship.* Cambridge: Harvard University Press.

Stevens, Anthony. 1982. *Archetypes.* London: Routledge & Kegan Paul.

Stokes, Adrian. 1972. *The Image in Form.* London: Penguin.

Stone, Lawrence. 1977. *The Family, Sex and Marriage in England, 1500–1800.* London: Weidenfeld & Nicolson.

Storr, Anthony. 1972. *The Dynamics of Creation.* London: Secker & Warburg.

Strathern, Andrew, and Marilyn Strathern. 1971. *Self-Decoration on Mount Hagen.* London: Backworth.

Strehlow, T. G. H. 1971. *Songs of Central Australia.* Sydney: Angus and Robertson.

Tanner, Nancy M. 1981. *On Becoming Human*. Cambridge: Cambridge University Press.

Thevoz, M. 1976. *Art Brut*. New York: Rizzoli.

Thompson, Laura. 1945. "Logico-Aesthetic Integration in Hopi Culture." *American Anthropologist* 47:540–53.

Thompson, Robert F. 1973. "Yoruba Artistic Criticism," in d'Azevedo, pp. 19–61.

———. 1974. *African Art in Motion*. Berkeley: University of California Press.

Thorpe, W. H. 1966. "Ritualization in Ontogeny: I. Animal Play," pp. 311–19, and "II. Ritualization in the Individual Development of Bird Song," pp. 351–58, in J. Huxley.

Tiger, Lionel, and Robin Fox. 1971. *The Imperial Animal*. New York: Holt, Rinehart and Winston.

Tinbergen, N. 1952. "Derived Activities: Their Causation, Biological Significance, Origin, and Emancipation During Evolution." *Quarterly Review of Biology* 27(1):1–32.

Tomkins, Silvan S. 1962. *Affect, Imagery, Consciousness*. Vol. 1: *The Positive Affects*. New York: Springer.

Trilling, Lionel. 1976. "Why We Read Jane Austen." *The (London) Times Literary Supplement*, March 5, pp. 250–52.

Turnbull, Colin. 1961. *The Forest People*. London: Chatto & Windus.

———. 1972. *The Mountain People*. New York: Simon & Schuster.

Turner, Victor W. 1966. "The Syntax of Symbolism in an African Religion," in J. Huxley, pp. 295–303.

———. 1967. *The Forest of Symbols*. Ithaca: Cornell University Press.

———. 1969. *The Ritual Process*. London: Routledge & Kegan Paul.

———. 1974. *Dramas, Fields and Metaphor*. Ithaca: Cornell University Press.

Ucko, Peter J., and Andrée Rosenfeld. 1967. *Palaeolithic Cave Art*. London: Weidenfeld & Nicolson.

Valéry, Paul. 1964. *Aesthetics*. London: Routledge & Kegan Paul.

van Lawick-Goodall, Jane. 1975. "The Chimpanzee," in V. Goodall, ed., *The Quest for Man*, pp. 131–69. London: Phaidon.

Vaughan, James H., Jr. 1973. "əŋkyagu as Artists in Marghi Society," in d'Azevedo, pp. 162–93.

Washburn, Sherwood L., and C. S. Lancaster. 1973. "The Evolution of Hunting," in C. Lorin Brace and J. Metress, eds., *Man in Evolutionary Perspective*, pp. 57–69. New York: Wiley & Sons.

Weiner, J. S. 1971. *Man's Natural History*. London: Weidenfeld & Nicolson.

White, R. W. 1961. "Motivation Reconsidered: The Concept of Competence," in D. W. Fiske and S. R. Maddi, eds., *Functions of Varied Experience*, pp. 278–325. Homewood, Ill.: Dorsey Press.

Whiten, Andrew. 1976. "Primate Perception and Aesthetic," in Brothwell, pp. 18–40.

Wilson, E. O. 1975. *Sociobiology: The New Synthesis*. Cambridge, Mass.: Belknap.

————. 1978. *On Human Nature*. Cambridge, Mass.: Harvard University Press.

Winner, Ellen. 1982. *Invented Worlds: The Psychology of the Arts*. Cambridge, Mass.: Harvard University Press.

Witherspoon, Gary. 1977. *Language and Art in the Navajo Universe*. Ann Arbor: University of Michigan Press.

Wolfe, Tom. 1976 (orig. 1975). *The Painted Word*. New York: Bantam.

Wolin, Sheldon. 1977. "The Rise of Private Man," *New York Review of Books*, April 14, pp. 19–26.

Yetts, W. P. 1939. *The Cull Chinese Bronzes*. London: Courtauld Institute.

Young, J. Z. 1974 (orig. 1971). *An Introduction to the Study of Man*. Oxford: Oxford University Press.

————. 1978. *Programs of the Brain*. Oxford: Oxford University Press.

Zolberg, Vera. 1983. "Changing Patterns of Patronage in the Arts," in Jack B. Kamerman and Rosanne Martorella, eds., *Performers and Performances: The Social Organization of Artistic Work*, pp. 251–68. New York: Praeger.

Photographic Credits